This publication accompanies the exhibition **LIVES OF THE HUDSON** Curated by Ian Berry and Tom Lewis

The Frances Young Tang Teaching Museum and Art Gallery
Skidmore College
Saratoga Springs, New York
July 18, 2009–March 14, 2010

Published in 2010 by The Frances Young Tang Teaching Museum and Art Gallery at Skidmore College, and DelMonico Books, an imprint of Prestel Publishing.

The Frances Young Tang Teaching Museum and Art Gallery
Skidmore College
815 North Broadway
Saratoga Springs, New York 12866
T 518 580 8080
F 518 580 5069
www.skidmore.edu/tang

Prestel, a member of Verlagsgruppe Random House GmbH

Prestel Verlag
Königinstrasse 9
80539 Munich
Germany
Tel: 49 (0)89 24 29 08 300
Fax: 49 (0)89 24 29 08 335
www.prestel.de

Prestel Publishing Ltd.
4 Bloomsbury Place
London WC1A 2QA
United Kingdom
Tel: 44 (0)20 7323 5004
Fax: 44 (0)20 7636 8004

Prestel Publishing
900 Broadway. Suite 603
New York, NY 10003
Tel: 212 995 2720
Fax: 212 995 2733
E-mail: sales@prestel-usa.com
www.prestel.com

© 2010 The Frances Young Tang Teaching Museum and Art Gallery at Skidmore College, and Prestel Verlag, Munich • Berlin • London • New York

Editors: Ian Berry and Tom Lewis
Design: Barbara Glauber and Erika Nishizato / Heavy Meta
Printing and binding: CS Graphics, Singapore

Library of Congress Cataloging-in-Publication Data
Berry, Ian, 1971–
Lives of the Hudson / Ian Berry and Tom Lewis ; essays by Ian Berry... [et al.].
p. cm.
Published to accompany an exhibition held at the Frances Young Tang Teaching Museum and Art Gallery, Skidmore College, Saratoga Springs, N.Y., July 18, 2009–Mar. 14, 2010.
Includes bibliographical references.
ISBN 978-3-7913-5047-9 (alk. paper)
1. Hudson River (N.Y. and N.J.)—In art—Exhibitions. 2. Hudson River (N.Y. and N.J.)—Exhibitions.
I. Lewis, Tom, 1942– II. Frances Young Tang Teaching Museum and Art Gallery. III. Title.
N8214.5.U6B47 2010
704.9'4997473—dc22

2010007721

ISBN 978-3-7913-5047-9

British Library Cataloguing-in-Publication Data: a catalogue record for this book is available from the British Library; Deutsche Nationalbibliothek holds a record of this publication in the Deutsche Nationalbibliografie; detailed bibliographical data can be found under http://dnb.ddb.de.

The paper in this book meets the guidelines for permanence and durability of the Committee on Production Guidelines for Book Longevity of the Council of Library Resources.

Front cover:
Seneca Ray Stoddard, *Untitled*, n.d. (detail)
Albumen print, 4¼ x 7¼ inches
The Chapman Historical Museum, Glens Falls, New York

Back cover:
Sanford Robinson Gifford, *A Sunset, Bay of New York*, 1878 (detail)
Oil on canvas, 20¾ x 40¾ inches
Everson Museum of Art, Syracuse, New York

Previous page:
Unknown, *Highlands of the Hudson*, New York Central System, c. 1920
Playing cards, 4 x 2½ inches
Albany Institute of History and Art, Albany, New York

LIVES of the HUDSON

IAN BERRY AND TOM LEWIS

The Frances Young Tang Teaching Museum and Art Gallery
at Skidmore College

DelMonico Books • Prestel
Munich Berlin London New York

CONTENTS

THE NATURAL RIVER

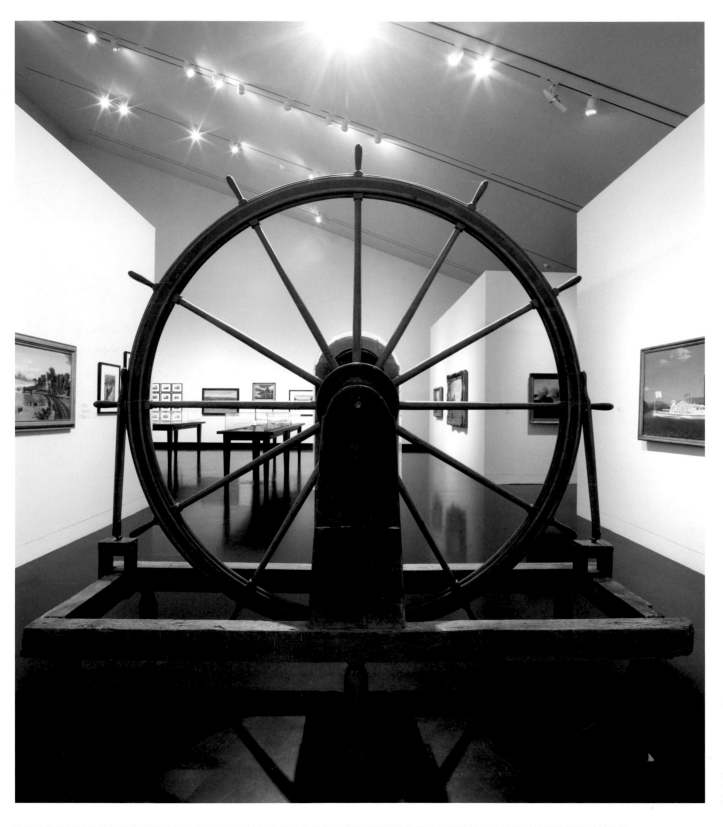

Installation View, *Lives of the Hudson*
Tang Museum, Skidmore College, Saratoga Springs,
New York

INTRODUCTION

Lives of the Hudson explores the long history of one of America's greatest rivers. Four themes have guided us in our organization of this project: the natural river, the imagined river, the human river, and the working river.

Along with important works by Hudson River School painters, *Lives of the Hudson* presents objects of material culture, science, and modern and contemporary art. We have combined information about the river from physical descriptions to the human effects of tourism and industry, with provocative images by contemporary artists who ask us to reconsider our use of the river and our relationships with nature and history. Our focus is the last two hundred years and thus we present an intersection of contrasting and varied stories—environmental, historical, and individual—whose journeys all lead back to the Hudson itself.

The stories told here in images and words raise numerous questions about the Hudson's many lives. We invite you to consider them as you look with a renewed vision at a river that has flowed through millennia of geological and ecological history and centuries of civilization and culture.

RIVER

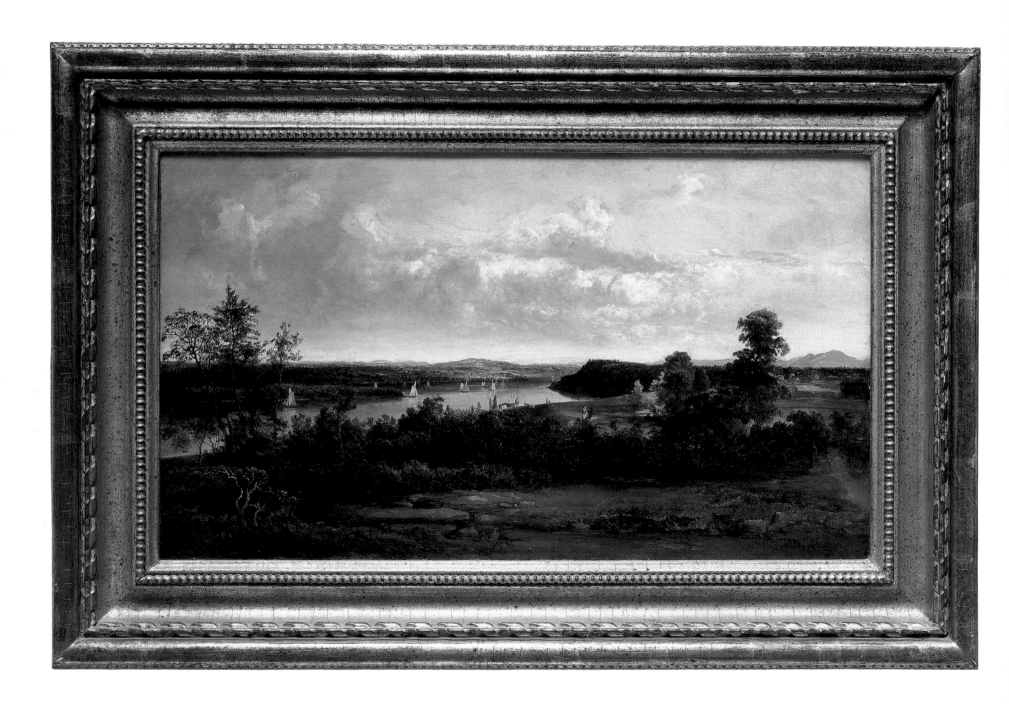

Thomas Doughty, **View of the Hudson River Valley Near Tivoli**, 1841
Oil on canvas, 19⅝ x 29¼ inches

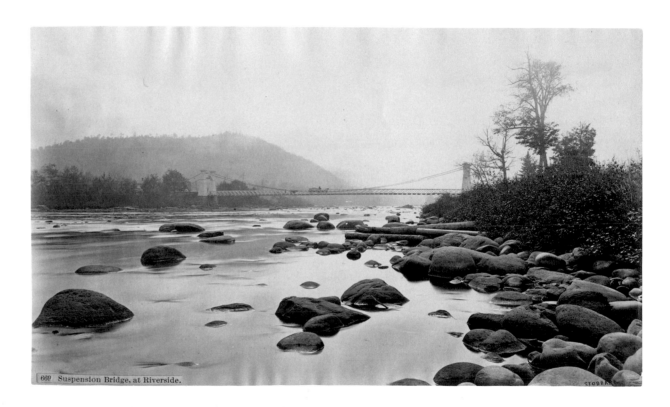

669 Suspension Bridge, at Riverside.

Seneca Ray Stoddard, **Suspension Bridge at Riverside**, c. 1880
Albumen print, $7\frac{7}{8}$ x $4\frac{1}{4}$ inches

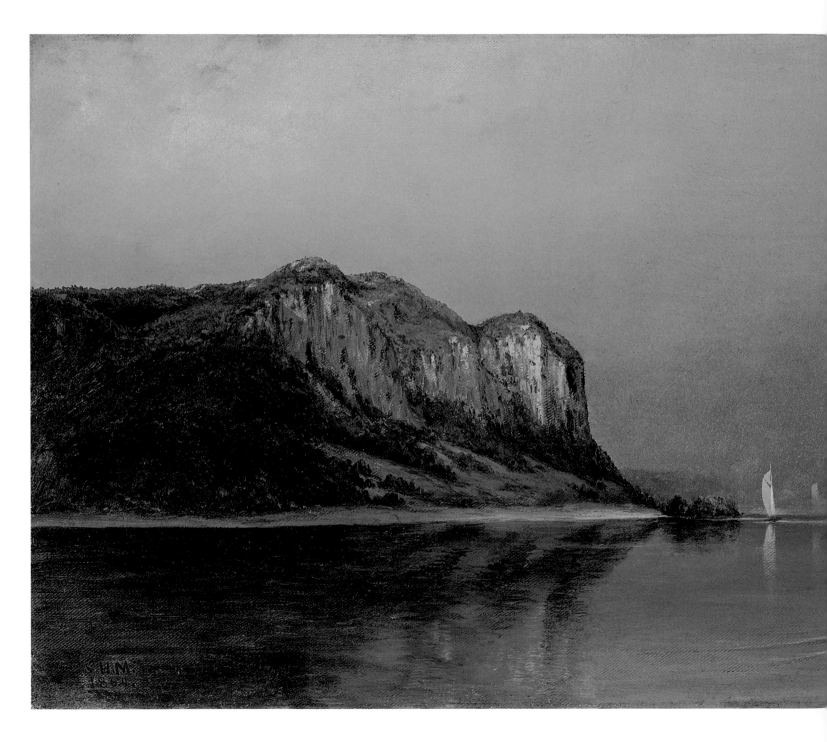

Charles Herbert Moore, **The Upper Palisades**, 1860
Oil on canvas, 12 x 20¼ inches

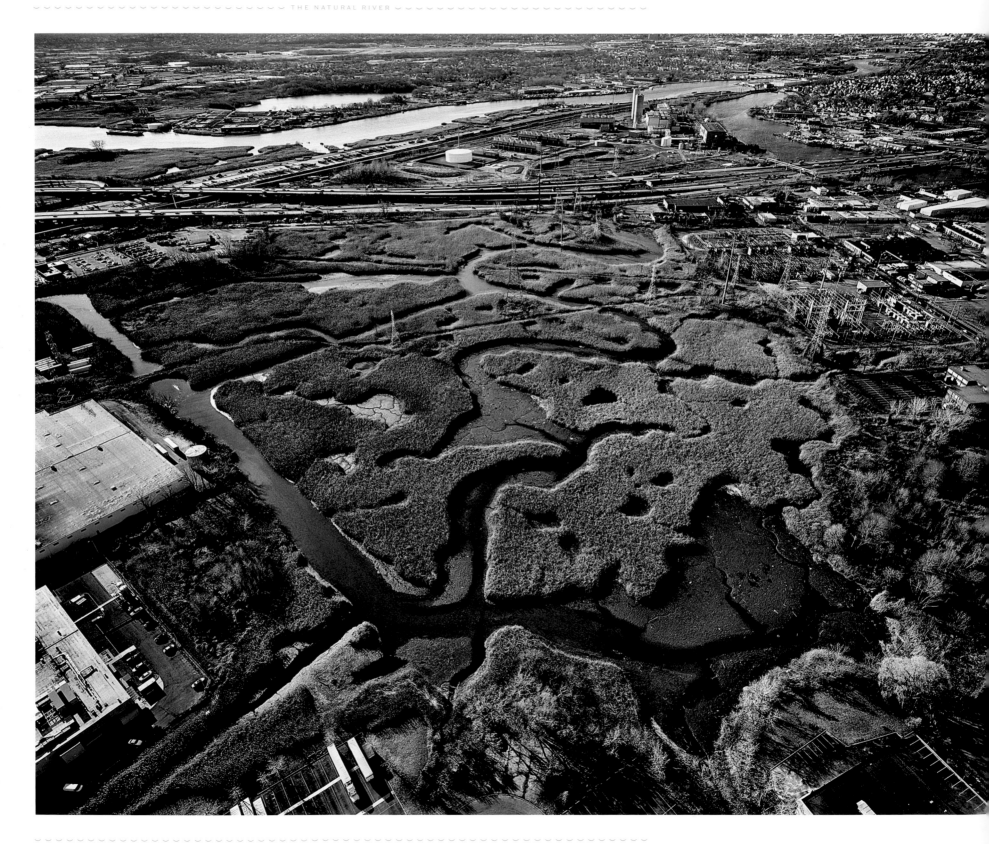

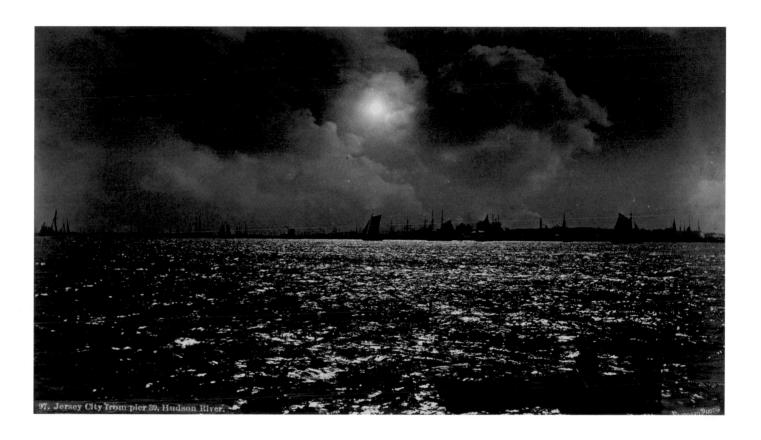

97. Jersey City from pier 39, Hudson River.

Opposite: Michael Light, **Bellman's Creek Marsh Looking North,**
I-95 and Overpeck Creek at Left, Ridgefield, NJ, 2007
Pigment print on aluminum, 40 x 50 inches

Above: Seneca Ray Stoddard, **Jersey City From Pier 39, Hudson River,** c. 1885
Albumen print, 7¾ x 4¼ inches

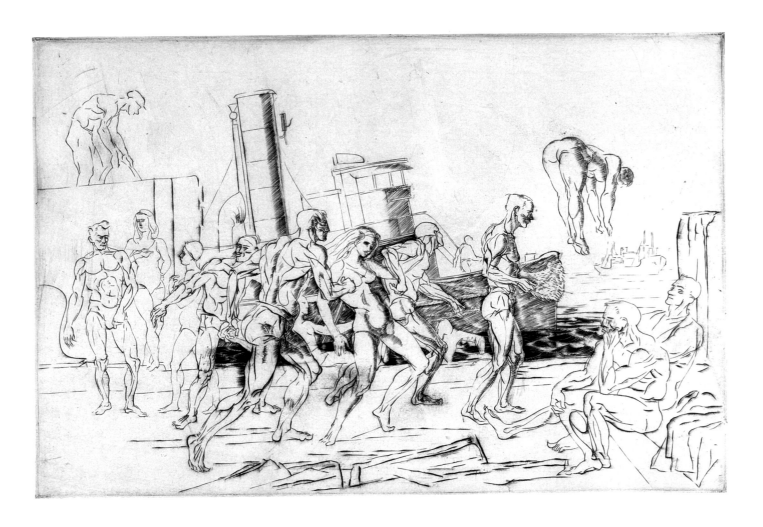

Reginald Marsh, **Swimming in the Hudson**, n.d.
Etching on paper, $10\frac{1}{16}$ x $13\frac{1}{4}$ inches

READING THE RIVER

Akiko Busch

There are countless ways to read the Hudson River, whether in its shifting graphs of light or in its silky feel on the skin, but if you are a swimmer, sooner or later you are likely to find yourself reading its numbers as well. They may have to do with the time of day and temperature, the strength of the current, the velocity of the water, or the timing of the tides.

But on this summer morning, I find again that the numbers most difficult for me to calculate are those of the flood and ebb cycles of the river's currents. Because the lower Hudson River is an estuary, tidal some 150 miles from its mouth to Troy, there are times when it runs to the north and times it runs to the south. The flood cycle occurs as water is pushed from the ocean north to the source; ebb occurs as the river drains to the south. You could be forgiven for imagining that the flood current would coincide with high tide, and ebb current with low, but you would still be wrong.

Such calculations are counterintuitive; the Hudson is a river easy to misread. Tides cause the water to move vertically, while the currents cause it to move horizontally. Yet at the moment the tide is high, the flood cycle is not yet complete, nor at low tide has the ebb cycle completed. The disparity has to do with the shifting levels of water in the ocean and in the river, with displacement, and how things do not occur when you most expect them to. It is possible for the current to be flooding as the tide begins to fall. The guidebook I read calls this "nonsimultaneous phenomenon."

Another way to think of this is that water has its own momentum; it doesn't stop. On this July morning, slack before the flood current comes in is at 12:11. If I get in the water thirty minutes or so before that, I'll still feel the pull of the ebb current, but it will diminish quickly and by the time I am out in the river, the water will be quiet.

But swimming in a river is not just a matter of calculating the force and volume of the water at a

particular moment; there is some shift in your own weight that comes into play as well. Greg Furman, a friend who is a swimmer and poet, writes of watching hippos converging in the Mara River in Kenya:

as they play musical sofas surreal in the rushing currents
they have much in common with refrigerators pianos
stoves small trucks and all massive immovable objects
yet the roman's 'river horse' surprisingly right
their underwater trot like triple crown winners in slow mo'
for in the water they are gigantic thoroughbreds
light on their feet

Perhaps that lightness, or just the possibility of such a lightness that is unavailable to us on solid ground, is what all swimmers are after.

Pay attention and you'll find that being in water transforms the weight of things. That, too, may be a matter of displacement. Because it is not just our bodies, of course; it is all the huge and immovable things we bring with us, or those things that we imagine to be huge and immovable, that can find buoyancy in water. The poet Kim Stafford has said that most things can be found by the water, but swimming is a way of reconfiguring the calculus of what we carry with us, what we leave behind. Which is to say, things can be lost by the water as well.

Or maybe it is not so much a redistribution of weight, but rather, a reimagining of it, as though the natural order of things, and something so simple as being

in a green river on a summer afternoon, can sometimes allow us to reinvent our sense of weight. I look out across the water now. A double-crested cormorant skitters along its surface looking for fish. The delicate rosette of a water chestnut floating on the surface catches the sun just so. It remains amazing to me how a river with such weight to it nonetheless allows its residents to move with such a lightness of being.

I have not yet found any equation to adequately explain that, try as I do to calculate the difference

Pages 18-25: William F. Link, **Hudson By Daylight**
Map: From New York Bay to the Head of Tide Water, c. 1878
Foldout Map, 5¼ x 108 inches

between high tide and flood current, or to gauge the number of minutes that separate the low tide from the ebb current, or even to guess at how the flow and velocity of the water are two different things. At slack tide the river has a stillness to it, but in a matter of minutes as the flood tide comes in, the current will be moving slowly along the bank, more quickly in the middle of the river where the channel is deep. There are times, too, when the tide is shifting, when the river is moving in one direction at the bank and in the other direction midriver. All of these are subject to further vagaries of climate, to freshwater run-off, to rainfall, to wind; taking measure of the Hudson is both an exact and inexact exercise.

And I think of all those things that lose their weight in the water, whether it something the size of a button or the size of a piano, and how it is possible for anything to acquire lightness. And how sometimes things can come and go at the precisely the same moment. Simultaneous phenomena can be just as difficult to grasp as nonsimultaneous phenomena.

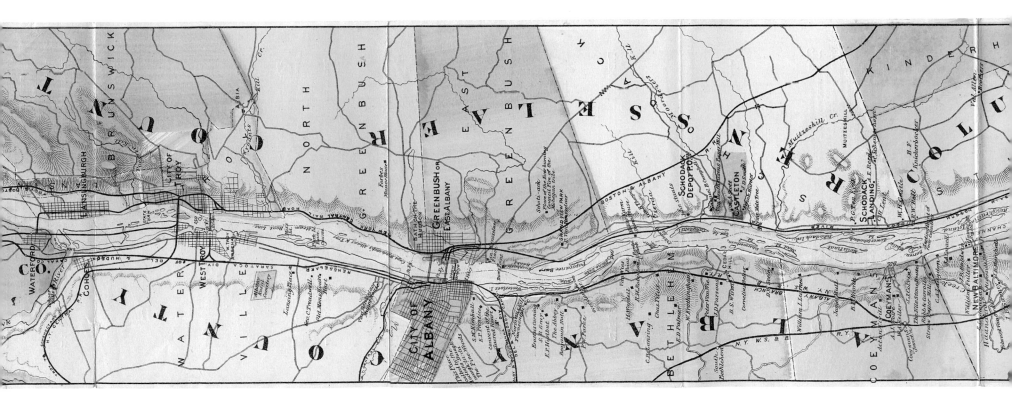

River lore has it that the shifting direction of the water will cause a stick tossed into the Hudson at Troy to take a year and a half to reach the Atlantic Ocean. A guidebook to the river I once read said it would take eight months, but then I overheard a boat captain say it would take a year.

So it is impossible to know that, just as it is impossible to understand how substance can be so fugitive, how it can seem to vanish with the tide or with the current, or with the thin surface current made by the wind, or washed down to the mouth of the river or swept upriver instead with the flood current towards the source. Or perhaps it lingers at the edge of the stream or is caught up in something faster midriver. I wonder at how long it will take to get where it's going, but most of all I wonder at all the different ways you can lose something, at the drift and flow of all the things that leave us.

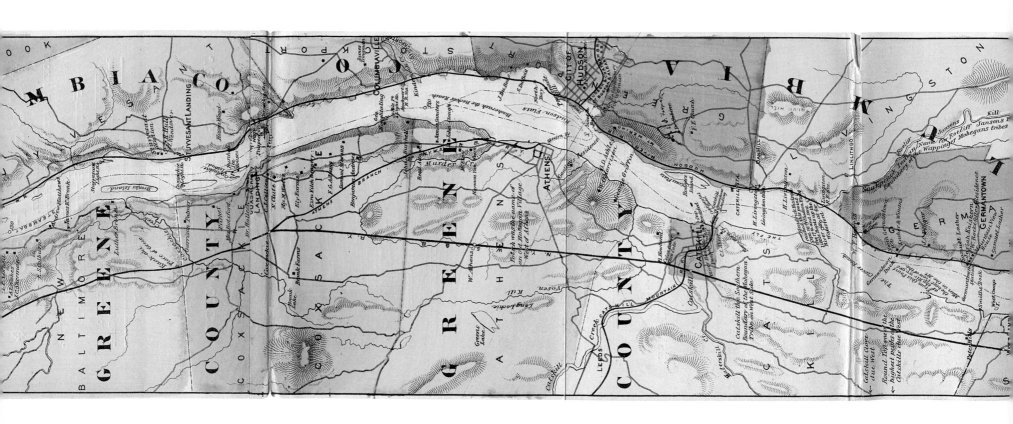

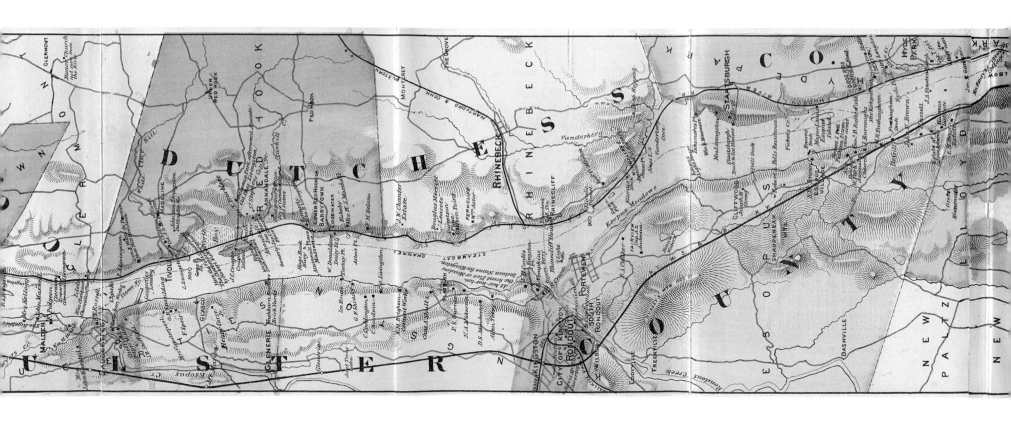

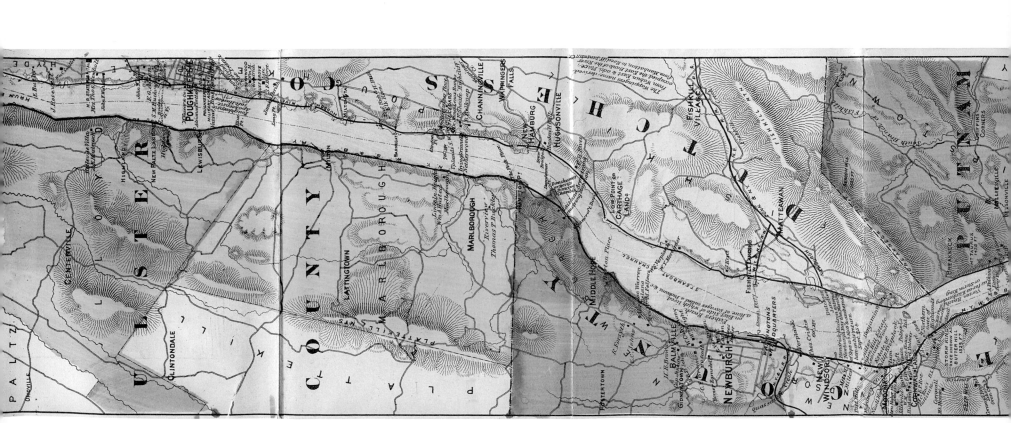

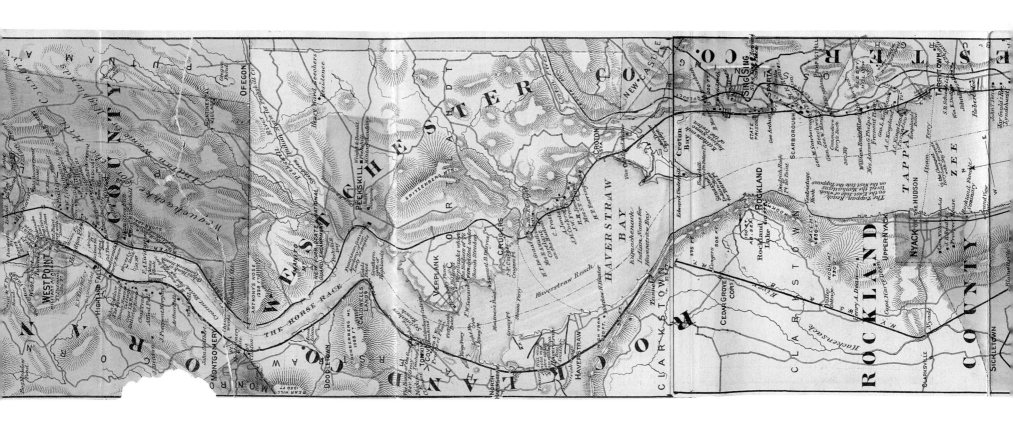

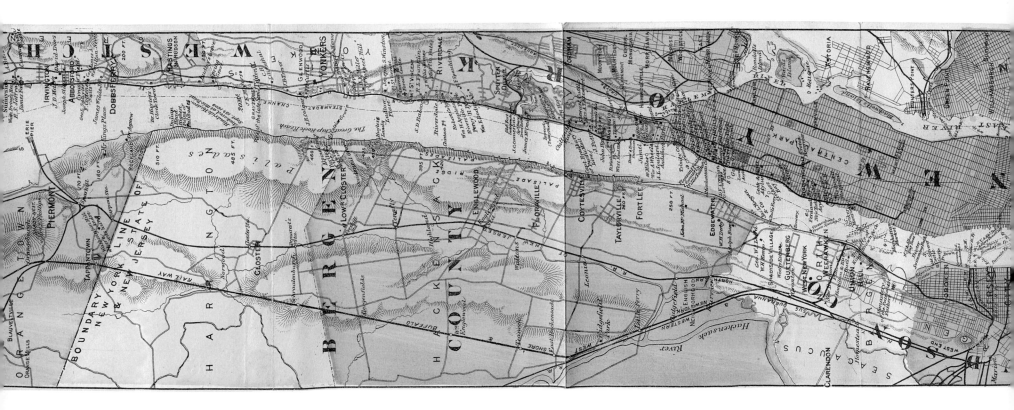

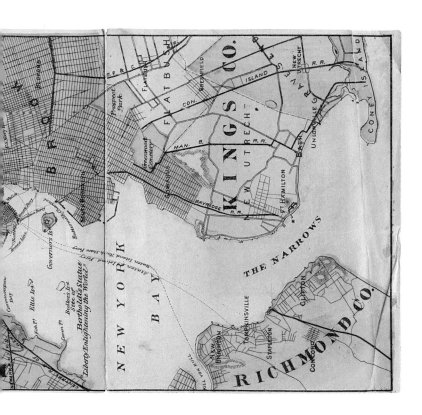

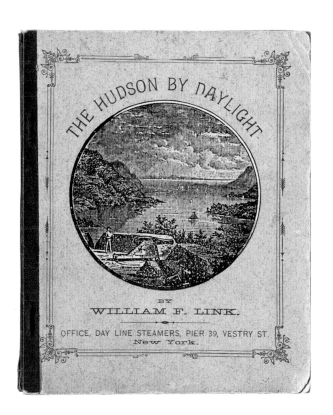

William F. Link, **The Hudson By Daylight**, 1878
Softcover map book, 6¼ x 5 x ¼ inches

GENERAL DESCRIPTION.

UDSON RIVER, in many points of view, may be considered one of the most important streams in the world. It cannot vie with the Mississippi, or the Ohio, and other rivers, either in size or extent; but, in all other respects, it is altogether their superior. For steamboat and sloop navigation, stretching as it does for one hundred and sixty miles inland, through a rugged chain of Highlands, and carrying tide water the entire distance, it is certainly unsurpassed.

The Hudson rises in a marshy tract in Essex county, east of Long Lake. Its head waters are nearly four thousand feet above the level of the sea. After receiving the waters of the Scroon on the north, and the Sacondaga, which flows from Hamilton county, on the west, it turns eastward until it reaches the meridian of Lake Champlain, where it suddenly sweeps round to the southward, and continues in a direct course to New York. One mile above Troy it receives the Mohawk River on the west, the latter being the largest stream of the two at their junction.

The entire length of the Hudson is three hundred and twenty-five miles. The picturesque beauty of its banks,—forming gentle grassy slopes, or covered with forests to the water's edge, or crowned by neat and thriving towns, now overshadowing the water with tall cliffs, and now rising in mural precipices,—and the legendary and historical interests associated with numerous spots, combine to render the Hudson the classic stream of the United States.

Ships can ascend the river as far as Hudson, one hundred and fifteen

1*

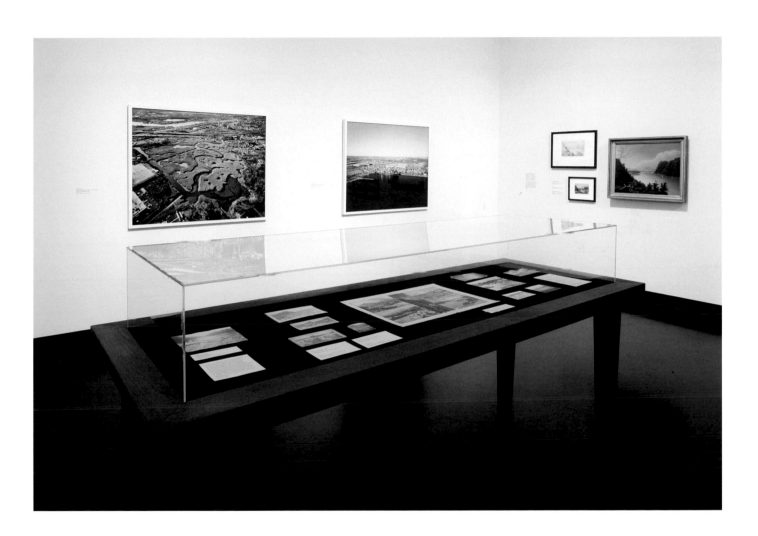

Installation View, *Lives of the Hudson*
Tang Museum, Skidmore College, Saratoga Springs, New York

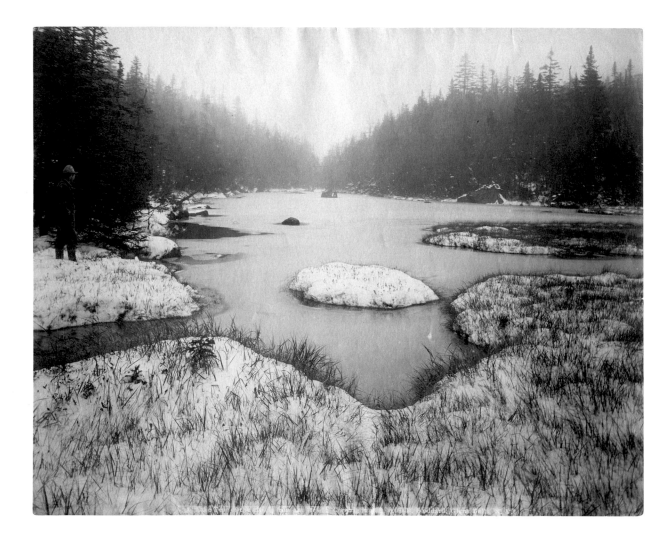

Seneca Ray Stoddard, **Lake Tear of the Clouds**, n.d.
Albumen print, 8⅛ x 6½ inches

THE WATERS GATHER:
COMMENTS ON THE SOURCES
OF THE HUDSON

Judy Halstead

first wondered where a stream went when I was nine. It was the first time I fell in love; the stream behind my parents' new house became the object of my affection. While not deep, it ran rapidly, continuously, and fairly clear. I started keeping track of the depth of the water as the seasons changed. Within weeks of discovering my love, my dog and I followed it downstream. Where did it go? In our housing development, it mostly bordered and wandered through lawns. Sometimes it meandered serenely through open woods or fields. After a while, another stream, one I would later love even more, joined mine. Near a church and houses, the stream headed under a busy road and presented a tough decision. It was wider and deeper now. Should I continue to follow my stream? Was it still my stream? I would have to cross a busy highway (Route 50, I know now). Pammy would have to cross the busy road too. What would my mother think? But the stream pulled me forward.

It became tougher going now as it passed into a valley of its own making, away from houses, and through deeper, thicker woods. Though largely a placid stream near my house, it now bubbled and leaped. The stream became alternately cascades, ripples, and small ponds. It distracted an eager young girl and her Springer Spaniel from worrying about the time of day. Time seemed to stand still. I wondered, where does this stream go? What does it become?

I now know the stream I considered my own that day is a tributary of the Indian Kill, itself a tributary of the Mohawk. The water that flowed past my yardstick as I measured my stream's depth eventually flowed to the Hudson. And finally, to New York City and the Atlantic beyond. I never found that out when I was nine, but that is where my stream went. And still goes.

The Hudson we know is a gathers of many streams and rivers throughout a watershed that drains 13,400 square miles.[1] Below Troy it becomes an estuary that gathers tidal water from the Atlantic as well as freshwater.

The Hudson watershed has three major components: the waters that feed the lower Hudson; the waters that feed the great Mohawk River, which enters the

1. United States Geological Survey (USGS) estimates of monthly and annual freshwater net discharge in cubic feet per second of the Hudson at its mouth, New York, NY. http://ny.water.usgs.gov/projects/dialer_plots/Hudson_R_at_NYC_Freshwater_Discharge.htm. Accessed February 8, 2009.

Hudson at Cohoes; and, the Hudson I know best, the waters of the north that initially gather in the wildness of the Adirondacks. In each of these watersheds, rills flow to creeks, creeks run to brooks, and brooks pour into rivers. Rain and snowmelt fill the rills, brooks, and creeks. It rains on forests, corn fields, wetlands, dairy farms, factories, train tracks, highways, suburbs, and cities. In each of these watersheds, it rains on us. It rains while we live, while we work, while we play, while we shop. To me, the Hudson is a remote, wild, Adirondack Park river, slicing through biologically rich forests in an area classified by New York State as "primitive."[2] It's a turbulent, wilderness river with waves, holes, pour-overs, and heavily forested shores; it's a river that relatively few know first hand, but it has always meant "Hudson" to me.

Conventional wisdom designates Lake Tear-of-the-Clouds, a tiny swampy pond on Mount Marcy, as the origin of the Hudson. Lake Tear-of-the-Clouds, which Seneca Ray Stoddard captured so well in the fog of an early spring in 1899, is the highest altitude permanent surface water that flows to the Hudson. It empties into Feldspar Brook, which drops steeply to the Opalescent River, here a tumbling little creek. A water molecule leaving the pond above drops about four hundred feet per mile during its four-mile descent to Flowed Land Lake in the valley below.[3] Our molecule heads into Calamity Pond and then Calamity Brook. At the outflow of the nearby placid, 450-acre, cedar-lined Henderson Lake, map-makers give the Hudson its name,[4] but our molecule from

John Stoney, **Understanding Landscape Photography #1, Upper Hudson,** 2009
Colored pencil on rag paper, 30¼ x 22⅞ inches

2. Jerry C. Jenkins and Andy Keal, *Adirondack Atlas: A Geographical Portrait of the Adirondack Park* (Syracuse: Syracuse University Press, 2004), 24.

3. Based on information in map accompanying Tony Goodwin, *Guide to Adirondack Trails: High Peaks Region*, 11th ed., (Glens Falls, NY: Adirondack Mountain Club, 1985).

4. New York State Adirondack Park Agency: Town of Newcomb, Essex County Historic Tahawus Tract. http://www.apa.state.ny.us/Press/OSI_Tahawus.htm. Accessed February 8, 2009.

5. Unless otherwise noted, flow information given is based on USGS annual average discharge data from 2004 to 2007 given at http://waterdata.usgs.gov. Accessed February 2009.

6. Based on information available in Walter F. Burmeister, *Appalachian Waters 2: The Hudson River and Its Tributaries* (Oakton, VA: Appalachian Books, 1974).

7. Jenkins and Keal, 198.

8. USGS, http://waterdata.usgs.gov.

Lake Tear-of-the-Clouds never enters Henderson Lake. It flows into the mountain stream called the Hudson River downstream of Henderson Lake, at the confluence with Calamity Brook.

Brooks and rills of the western High Peaks gather together, and by Newcomb, seven miles further downstream from Calamity Brook, the Hudson's flow averages 520 cubic feet per second.[5] Noting quantitative values for the river's flow as it travels downstream enables us to envision the waters gathering, the volume of the Hudson building as waters throughout the watershed unite.

From Newcomb, the Hudson River headwater continues, largely unaffected by human development, for forty-seven more miles to the confluence with the Sacandaga River, dropping an average of fourteen feet a mile.[6] Leaving Harris Lake and crossing under route 28N, the Hudson River heads south for twenty-six miles before it again comes within miles of a road. As it flows, the river gathers water. The Cedar River, the Indian River, the Boreas, and other tributaries add to the volume. The upper half of this scenic whitewater run is sufficiently remote that few paddle or even see it.

The lower half begins with a sharp turn to the east at the confluence with the Indian River. Now our water molecule is in the Hudson Gorge, "considered, rightly, to be one of the [Adirondack] Park's and the country's greatest treasures."[7] While the annual average flow through the Gorge is about two thousand cubic feet per second, it swells rapidly in spring, often reaching fifteen thousand or more in April or May.[8] Unrelentingly, it courses through the ten-mile-long wilderness canyon with a raw, isolated beauty. The Hudson Gorge is whitewater, only to be run by rafts with experienced guides, accomplished kayakers, and the occasional canoeist skilled in class 3–4 whitewater.

Like nearly anyone else with the opportunity to see the Gorge, my whitewater buddies and I put in on the Indian River, just downstream of the dam on Lake Abenakee. I am always in awe when, at Cedar Ledges Rapids, we enter the Hudson Gorge itself. Walls of rock, moss-covered in places, meet the water. The dense woods that line the river mile after mile exhibit a visual softness that I never encounter canoeing or hiking elsewhere in the Adirondacks. White cedar and hemlock contribute to this effect. When we stop in an eddy to rest and play in the nearby wave, ferns greet us.

Midway through the Gorge, just before the most difficult rapids begin, cliffs rise two hundred feet at Blue Ledges, where both bald and golden eagles are known to nest. Below stretches the Narrows, one of more than a dozen significant named rapids. Here, in the biggest water of the Gorge, I'm often too preoccupied to think of eagles. Throughout the tumultuous Hudson Gorge, clear water leaps over ledges, around rocks, and into great waves. The whitewater of the Gorge has a rhythm. Calm pools give paddlers respite between most rapids. Playful chutes alternate with huge waves and channels requiring tight maneuvering. As we enter the lower half

of the Gorge, I watch for signs that we are approaching Givney's Rift, the most technically demanding rapid. Far above us on the left, a sheer cliff on Kettle Mountain reminds me to focus for the challenge ahead. Once I'm downstream of Givney's, my attention returns to the sublime and utterly unique scenery surrounding those of us lucky enough to experience it. This river keeps me paddling.

Below the Gorge, the river heads south again. Often whitewater but less intense, it continues and grows, gathering more water in. Some days fishermen compete with kayakers and canoeists for space in this portion, but the river is still largely devoid of inhabitants—an apparently unspoiled, idyllic, natural place. The Hudson River passes by the hamlets of North Creek and Riparius. Its biggest tributary so far, the Schroon River, joins it outside Warrensburg.

At Hadley, about twelve miles below the confluence with the Schroon, the entire Hudson River, now with an average annual flow of roughly 3,600 cubic feet per second, pounds its way through the narrow slot know as Rockwell Falls, roughly twenty feet wide.[9] Thundering and deadly, this waterfall flows into a dramatic little canyon before the river meets the Sacandaga River just downstream. The Sacandaga, which defines the border of Saratoga and Warren Counties, forms the largest tributary of the Hudson after the Mohawk. The annual average flow of the river nearly doubles to 2,600 cubic feet per second.[10]

The Sacandaga is a tamed river. About six miles above its meeting with the Hudson, the Conklingville Dam, built in 1930, impounds the forty-two-square mile Great Sacandaga Lake, the largest reservoir in New York State.[11] Together the Stewart's Bridge and Conklingville dams regulate the Sacandaga's waters for flood control and electricity generation. The Hudson-Sacandaga confluence defines the end of the Hudson headwaters. Above it, humans have made arguably little impact on the still relatively pristine Hudson that flows free and untamed. Below, as the Hudson River heads west to Glens Falls before turning south again, humans have made their mark.

Now, the Hudson is a changed river, subdued and harnessed. As it continues its descent to the Mohawk, fifteen dams control its flow between Hadley and Troy.[12] This section of the upper Hudson has, on average, a dam every five miles, generating electricity and aiding navigation. Spier Falls Dam, in a wooded valley not far from Saratoga Springs, is by far the tallest of these, with a height of 145 feet,[13] at the time of its completion in 1903, the world's largest dam built solely to produce electricity.[14] By the time the river reaches Glens Falls, it has emerged from the Adirondack foothills, but its steady drop, which once fostered rapid industrial growth in this region, continues.

Still the river gathers in more water from its tributaries, the Battenkill, Fish Creek, the Hoosic, and others. By Fort Edward, it has an average annual flow of roughly 6,500 cubic feet per second, by

9. Ibid.

10. Ibid.

11. Hudson River-Black River Regulating District: Upper Hudson River Watershed. http://www.hrbrrd.com/upperhudson.html. Accessed February 8, 2009.

12. New York State Department of Environmental Conservation, Dam Inventory, http://www.dec.ny.gov/pubs/42878.html. Accessed January 27, 2009.

13. NYS Dam Inventory, http://www.dec.ny.gov/pubs/42978.html. Accessed January 27, 2009.

14. Town of Edinburg: Sacandaga Reservoir. http://www.edinburgny.com/ReservoirHistory.html. Accessed February 8, 2009.

15. USGS, http://waterdata.usgs.gov.

16. Ibid.

17. USGS, http://ny.water.usgs.gov/projects/dialer_plots/Hudson_R_at_NYC_Freshwater_Discharge.htm. Accessed February 8, 2009.

Stillwater over eight thousand, by Waterford over ten thousand.[15] The Mohawk River, at nearly eight thousand and by far the Hudson's largest tributary, flows into the Hudson between Cohoes and Waterford, just above the Federal Dam. The average annual flow is now roughly eighteen thousand cubic feet per second.[16]

Only the upstream half of this waterway, just over half its length, is truly a freshwater river. Starting at the Federal Dam in Troy and continuing to its mouth at Manhattan, the Hudson becomes a tidal estuary. Because the freshwater from the upper Hudson and the Mohawk now merge with the salt water of the Atlantic tides, measuring the freshwater flow of the Hudson is tricky. But scientists estimate that roughly 20,000 cubic feet per second of Hudson freshwater flow into the Atlantic.[17]

Is Lake Tear-of-the-Clouds the source of the Hudson? The little stream I followed as a nine-year-old has its own claim as the Hudson's source as surely as does Lake Tear-of-the-Clouds or Henderson Lake. Streams and creeks and springs throughout the vast watershed each have their claim as well as their waters gather into the flow of the majestic Hudson.

Annea Lockwood, **Feldspar Brook issuing from Lake Tear of the Clouds, the source**, 1982
Black and white photograph

Annea Lockwood, **Hanging Spear Falls, the
Opalescent River, a tributary of the Hudson River**, 1982
Black and white photograph

In foreground: Jason Middlebrook
Pine Bench with 50 Miles of the Hudson River #1, 2009
Pine log and steel legs, 19 x 22 x 127 inches

Annea Lockwood, **A Sound Map of the Hudson**, 1982
Audio installation with map and monitor

Installation view, *Lives of the Hudson*
Tang Museum, Skidmore College, Saratoga Springs,
New York

Kysa Johnson, **blow up 95—
the molecular structure
of environmental pollutants
ethane, methane, propane,
hexane, bonzero and aerolein
after Cole's** *American
Lake Scene*, 2008
Chalk, Chinese white and
blackboard paint on panel,
48 x 36 inches

A SUSPENDED LANDSCAPE

Karen Kellogg

"If there is magic on this planet, it is contained in water."

—Loren Eiseley, *The Immense Journey*

Water molecules are surprisingly simple, merely two hydrogen atoms bonded to a single oxygen atom. Yet a turbulent, flowing continuum of water molecules has always captivated us as a species. Rivers are mysterious, complex, magical; they give life and take it away, they possess the power to carve a landscape and a soothing quiet that causes us to pause and reflect, they provide a conduit for connection and cooperation, and they act as barriers and tools for suppression. Rivers promise power to those who can control them and absolution to those who throw their sins into the currents.

Despite our long reliance upon and relationship with rivers, we frequently misunderstand them. They are not a slate, cleansed as the waters travel downstream, but rather a book—a book whose varied chapters dutifully record our intimate interactions. Some talk of extraction, some talk of manipulation, and some talk of contamination, but the words are visible and clear to those who look beyond our romanticized image of rivers. The Hudson River

is a particularly interesting read, and perhaps the most gripping chapters were written in the twentieth century, with industrialization as the protagonist. Technological advancements, the internationalization of markets, and increased consumerism fueled the engines of industrial development. The resulting scale, intensity, and variety of environmental change were unprecedented, and nowhere was this more evident than in the Hudson River watershed. As paper and textiles mills, tanneries, railroads, power plants, and a variety of other industries lined the shores with increased density, and tankers and barges floated with greater frequency, the Hudson was pushed toward the brink of ecological collapse during the 1900s. Its waters fostered development, and its bed became a dumping ground for that development's waste.

Many of the chemicals that Kysa Johnson references in her paintings, along with a multitude of others, were logged in the pages of the Hudson River ecosystem. Some gathered and sat quietly in the sediments when the river ran at its baseline level but re-suspended periodically during heavy flows. Others accumulated in

the fat tissues of organisms, only to be recirculated time and time again through the who-eats-whom food web of life. Others changed basic water quality parameters such as pH, thus fundamentally altering the environmental conditions that dictate the survival of species in the ecosystem. To the human constituents of the watershed, these same chemicals were related to cancer rates, neurological disorders, and respiratory illness. Still other chemicals reached far beyond the regional point of use to contribute to an atmosphere that is modifying the climatic patterns in nearly every corner of the world.

Thus rich colors, depth, and clarity, as depicted in Asher B. Durand's *In the Woods* (1855), became an increasingly inaccurate portrayal of nature during the twentieth century. At first glance, images of nature today appear pristine, with the major features, such as soil, vegetation, and water, still intact. As Johnson captures, however, the human imprint is ubiquitous and unmistakable. There is an overarching paleness or transparency to an image marked with the presence of our species. Ecosystems are mere apparitions of their former selves, pocked with human resource use and pollution. As Johnson's work suggests, the human modifications have not simply changed the superficial aesthetics of nature, but altered the very core of the ecosystem. As you lose yourself in the depth of Johnson's image, the soil becomes murky, the bark incomplete, the leaves discolored, the stream a

disconnected series of bubbles, and this total loss of nature has potentially profound penalties for the human psyche. Just as a room, surrounded by mirrors reflecting our presence at every turn, can be dizzying and disorienting, so can an environment where human influence is ever-present. Johnson's image mourns a dramatically altered nature in which we are unable to separate the real from the façade, and to ground ourselves in the perspective that we are a single species among many. We've lost the joy and humility that comes with walking beneath an untouched forest canopy to the bank of a pure and powerful river, whose crashing waters remind us of our own insignificance.

There remains not a single slice of nature free of the human imprint, and many ecosystems are so compromised by our impact that the clear delineation between life and death portrayed in Asher B. Durand's work no longer applies. Many landscapes hang suspended between life and death, and this suspension is not without consequence. Paradoxically, we, as a species, must rely on the services provided by intact ecosystems that are fully alive. Ecosystems purify our air and water, provide us with food, clothing, and shelter, regulate our climate, and decompose our waste, and they continue to provide the base for our economic development. Although our understanding of ecosystem functionality is not fully developed, we can comprehend fairly clearly what the loss of such services might mean to us as a species. Scientists continue to present data that

suggest we are pushing our natural systems to the brink and fundamentally compromising the security of future generations. There is growing scientific consensus that our activities are corroding our own life support systems, and Johnson captures what the science is telling us. But her image tells us also about the quiet desperation that comes when one continues to cling to life through the process of death, and the haunting undertone in her work reflects nature's anguish as well as our own.

Our course is not yet inevitable, however. There is a new chapter being written about the Hudson River that might well be titled resilience and recovery. The same waters that motivated massive exploitation also prompted the beginning of an equally unprecedented conservation movement in the late twentieth century. As people began to understand the extent of the degradation along the Hudson River and comprehend its social, cultural, economic, and ethical ramifications, efforts arose to give the ecosystem some space. There was a call to curtail human influence enough so that the river could begin a process of repair and restoration, and the river has proved itself to be amazingly hardy. Water quality has improved, fish are returning, and people in the watershed have developed a renewed appreciation for the richness, depth, and clarity of an ecosystem that bears a slightly lighter human mark. The Hudson's archives still record our abuse, but we find ourselves once again captivated by the beauty of this flowing volume of water molecules and the magic that is water.

Kysa Johnson, **blow up 89—the molecular structure of environmental pollutants ethane, methane, propane, hexane, benzene, and acrolein after Durand's** *In The Woods*, 2008
Watercolor and graphite on board, 20¼ x 16 inches

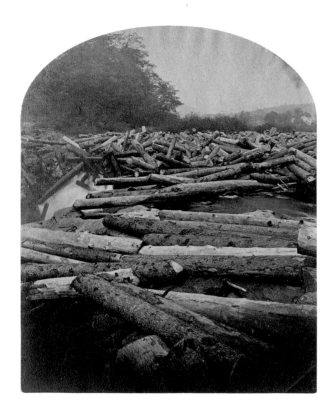

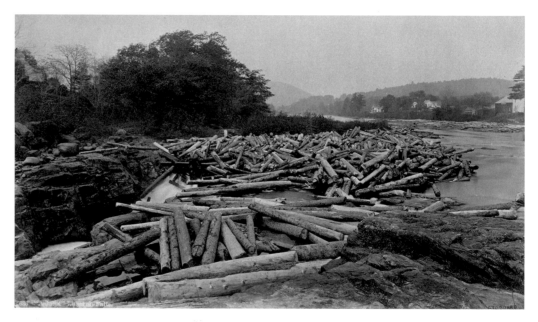

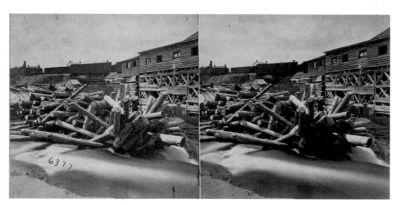

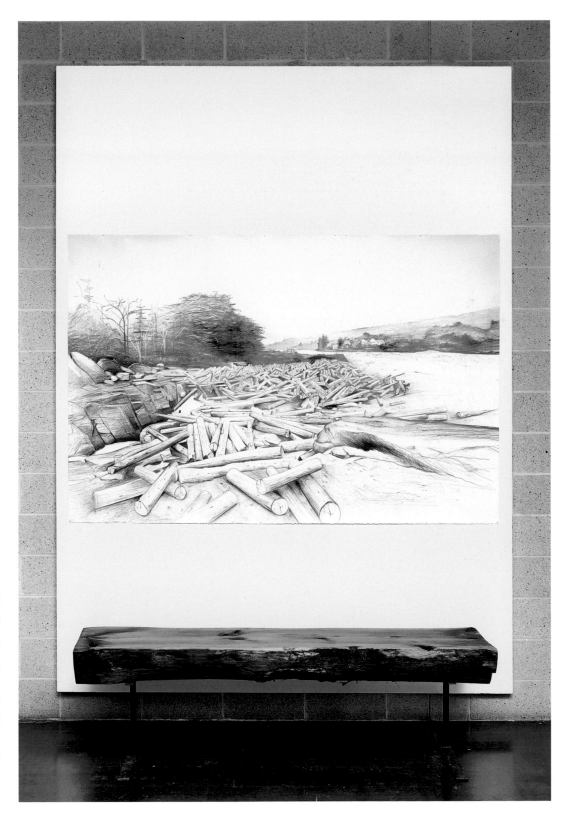

Opposite, clockwise from top left:
Seneca Ray Stoddard, **Untitled**, n.d., Albumen
print (stereograph), $3\frac{3}{8}$ x 3 inches;
A Jam, Luzerne Falls, c. 1880, Albumen print,
$4\frac{1}{4}$ x $7\frac{1}{2}$ inches; **Logs Washed over the
Dam West of the Bridge**, n.d., Photographic
stereograph, $3\frac{1}{4}$ x $6\frac{1}{2}$ inches

Right, foreground: Jason Middlebrook,
**Pine Bench with 50 Miles of the Hudson
River #1**, 2009, Pine log and steel legs,
19 x 22 x 127 inches

On wall: Jason Middlebrook, **Log Jam on the
Hudson**, 2009, Graphite on paper, $55\frac{1}{2}$ x 88 inches

Installation view, *Lives of the Hudson*
Tang Museum, Skidmore College, Saratoga Springs,
New York

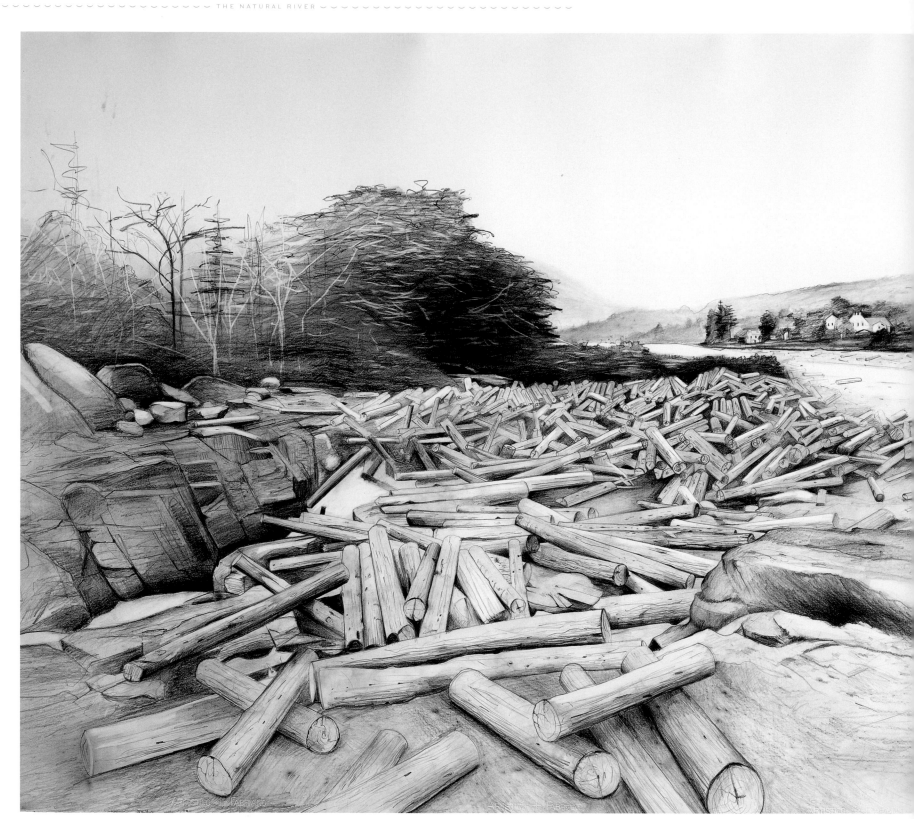

Jason Middlebrook, **Log Jam on the Hudson**, 2009
Graphite on paper, 55½ x 88 inches

DESTRUCTION OF FORESTS IN THE ADIRONDACKS.—Drawn by Julian Rix.—[See Page 805.]

1. Dead Timber, Mount Maxon. 2. Mount Maxon. 3. Dead Water, Schroon River. 4. Coffer-Dam, Lower Works, at Tehawus, Hudson River. 5. Indian Lake, Overflowed Lands.

Julian Rix, **Destruction of Forests of the Adirondacks**, 1884
Harper's Weekly, December 6, 1884, pages 802–803
Newsprint, 16 x 22 inches

BLAME THE HUDSON

Lawrence Hott

You can blame the wilderness preservation movement on the Hudson River. You can also blame it on the Adirondacks. The recognition that its watershed needed protection from over logging kickstarted the whole idea of setting land aside and keeping it forever wild.

The 1894 Forever Wild amendment to the New York State Constitution has brought me much pleasure and profit. I've been canoeing its protected waterways and filming its landscapes for more than two decades. I first came to the Adirondacks, in the early 1980s, to make a film about its history for the Adirondack Museum in Blue Mountain Lake. That's when the museum director gave me a warning: "This is a hardscrabble place, not just a playground, and not everyone thinks preservation is such a good idea." Then he told me a story.

A few years before, the museum hosted a photography exhibit featuring the impact of uncontrolled and unplanned development on rural areas. Once placid streets now bristled with fast-food restaurants, car dealerships, and tourist shops. The museum, hoping to start a discussion on the dangers of unchecked

building, invited members of the communities likely to be affected to come to the show's opening. Instead of deploring the images and turning into preservationists, nearly all attending exclaimed, "That's what we want for our town." Never assume.

The museum director's warning was a way of telling me that the original battles over the founding of the Adirondack State Park have not gone away. In fact, they burn just below the surface of every development issue in the country.

Environmental conflicts often boil down to a competition between beauty and utility. The clear-cutting of the Adirondack forests created jobs in an area where work was scarce, but the logging scarred the mountainside. Even worse, the ravaged soil could no longer absorb the rainwater, flooding the Hudson and making the water supply for the Erie Canal, the economic engine for New York in the mid-19th century, unstable. In an odd twist, two business interests, loggers and shippers, battled it out over who got to survive. Seneca Ray Stoddard's

dramatic photographs of stumps and devastation helped convince the public that the beauty of the forests trumped the utility of logging.

It wasn't long before the Hudson River's legacy would have an impact on two of America's iconic outdoorsmen, John Muir and Gifford Pinchot. Muir, writer, preservationist, and founder of the Sierra Club, fought a pitched battle from 1909 to 1913 against the construction of the Hetch Hetchy Reservoir in Yosemite National Park. His bitter enemy in the fight was his old pal, Gifford Pinchot, conservationist and first chief of the U. S. Forest Service. What they were fighting about, naturally, was two goods. The reservoir would create a reliable, safe water supply for San Francisco, but in doing so it would wipe out a grand landscape, a mirror image of the famous Yosemite Valley. Muir proclaimed, "Dam Hetch-Hetchy! As well dam for water-tanks the people's cathedrals and churches, for no holier temple has ever been consecrated by the heart of man."

The heart of man didn't agree and Muir lost the battle when the U. S. Congress voted to authorize the dam. Heartbroken, he died a year later, in 1914.

Muir, literate and well-informed, was no doubt aware of the Forever Wild movement in New York State. Much of his most dramatic and effective preservation work —the establishment of Yosemite and Sequoia National Parks, the founding of the Sierra Club—came about in the 1890s, when the Adirondack Park's protections became final. And the fight over Hetch Hetchy was as much over the preservation of the valley as to protect

the Tuolumne, a natural and free-flowing river, the Hudson's west coast cousin.

The Hudson is not free-flowing (there are 350 dams in its watershed), natural, or particularly clean, and sadly, this is not an unusual state for America's rivers. The Hudson, an industrial corridor since the early seventeenth century, suffered indignities sooner than other American rivers and, as a consequence, garnered protectors earlier as well. In the classic 1960s Storm King case, defenders of the river challenged Consolidated Edison's bid to build a giant pumped storage electricity power station near Cornwall-on-Hudson. The battle had an impact on river preservation efforts all over the country, especially in Ohio.

George B. Gow, **The Story of a Great Enterprise**, **The Hudson River Water Power Company**, 2nd Edition (cover) 7⅞ x 10½ inches

The Storm King case was still going strong when on a quiet night in June 1969 the Cuyahoga River in Cleveland caught on fire; a passing coal train threw up sparks that ignited oil slicks and debris on the water's surface. The city's African-American mayor, Carl Stokes, capitalized on the publicity to push for federal water and sewer funds, but the result was notoriety instead, which embarrassed Cleveland. People named the city "the mistake by the lake." But the sizzling river had an upside for Ohio and the nation.

The combination of pressure from Storm King opponents on the Hudson and national disgust over a burning, polluted river in Cleveland, led to the creation of the Environmental Protection Agency and passage of the Clean Air and Water Acts. The Storm King project never happened. It would have created a relatively clean source of energy for New York's citizens, but the aesthetic and environmental damage proved unacceptable. In a similar way, the industry along the Cuyahoga River created jobs and a booming economy for Cleveland, but the effluent from the factories was almost the city's undoing. The conflict between beauty and utility, so evident in the tensions surrounding the founding of the Adirondack Park and the protection of the Hudson River watershed, are very much with us in every environmental battle in America.

Unknown, **The Hudson South from Newburgh, from *Picturesque America***, 1894, 13 x 10 inches

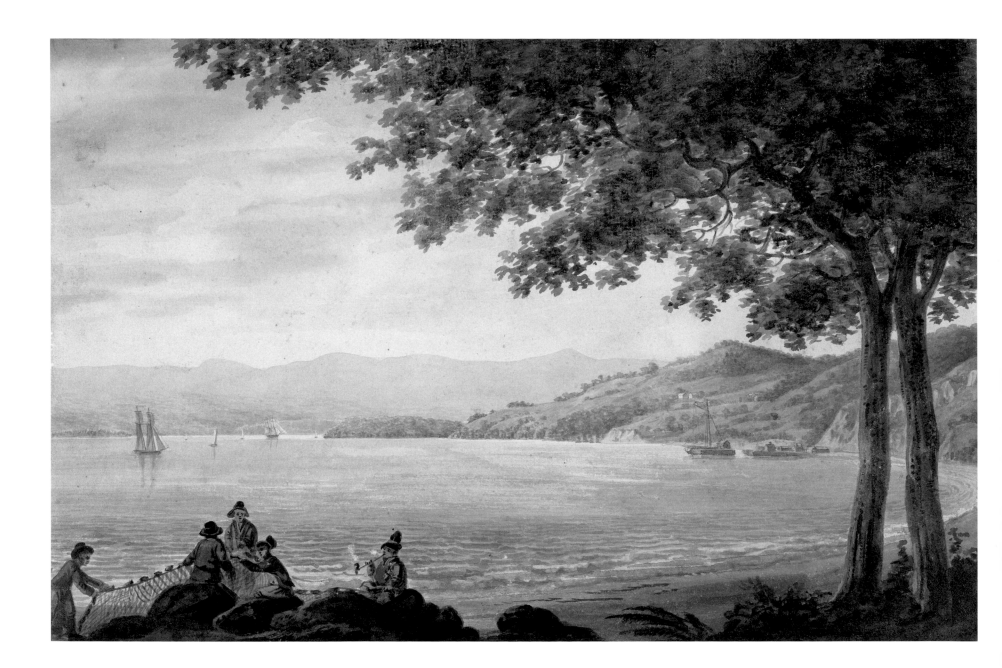

Pavel Petrovich Svinin, **Shad Fisherman on the Shore of the Hudson River**, c. 1813
Watercolor, 10 x 15½ inches

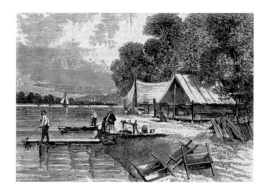

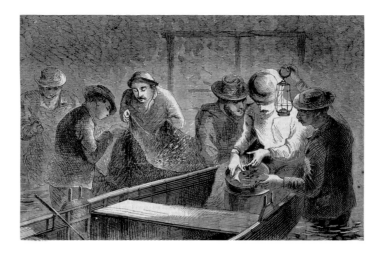

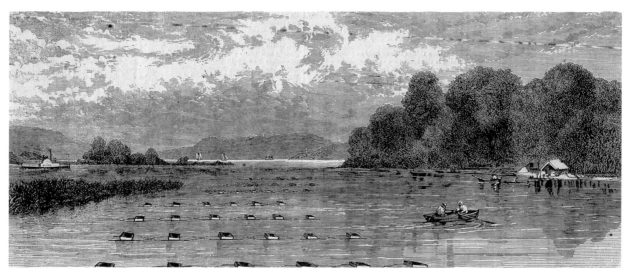

Theodore R. Davis, **The Hatching Ground/Spawning the Shad/Camp Green**, 1872
Harper's Weekly, April 27, 1872, page 325, Newsprint, Overall page 16¾ x 11 inches

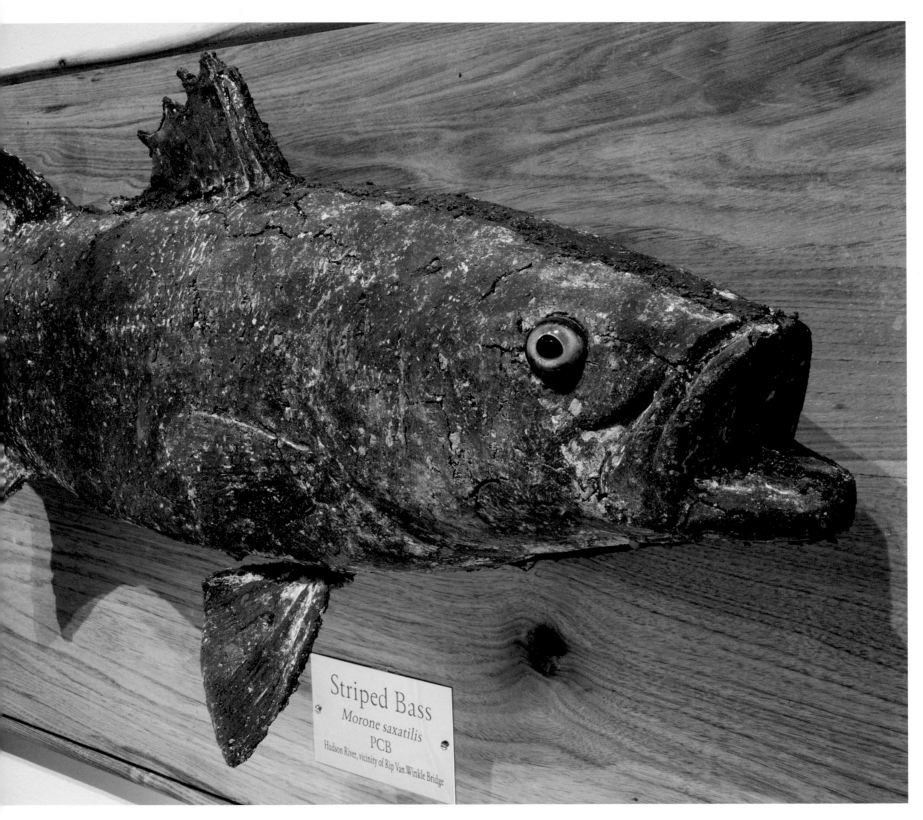

Striped Bass
Morone saxatilis
PCB
Hudson River, vicinity of Rip Van Winkle Bridge

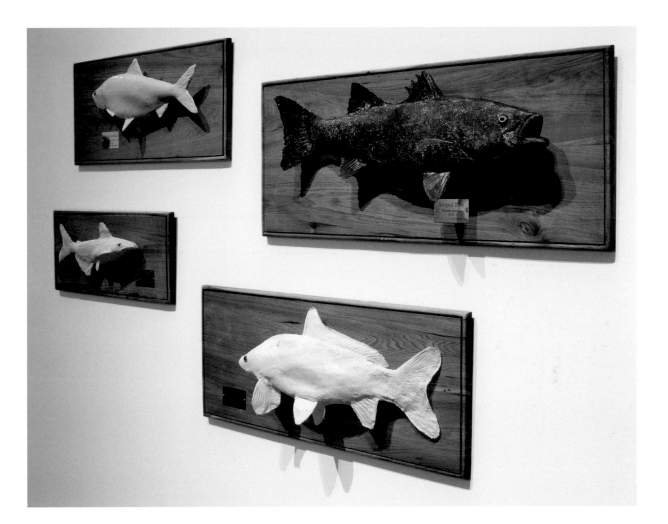

Opposite: Bob Braine and Leslie C. Reed, **Hudson River Fish Mount, Morone saxatilis (Striped Bass)**, 2009 (detail), Hudson River sediment, polymer, butternut, 15¼ x 37¼ x 6 inches

Right, clockwise from top left:
Bob Braine and Leslie C. Reed, **Hudson River Fish Mount, Alosa sapidissima (American Shad)**, 2009 Epoxy, autobody paint GM925A, Crocus Cream, butternut, 10 x 24 x 4½ inches; **Hudson River Fish Mount, Morone saxatilis (Striped Bass)**, 2009, Hudson River sediment, polymer, butternut, 15¼ x 37¼ x 6 inches; **Hudson River Fish Mount, Ictalurus punctatus (Catfish)**, 2009 Road salt, plaster, butternut, 12¾ x 28¼ x 3¼ inches; **Hudson River Fish Mount, Cyprinus carpio (Carp)**, 2009 Toilet paper, butternut, 14 x 33½ x 6 inches

Installation view, *Lives of the Hudson*
Tang Museum, Skidmore College, Saratoga Springs, New York

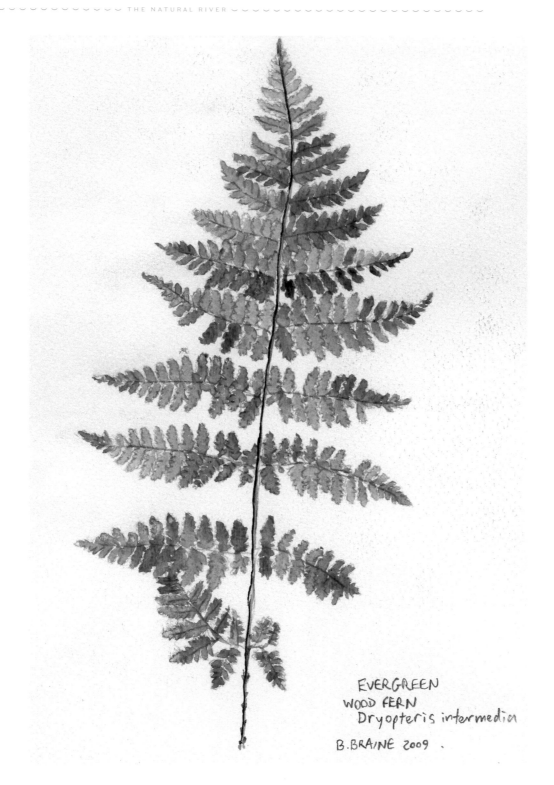

EVERGREEN
WOOD FERN
Dryopteris intermedia

B. BRAINE 2009 .

Bob Braine and Leslie C. Reed, **Dryopteris intermedia**
(Evergreen woodfern), 2009
Watercolor on paper, 16⅝ x 13⅛ inches

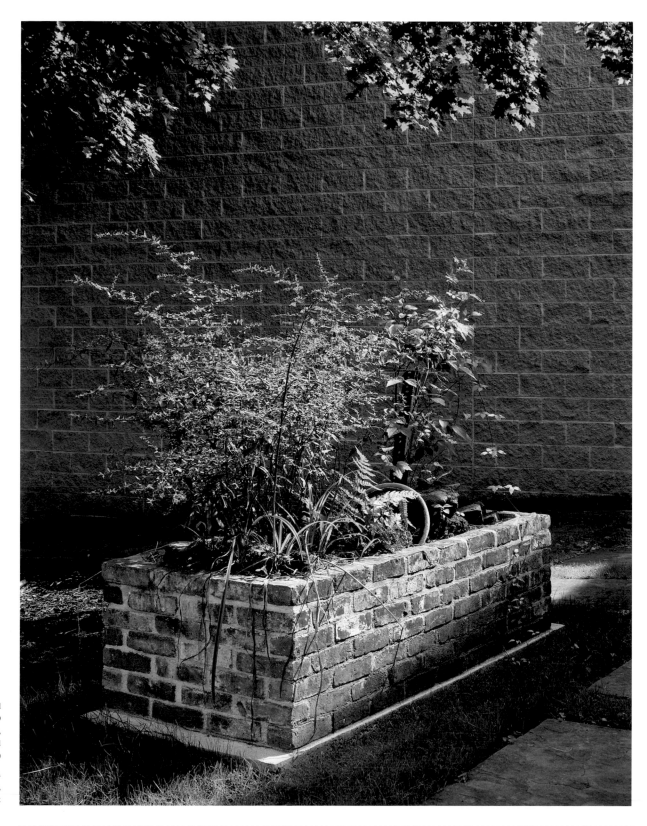

Bob Braine and Leslie C. Reed
Brick Row Planter, Mayone Woodland, 2009
Salvaged Atlas & Mayone Bros. Bricks,
woodland plants, mortar, soil
Approx. 44 x 70 x 28 inches (with plants)

Installation view, *Lives of the Hudson*
Tang Museum, Skidmore College, Saratoga Springs,
New York

Left to right: Bob Braine and Leslie C. Reed, **Rosa multiflora (Multiflora rose)**;
Lindera benzoin (Spicebush); Alliaria petiolata (Garlic-mustard), 2009
Watercolor on paper, 16⅝ x 13¼ inches each

SPICEBUSH
Lindera benzoin

L. Reed 2009

GARLIC MUSTARD
Alliaria petiolata
B. BRAINE 2009.

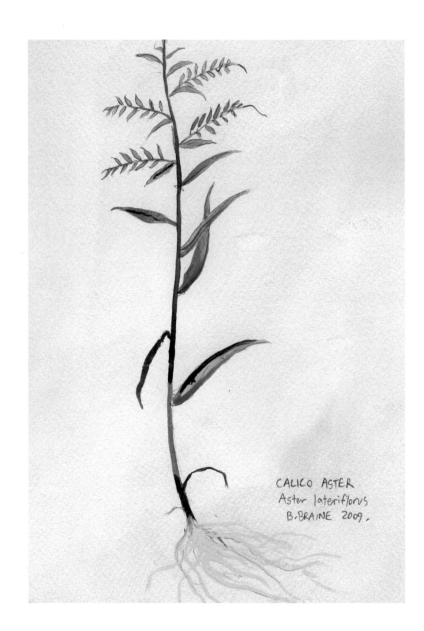

Left to right: Bob Braine and Leslie C. Reed, **Osmorhiza longistylis**
(Anise root); **Symphyotrichum lateriflorus (Calico aster); Maianthemum stellatum**
(Star flower); **Hemerocallis fulva (Orange daylily)**, 2009
Watercolor on paper, 16⅜ x 13⅛ inches each

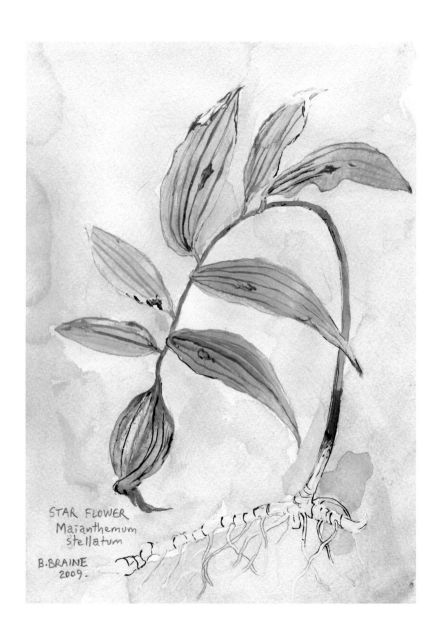

STAR FLOWER
Maianthemum
stellatum

B. BRAINE
2009.

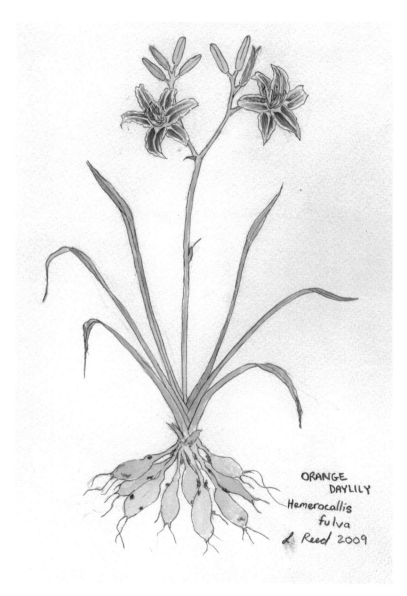

ORANGE
DAYLILY
Hemerocallis
fulva
L. Reed 2009

HYBRID HUDSON

Rik Scarce

t wasn't thoughtless vandalistic mayhem when Bob Braine went out hunting for automatic lawn sprinkler heads in the dead of night as a teenager. He was a radical environmentalist on a mission, angry "at what I saw as a waste of water," he says. Braine's rampages had a purpose, ecological sabotage guided by a deeply felt bond to nature.

Although his outlet for raising hell on behalf of the environment has shifted from the destructive to the constructive and from the blunt to the subtle—Braine insists that the art works he and Leslie Reed produce are not activist but "contemplative"—the goal remains the same: implicating society in nature's plight.

Braine and Reed share something else with radical environmentalists besides their mission: a degree of misanthropy, especially toward those they see as nature's abusers. Braine says, "I call personal watercraft 'fiberglass suppositories': the asshole on top riding around in circles. No real connection, just watching the world whiz by. It may as well be on an LCD screen or something." Listening to another of Braine's stories, of a snake-

hating neighbor, recalls Edward Abbey's words: "I'd sooner kill a man than a snake."

Braine's nature isn't to be zipped past or polluted for kicks, nor is it to be loathed because of an ancient prejudice; it is a troubled and troubling part of our lives, a place in need of healing and honoring from which too many of us are disconnected and in which we see little but utility.

Moreover, Braine and Reed's worldview—like that of all serious environmentalists, whether of the radical stripe or not—is grounded in ecological science. That science is integral to their art and to their lives. They possess an ecologist's knowledge of Murderers Creek, the small tributary of the Hudson that flows through their backyard, and its environs, and an intense awareness of such details as the timing of fish runs and the species composition of the struggling forests around their home.

All the while, society looms. Humans are the ghosts implicated in all of Braine and Reed's works, the artists' object an exploration of the nexus of culture

Bob Braine and Leslie C. Reed, **Brick Row Planter, Mayone Woodland,** 2009 (detail)
Salvaged Atlas & Mayone Bros. Bricks, woodland plants, mortar, soil, Approx. 44 x 70 x 28 inches (with plants)

and nature. Braine says of the ecological world today, "There's evidence of lots of great things happening, but there's such a dark undercurrent. By the same token, it's a dichotomy. You do have functioning systems. And that's what we're celebrating here. The real, true wilderness is a place where, even though everything is touched by humans, all these things are still functioning."

Commenting on a past project that traced the routes of invasive plants from their native lands to their New World homes, Reed notes, "We were specifically interested in how the species' travel had to do with human activity, how connected it is. We were interested in how connected the human world is to nature. People love to separate these things,

but they're actually inseparable." For four thousand years Westerners have struggled to wrest society from nature. Braine and Reed insist that, for better or for worse, we can never divorce ourselves from it.

To the contrary, to use Donna Haraway's term, we create social-natural "hybrids." An esteemed Hudson Valley ecologist told me, "An Indian from Henry Hudson's time wouldn't recognize this place," so radically have the plant and animal communities changed. Indeed, the nature surrounding Brick Row, the 1857 row house neighborhood where Braine and Reed live in the riverside town of Athens, is a hybrid of the historically familiar and the impossibly foreign. Successive generations of humans have

created a bricolage of flora and fauna containing bits and pieces of the local and the exotic, the untouched and the artificial, resulting in ecosystems as cultural as they are natural.

So today the Hudson region has become our garden: the hybrid Hudson. That the gardening is largely unintentional is beside the point. Could it have happened any other way? In our society, nature is in constant upheaval, the source of the raw materials for all that we enjoy and the sink for all that we detest. Braine and Reed live surrounded by that source-sink paradox so central to the industrial age. Murderers Creek has been dug up for the very clay in the bricks used to build their home, dammed to create a subdivision pond, and abused as an industrial dump.

Similarly, from her Catskill home Susan Wides gazes out on a mountainside scar where an incline railway once carried Hudson River School artists out to capture the sublime. Whether for industry or leisure, nature is the utilitarian object par excellence.

But it is not only nature's physical dimensions that emerge as restless in modern times. Nature shifts conceptually as well, its meaning never frozen for long. Native peoples had no need for "nature," and their vocabularies contain no such notion. That's not the case in English, of course.

In fact, "nature's meaning" is the wrong way to put the issue. There is no nature, only *natures*. Eco-warrior Braine's adolescent nature was pure, his Long Island neighbors despoilers of it. Such is not the case with Braine and Reed's "fish trophies" or their brick Brick Row planters, physical and conceptual hybrids that convey the complex meanings of a place that is home to wild but toxin-filled fish and beautiful flora both indigenous and foreign. Can something truly wild embody such artificiality? Where does the Hudson end and Australia—home of *Phragmites*, the tall, wavy-headed reed that crowds out native cattails—begin?

Nature is nothing if not a contested entity at the fundamental level of meaning and reality; ours is a world of clashing natures, natures that collide mentally and materially. That observation holds even among natural scientists, whose views the public often sees as monolithic. One heretical Hudson region wetlands expert has argued that the supposed ecological scourge *Phragmites* actually creates beneficial niches for some birds.

Detail on left, installation view above: Bob Braine and Leslie C. Reed, **Tectonic Plate Entrance Mat #2, Sleepy Hollow Res Oblique View Looking South East**, 2009
Digital print on nylon and rubber, 67½ x 145 inches

Susan Wides, **Hudson River Landscape
(Sunset Rock on North Mountain**), October 14, 2007
Chromagenic Print, 50 x 40 inches

In a place filled with species and cultures that evolved elsewhere—a place home to Storm King, the mountain that transformed the environmental movement, and a nuclear power plant that emits radioactivity into a grand river that itself begins at the base of a dam in a "forever wild" forest—can we conceive of nature as singular and unambiguous? Braine, Reed, and Wides give the lie to a denotative, permanent nature. Art, they show us, is an indispensable instrument for exposing our taken-for-granted environments.

The ethics and the politics embedded in their works prompt us to consider the casual thoughtlessness inherent in our reconstructions—physical and conceptual—of nature. What happened that we lost the ability to question whether a small, living creek should be dammed for a subdivision's languid pond, or whether junk cars should be left to rust in an emerald landscape?

As they probe this hybrid place, Braine, Reed, and Wides create conversations between natures and multiple social groups here today, and long since gone, and groups that will inhabit the region in coming generations. Pondering the dammed section of Murderers Creek, Braine sees history and tragedy yet feels a sense of responsibility to inform, provoke, and heal. "I think backwards from the relationship of the people to the land that creates that kind of pathology in the population," he says. "It's a really wide net. We [he and Reed] are trying to illustrate the links that illuminate those relationships."

Wides says something similar: "As I researched the history of Kaaterskill Clove and of the Hudson River School, I began to compare the sites as depicted in nineteenth-century paintings to the way they look today. One of the sites where Thomas Cole chose to paint near his home was transformed into a car junkyard.… I hiked to the sites of the paintings and continued developing my own connection to the spirit of the place, and my photographs evolved into a meditation on painting and photography's ability to communicate a transformational experience of landscape."

Can artistic transformation cure our pathological relationships with the Hudson's natures? The river's hybrid landscape embraces physical and cognitive artifice. We have built it, and infused it with meanings, and we constantly remake and re-conceptualize it. Braine, Reed, and Wides present us with that sobering reality, one we all know but try to hide from: nature is ours. And they ask whether now might not be the time to own up to our authorship, to replace accident and whim with intention and good will as we re-create and re-mean this place once more.

THE IMAGINED

RIVER

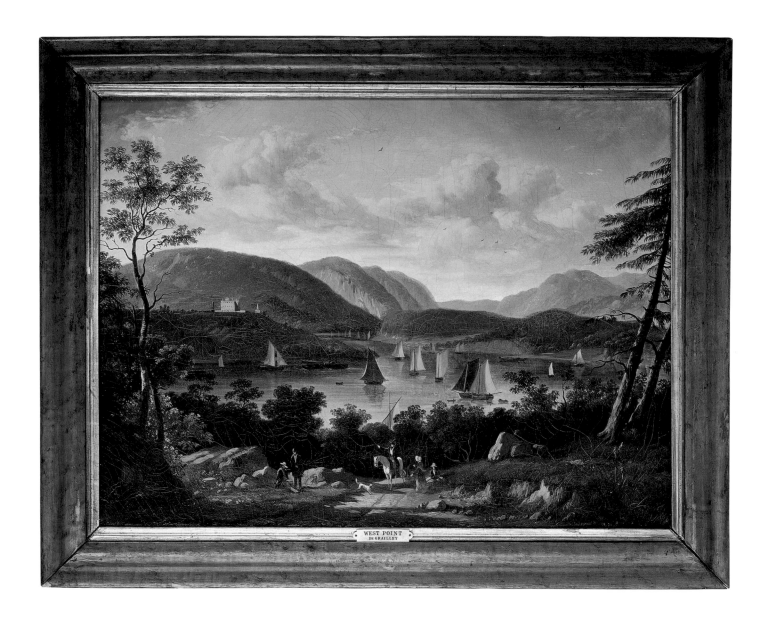

WEST POINT
De GRAILLEY

Victor DeGrailly, **West Point**, n.d.
Oil on canvas, 27 x 34 inches

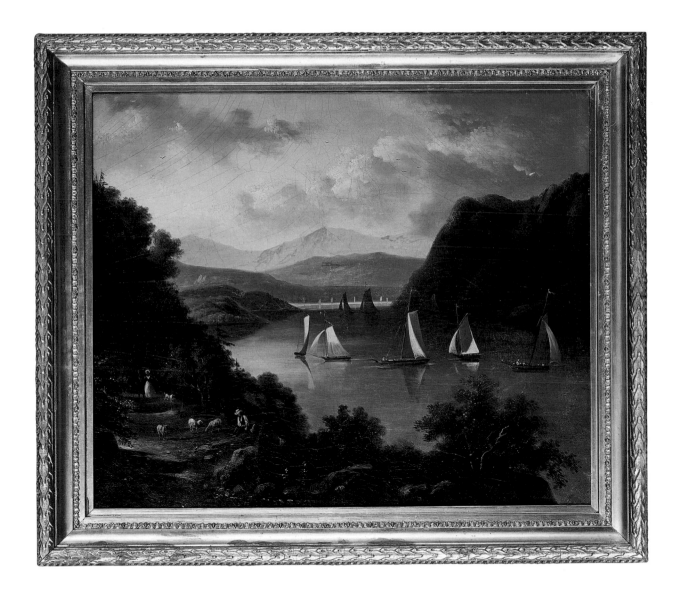

Victor DeGrailly, **View Near Anthony's Nose**, n.d.
Oil on canvas, 27 x 30 inches

John Stoney, **Stills from *For your love*,** 2009
HD video loop with sound, 5 minutes

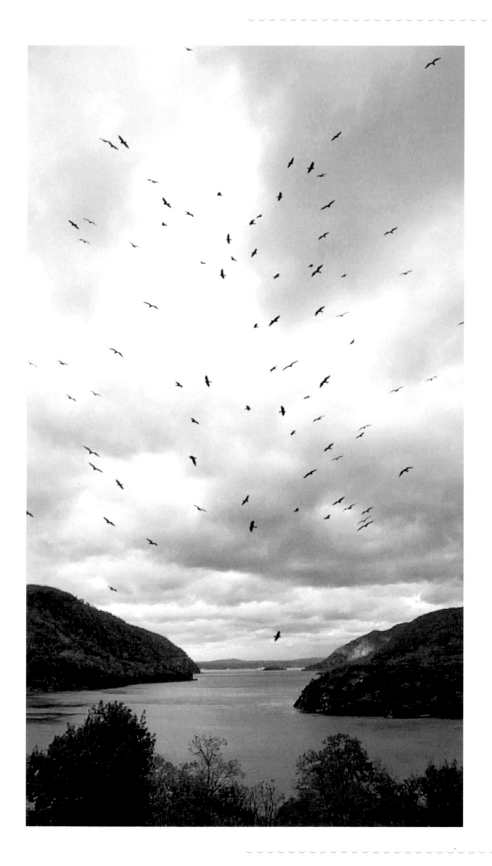

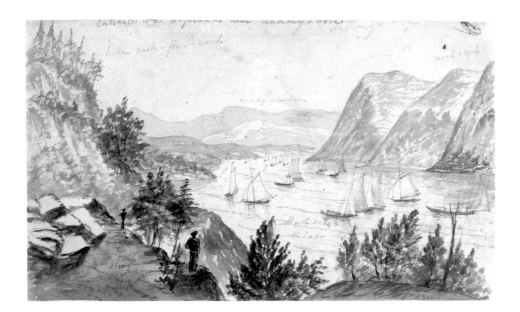

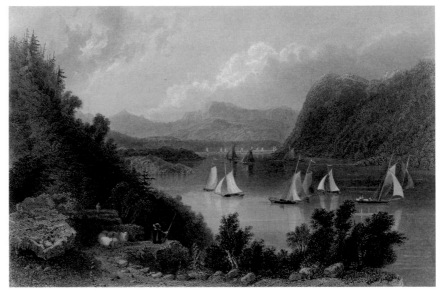

Left: Attributed to William H. Bartlett, **Entrance to the Highlands**
Near Anthony's Nose, Hudson River, c.1839
Graphite and watercolor on paper, 7⅛ x 11¹⁰⁄₁₆ inches

Right: William H. Bartlett, **View from Anthony's Nose. (Hudson River)**, n.d.
Hand-colored engraving, 4⅝ x 6⅞ inches

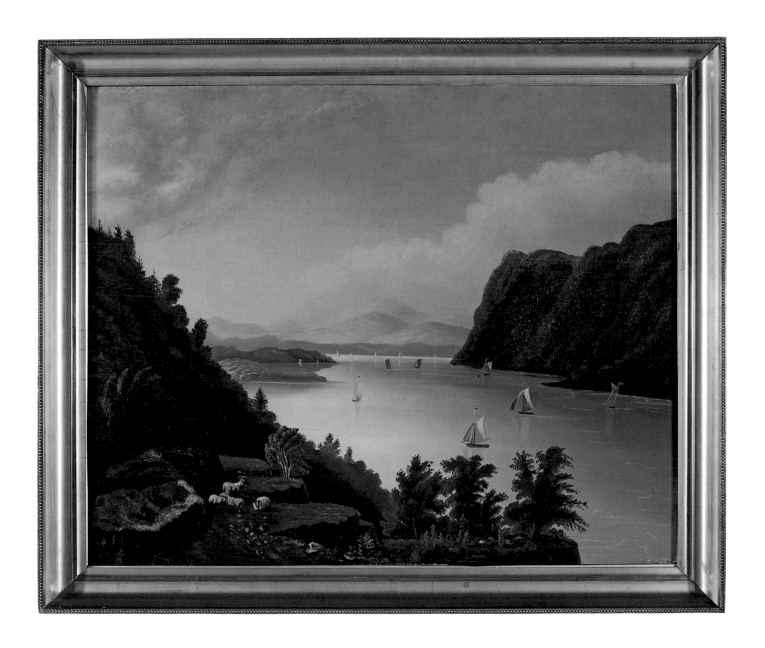

Unknown (After William H. Bartlett), **View Near Anthony's Nose (Hudson Highlands)**, c. 1850
Oil on canvas, 21⅞ x 27⅛ inches

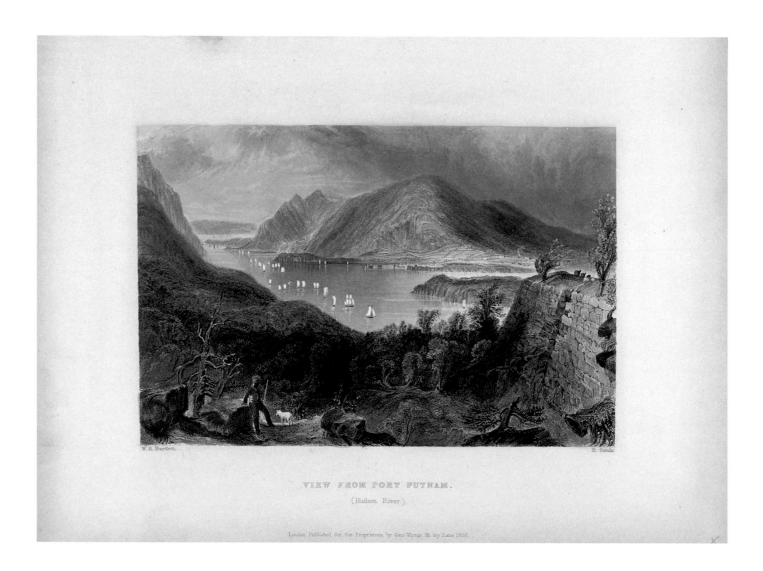

VIEW FROM FORT PUTNAM.

(Hudson River.)

London, Published for the Proprietors by Geo Virtue, 26, Ivy Lane 1837.

William H. Bartlett, **View from Fort Putnam. (Hudson River)**, 1836–1840
Hand-colored engraving, 4⅝ x 6⅞ inches

EDEN'S ARTIST
WILLIAM H. BARTLETT AS THE FIRST POPULARIZER
OF HUDSON RIVER VALLEY IMAGES

Gregory Pfitzer

When one thinks of nineteenth-century visualizations of the Hudson River Valley, the name Thomas Cole comes most prominently to mind. His highly deserved reputation as the preeminent artist of the region is based on the magnificent quality of his sublime landscape paintings. In his own day, however, Cole's works had only modest circulation, held as they were in private collections with limited audience access, or exhibited in galleries for a fee to those who could afford to see them. The most recognized disseminator of Hudson River views in the 1830s and 1840s was not Thomas Cole, in fact, but William H. Bartlett, a British artist and engraver, who marketed picturesque views of the region to receptive audiences in the United States and Europe. Appearing initially as elaborate hand-colored prints sold by subscription, and later as black-and-white steel engravings in *American Scenery*, a more widely circulating illustrated travel book, Bartlett's images (not Cole's) first established the visual vocabulary of the Hudson River Valley for popular audiences on both continents.[1]

Cole had coveted the *American Scenery* title himself. In 1835 he negotiated with London publisher Charles Heath for the production of an illustrated volume of Hudson River sketches that he hoped might be paired with text from Washington Irving to produce a "picturesque annual" for the British and American book markets. By August of that year painter and publisher had come to terms for thirty "outline drawings of scenery along the Hudson" at a pound sterling each, as well as "detailed sketches of buildings, steamboats, and other items of interest" in the region. Excited about the prospects, Cole wrote Irving to gauge his willingness to participate in the project. On September 15, 1835, the landscapist received the disappointing news that while Irving thought "the Hudson would certainly afford some good subjects for sketching both with pen and pencil," he could not commit to the project because of other literary obligations.[2] Discouraged but not defeated, Cole proposed several alternative authors and departed for a sketching trip up the Hudson. He worked throughout the fall on a group of "Selected Views for Heath's Annual," including some pencil and ink drawings that still survive (complete with "heavy framing lines, signatures in the corner,

1. William Henry Bartlett and Nathaniel Parker Willis, *American Scenery: Or, Land, Lake, and River: Illustrations of Transatlantic Nature*, 2 vols. (London: George Virtue, 1840).

2. For more on Cole's proposed project, see Ellwood C. Parry III, *The Art of Thomas Cole: Ambition and Imagination* (Newark: University of Delaware Press, 1988), 162-3, 165. The letter from Irving can be found in Washington Irving to Thomas Cole, 15 September 1835, Box 2, folder 5, Thomas Cole Papers, New York State Library, Albany, New York.

3. The list of potential Heath sketches is from a miscellaneous page among the Cole Papers, ibid., NYSL. A premature announcement of the Heath volume can be found in the *New-York Mirror*, 10 October 1835, 119.

and titles across the bottom") as well as a list of potential Hudson subjects of special interest to him, such as views of "Anthony's Face, the Highlands."[3]

Despite Cole's high ambitions for his illustrated Hudson River book, it was never completed, most likely because of competition from Bartlett's *American Scenery*, a pet project of one of Heath's most significant London rivals, publisher George Virtue. In 1836 Virtue hired Bartlett to travel to the United States to sketch hundreds of views from Nature, including dozens of the Hudson River Valley in anticipation of publishing them as colorized steel-engraved prints in monthly installments beginning in 1837, followed by a two-volume deluxe folio gift-book in 1840.[4] Trained under draftsman and architect John Britton, Bartlett had made a living as an engraver and illustrator of topographical geography works for a burgeoning illustrated book market in London. In pursuit of his work, Bartlett traveled all over the world, including Ireland, Canada, Syria, Egypt, and Palestine.

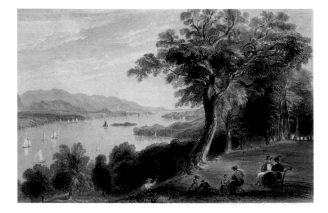

In 1836 he made the first of four trips for Virtue to the United States, where he created a series of pencil and sepia wash drawings of the Hudson River Valley views, including some Cole had planned to sketch himself, such as *Entrance to the Highlands Near Anthony's Nose, Hudson River.*[5] Virtue hired for the project many of the most talented London engravers, who used the latest lithographic techniques to convey contour across the surface of Bartlett's illustrations and to achieve reductions of scale without loss of detail crucial to the reproduction of panoramic landscapes reproductions.[6] The excellent colorists Virtue employed also did much to accentuate the visual appeal of these fine Bartlett sketches and engravings.

The publication of Bartlett's pictorial masterpiece was important not only for what it did to popularize

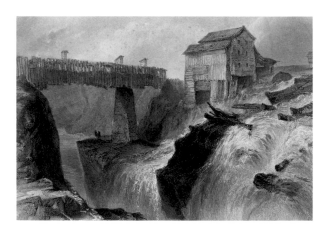

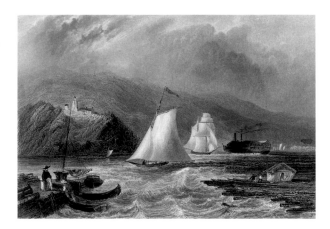

Left to right: William H. Bartlett, **Bridge at Glens Fall. (On the Hudson)**, 1836–1840; **View from Hyde Park. (Hudson River)**, 1836–1840; **Light House near Caldwell's Landing. (Hudson River)**, 1836–1840
Hand-colored engraving, 4⅝ x 6⅞ inches each

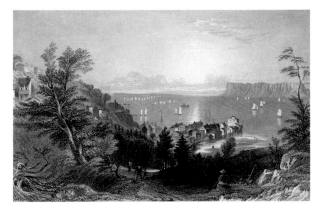

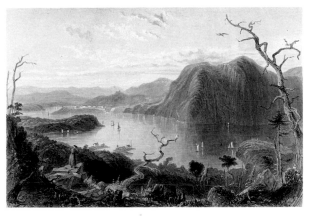

4. Particulars about the contractual relationship between Bartlett and Virtue can be found in the Bartlett/Virtue Letters, Box 1 in Series 2: Research Files, 1845-1995, as cited in "A Preliminary Finding Aid [to] The Eugene C. Worman Research material on William H. Bartlett," Archives of American Art, by Justin Brancato, Smithsonian Institution, Washington, D.C..

5. Note that this work is "attributed" to William H. Bartlett, although its provenance has not been fully established.

6. [Mary] Bartlett Cowdrey, "William Henry Bartlett and the American Scene," *New York History* XXII (October 1941): 389-90. Engravers on the project included: R. Wallis, J. Cousen, R. Brandard, J. T. Willmore, G. R. Richardson, and H. Adlard.

7. For more on copyists and Bartlett, see Cowdrey, "William Henry Bartlett and the American Scene," 391-393.

picturesque landscape visions of the Hudson River Valley, but also as a moment in the history of the book. *American Scenery* was not the first pictorial travel narrative of its kind, to be sure, but certainly the most beautiful and successful in the genre to date, and it spawned an entire cottage industry of such peripatetic works in the 1840s and 1850s. In issuing the volumes, Virtue anticipated that such lavishly illustrated gift-books would be viewed not merely as cheap guidebooks to consult and then discard, but rather as deluxe travel narratives worthy of purchase, collection, and display. Bartlett's images of the Hudson River had reached a wide audience when circulated as prints, but their presentation as book illustrations in keepsake volumes such as *American Scenery* increased significantly their currency and visual recognition. One measure of the wide dissemination of the images in *American Scenery* is the large number of forged copies of Bartlett's works that appeared in the years following his death—works such as *View Near Anthony's Nose (Hudson Highlands)*, a painting by an unknown artist "after William H. Bartlett"— produced by copyists of such varying competencies

that art historians have lumped them together in the anonymous category of "Bartletts."[7]

American Scenery may have eclipsed Cole's landscape paintings as an initial purveyor of the visual for mid-nineteenth century audiences, but, as the American painter surely recognized, it owed a considerable debt nonetheless to his aesthetic theory. Bartlett and his co-author, American writer Nathaniel Parker Willis, relied heavily for inspiration as well as title on Cole's "Essay on American Scenery," an address the painter

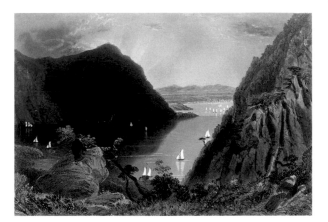

Clockwise from bottom left: William H. Bartlett, **Hudson Highlands. (View from Bull Hill)**, 1836–1840; **Village of Sing-Sing**, 1836–1840; **Crow-Nest, from Bull Hill. (Hudson River)**, 1836–1840
Hand-colored engraving, 4⅝ x 6⅞ inches each

published in the January 1836 edition of *American Monthly Magazine*, a periodical founded by Willis.[8] In the preface to volume one of *American Scenery*, Willis acknowledged his indebtedness to Cole's essay when he wrote: "Nature has wrought with a bolder hand in America," a condition that required her artists to understand "the effect of long continued cultivation on scenery." Cole had urged Americans to embrace the unique role of nature in their lives and to "cultivate" a "taste for scenery" commensurate with their birthright. Willis obliged, claiming with nationalistic pride that while "all other countries" displayed a "picturesque" quality in their natural settings, "the rivers, the forests, the unshorn mountain-sides and unbridged chasms" gave American landscapes "a lavish and large-featured sublimity." He also endorsed Cole's "doctrine of associations," noting the important role antiquities played in the development of a landscape sensibility. Willis noted with characteristic wit that Bartlett's *View Near Anthony's Nose, Hudson Highlands* depicted a river site that "stands amid a host of interesting localities, marked with the events of the revolution, and has witnessed, with less damage than other noses, many a conflict by land and water."

Paraphrasing Cole's reflections on the prelapsarian outlooks of Americans with respect to nature ("We are still in Eden," Cole had noted), Willis concluded that the typical American "looks upon all external objects as exponents of the future. In Europe they are only exponents of the past."[9]

American Scenery's indebtedness to Cole can be measured as well by the subjects Bartlett chose to sketch and the compositional choices he made. The British artist was certainly influenced by the Hudson River painter's visual codes, especially Cole's signature "blasted" trees, which he used to good effect along with more traditional framing devices like coulisse and chiaroscuro to convey the sublimity of nature. He introduced elements employed with less frequency by Cole, too, especially contemplative human observers who serve compositional purposes such as providing scale and defining picture depth, but who also perform an important psychological function by

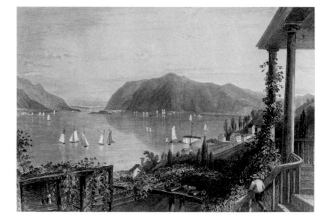

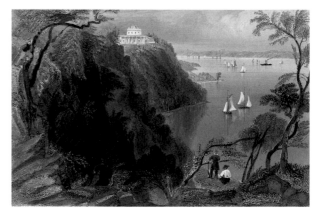

William H. Bartlett, *Top*: **Villa on the Hudson, Near Weehawken,** 1836–1840
Bottom: **View from Ruggle's House Newburgh. (Hudson River),** 1836–1840
Hand-colored engraving, Each 4⅜ x 6⅞ inches

8. T[homas]. C[ole]., "Essay on American Scenery," Lecture to the American Lyceum Society, New York, 8 May 1835, *American Monthly Magazine*, n. s., 1 (January 1836): 1–12.

9. Bartlett and Willis, *American Scenery*, I:iii, 90 and II:2 and Cole, "Essay on American Scenery," 1, 11–12.

10. For more on the relationship between human figures and nature, see Elizabeth McKinsey, "The Sublime in America—Niagara Falls as National Icon, 1800–1860," Ph. D. dissertation, Harvard University, 1976.

helping to reduce the terror of nature. Bartlett's frequent depictions of humans and their technologies (steamboats and bridges, for example) reinforced a sense of the Hudson River Valley as a domesticated landscape. Although best known for his uninhabited and sublime landscapes, Cole was not blind to nature's "unbounded capacity for 'improvement by art'" as his Heath contract for "detailed sketches of buildings, steamboats, and other items of interest" attests. With Cole's volume remaining unpublished, however, Bartlett became the artist most responsible for fixing in the popular mind the image of a picturesque Hudson, the figures in his prints insinuating by the ease of their presence that nature was something to be studied and contemplated rather than avoided and feared.[10]

There is no record of whether Cole felt any jealousy toward Bartlett for upstaging him. Nor is there any way to know how a collaborative Hudson River work by

Cole and Irving would have fared alongside *American Scenery* in the popular pictorial book market. One suspects, however, that the distinctions between Virtue's volumes and the projected Heath text would have proved few and minor. Cole, Irving, Bartlett, and Willis were all part of a shared community, and they borrowed freely from one another in pursuit of their common goal of popularizing landscape art. The initial success of *American Scenery* meant that in the short run Bartlett's picturesque visual memories of the Hudson River Valley triumphed in the popular imagination over Cole's more sublime vision. In the long run, Cole's reputation eclipsed Bartlett's, although in their day, Bartlett, not Cole, earned the distinction of being "Eden's artist."

Left to right: William H. Bartlett, **The Palisades—Hudson River**, 1836–1840; **View from West Point. (Hudson River)**, 1836–1840 Hand-colored engraving, Each 4⅝ x 6¾ inches

Shad Run

A historical novel of
love and intrigue
set in the beautiful
Hudson River Valley.

Howard Breslin
author of
THE TAMARACK TREE and THE SILVER OAR

Howard Breslin, **Shad Run**, 1955
Hardcover book, 8½ x 6 x 1 inches

SHAD RUN

Kathryn Davis

"Thin as a June shad," they used to say and it was no compliment, though thinness has become a virtue and the shad less plentiful. It used to be a virtue to be shaped like an hourglass. My heart beats faster just thinking about the way it was then, though of course things never get better, only different. We lived at the south end of the island. My father was the lighthouse keeper. We kept to ourselves for the most part, not because we were standoffish, but because that was the way everyone on the island behaved toward everyone else, waving when our paths crossed or helping with a sick child or, less often, sharing a piece of gossip in the guise of information. In those days even an after-dinner nap was thought to be uncanny. Of course we watched one another—why else have windows?

I was shaped like an hourglass and so was the island. The pinched place in the middle was where the factory owner lived; he liked looking at water from both sides of his house. They always want to have things both ways, the rich, which also explains the appeal of my waist and why they put their factories where they can't see them. We lived at the southern end of

the island, the bottom of the glass where the sand pooled and the PCBs eventually gathered. Often change is so gradual you don't even know it's happening.

Back then shad was the most important fish of the Hudson, being very delicious as food, and caught in such immense numbers as to make it a cheap dish for the poor man's table. The fish entered the Hudson toward the end of March or the beginning of April and ascended to the head of the tide to spawn; it was while on their passage up-river that the greater number and best conditioned were caught, several hundred being sometimes taken in a single catch. I remember seeing them flapping in the fishermen's nets, as sleek and silver and contained as the fishermen were out of control and wild like unbroke colts. Springtime, this all happened in springtime, the river foaming with fish, the round black rocks so wet from the spring floods they never got dry even when the sun was at its hottest. To the west the blue Katzbergs, the banks embowered with lindens, the river water twinkling like armloads of fallen stars.

Every spring it was the same thing. The fishermen put on quite a display. You could get yourself in trouble if you weren't careful—I should know.

Our island wasn't a real island; it became an island when they dredged the channel for the Albany boats. For years it still felt like it was part of the mainland, a section of the great alluvial plain where cows lived and corn grew and where the fields stretched out so far on either side you could actually see the earth's curve at the horizon, a curve so faint as to be almost imperceptible yet undeniably there, like the stomach of a young woman in her first trimester, lying on her back to acquaint her offspring with the sky and its queenly entourage of clouds.

Shad was considered a disreputable fish, then, because it was so plentiful, like the salmon the Eskimos feed their sled dogs. This is what one of the fishermen told me before asking for a kiss. The Eskimos give their dogs salmon and feed their guests the green slime from inside a caribou's intestines. Once when I was still a little girl the parson came calling by surprise and we actually hid dinner under the table, as if the worst of our sins could be so patently visible. But everyone knows the worst is always occult, the place in the mountains where the river issues like a black thread from a pinhole in the rock and keeps on streaming, dark and thick, forking at the top of the island and then meeting again at the bottom, widening, slowing, flowing through the city before entering the sea.

The shad descend the river at the close of May, at which time they're so lean as to be practically worthless. The rest of their lives they live in the ocean, returning to the river where they were born only when they're ready to spawn—somehow, mysteriously, they know how to find it. Supposedly the shad can recognize the river by its smell. The way I recognize you, the fisherman told me, and I told him I found it hard to think of fish having noses. The male is called the buck, he told me, the female the roe, the same as her eggs.

Of course the Hudson has a smell like no other, even I know that. It is the dark force that drives the world.

As for the shad, they are so full of small bones they are almost impossible to eat. You need to use tweezers to get all the bones out, and even then you are likely to miss the very bone that will lodge in your throat and choke you to death. This is why when you eat shad you have to be very careful.

I will tell you a secret: the future only exists as a vanishing point in any perspective rendering of the present. It is the pinhole in the rock, the egg in the sac, the place your progeny spills out of. Once you have lived on the river you never leave. Death is a joke compared to it. The river, the shad, the fishermen—there's no real difference. In the future boats will still be coming through cities from channel to the north and south, mostly elegant cabin cruisers but also canoes and kayaks and, eventually, the blue and yellow agency barges sent to test for poison.

Sometimes a boy will give his girlfriend a kiss. Sometimes the wake will boil with dead fish. Meanwhile the shad continue spawning in the springtime. No one ever gets away with anything.

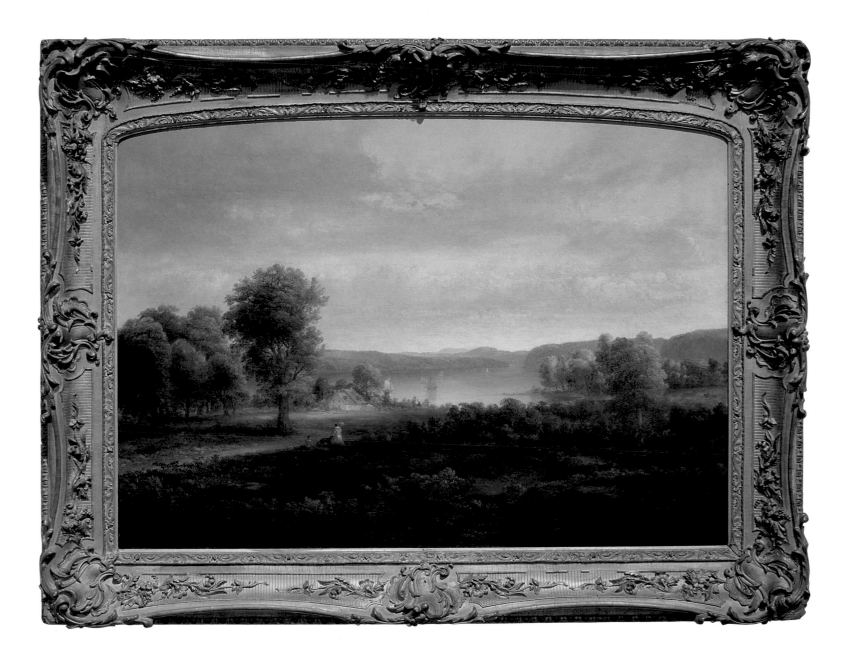

Thomas Doughty, **View on the Hudson in Autumn**, 1850
Oil on canvas, 45 x 59 inches

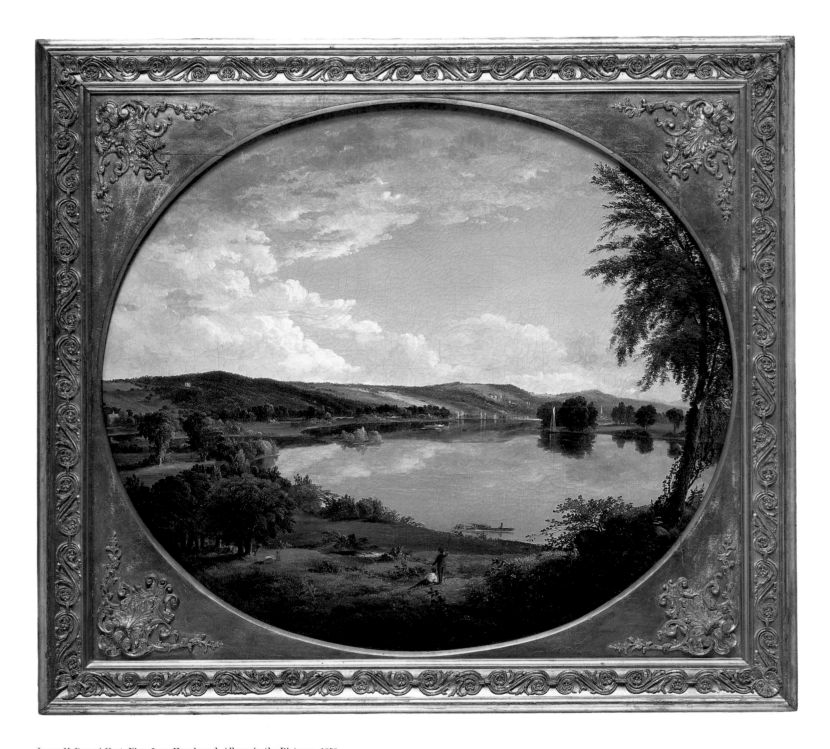

James McDougal Hart, **View from Hazelwood, Albany in the Distance**, 1850
Oil on canvas, 31½ x 27¾ inches

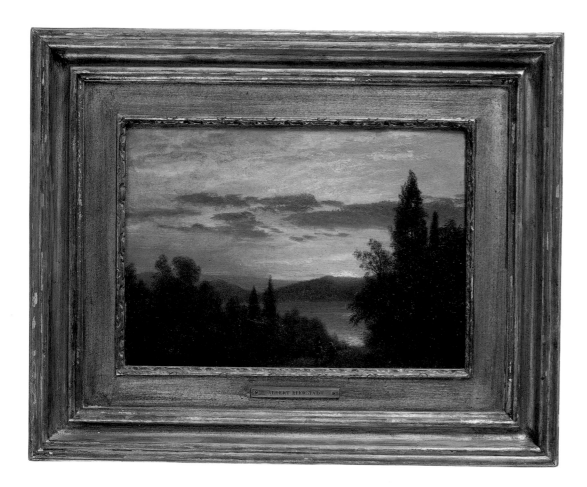

Albert Bierstadt, **On the Hudson River Near Irvington**, n.d.
Oil on board, 12¼ x 15 x inches

Opposite: Installation view, *Lives of the Hudson*
Tang Museum, Skidmore College, Saratoga Springs, New York

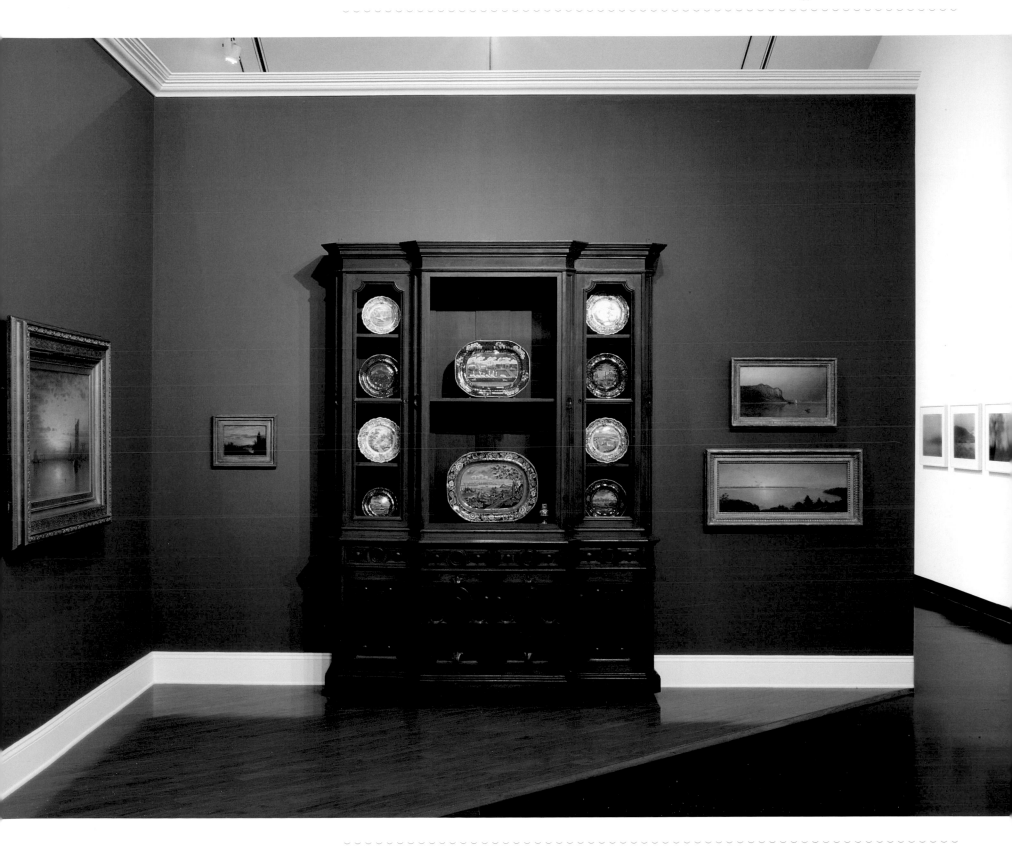

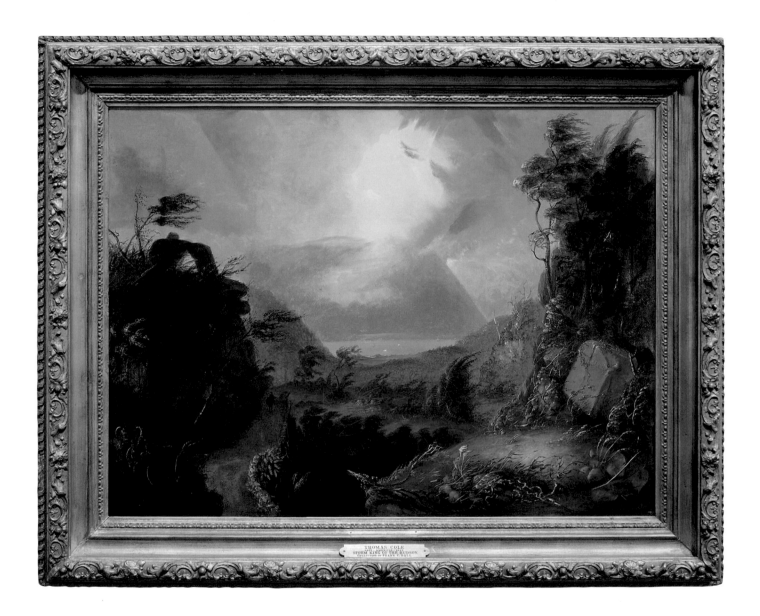

Thomas Cole, **Storm King of the Hudson**, c. 1825–1827
Oil on Canvas, 30½ x 38½ inches

COLE'S *STORM KING* AND MCCALL'S STUDY FOR *CROSSING THE HUDSON*

Paul Hayes Tucker

Henry Hudson called Storm King Mountain "Klinkesberg" because of the wrinkled rocks that ringed its mass as it emerged from the waters of the tidal estuary the Englishman was exploring in 1609. Dutch settlers later referred to it as "Boterberg," because, to them, it looked like a huge lump of butter. Its present name was proposed in the mid-nineteenth century by the popular Knickerbocker essayist and poet, Nathaniel Parker Willis, in an article for *The Home Journal*, a weekly literary magazine that in 1901 became *Town and Country*. "The tallest mountain, with its feet in the Hudson at the Highland Gap," Willis asserted, "is officially the Storm King, being looked to by the whole country around as the most sure foreteller of a storm. When the white cloud-beard descends upon his breast in the morning (as if with a nod forward of his majestic head), there is sure to be a rain-storm before night. Standing aloft among the other mountains in the chain, this sign is peculiar to him. He seems the monarch, and this seems his stately ordering of a change in the weather. Should not STORM-KING then be his proper title?" His suggestion stuck.

Rising 1,340 feet above sea level, the mountain that is the focus of Thomas Cole's magisterial painting is not the highest of the many that line the Hudson as the river flows from its source in the Adirondacks to merge with the Atlantic in New York City's harbor. But it is one of the most distinctive, particularly when viewed from the east, as Cole does here, enhancing its impact by a series of artful decisions. He locates it in the very middle of his expansive canvas, surrounding its looming form with swirling clouds and darting light while contrasting its monolithic presence with the varied terrain on his side of the river. Cole also frames the mountain with a collection of twisting trees and surging undergrowth reminiscent of those that the Italian painter Salvator Rosa frequently employed in the seventeenth century. And he links us to the "storm warner" with the meandering path that descends from our lofty vantage point toward the river, which Cole judiciously minimizes to maintain our focus on the mountain itself. He even repeats the mountain's trapezoidal shape in the smaller, silhouetted form pierced by an arch on the hill to the left and then, in reverse

reflection, in the opening he constructs in the middle ground: the edge of the sloping hill on the left parallels the right side of the mountain; the line of bending trees on the right imitates the mountain's slightly concealed left side. He also provides a further hint of its size by including a lone figure on the path and a boulder in the immediate foreground on the right, implying Storm King is immensely larger than either of these humble elements.

But it is the magnificent sky that provides the most dramatic foil for this formidable feat of nature. The darkened clouds descend diagonally on the left, only to arc and part suddenly on the right just above the mountain's summit, creating a dazzling tunnel of heavenly light made all the more startling by the even darker clouds further to the right. Cole has rapturously imagined and painstakingly captured a transcendent moment, suggesting both the awe he felt in front of his almost sacred motif and his ability to translate his feelings into liquid paint.

Like many Americans of his class and education, Cole believed nature held metaphysical secrets about human existence and the divine, and that America in particular was the natural remains of the Garden of Eden. Honored after his premature death in 1848 as the founding father of what eventually became known as the Hudson River School—a group of artists that included Asher B. Durand, Frederic E. Church, John F. Kensett, and Jasper Francis Cropsey, among others— Cole was keen to unite aspects of the picturesque and the sublime in his landscape paintings to underscore

his beliefs, demonstrate his facility as an artist, and raise the genre to the heralded level occupied by paintings of history, religion, and mythology, an aspiration he achieves in spectacular fashion in this monumental canvas, one of his most ambitious early essays.

Cole often found his noble goals compromised by the ignoble actions of his fellow early occupants of this area of New York State. By 1825, when he made his first trip up the Hudson and probably executed preparatory pencil and oil sketches for this painting, the river was already being polluted by tanneries, quarries, lumber mills, and steamboats. That violation—or at least its imminent threat—is perhaps implied in the windswept lower half of this painting, with its trembling forms, roiling land masses, and isolated boulder on the right which looks like a toppled tombstone. That Cole could still be deeply moved by the site, however, is a tribute to his tenaciously romantic vision and the powers of the place. —

Long after Cole's passing, artists continued to plumb the mid-Hudson for its special characteristics despite, if not because of, the frequent threats of change. Proof of that continuity is Anthony McCall's 2006 idea to illuminate the Poughkeepsie Bridge, just sixteen miles upstream from Cole's view of Storm King. Almost 180 years after Cole completed his canvas, McCall proposed lacing the bridge with white LED diodes that would illuminate an additional two meters of the structure every day over the course of a year, at the end of which the whole bridge would be lit. The project has yet to be realized and probably never will, but

Anthony McCall, **Study for Crossing the Hudson (The gradual illumination of the Poughkeepsie Railroad Bridge over a period of one year)**, 2007
Acrylic paint on paper, 8¼ x 13⅛ inches

it represents an ingenious adaptation of a number of contemporary practices, particularly performance art, which had attracted McCall at the outset of his career in the early 1970s. The bridge is the performer here, not McCall and his collaborators; it stands on its watery stage delivering a dramatic soliloquy, surprising the spectator every evening with its increased intricacy and reach. The project, therefore, encourages us to look at this steel structure more carefully and to understand how its individual parts constitute a much more complex whole.

The project also relates to McCall's keen interest in ideas of duration—how we measure, experience, and understand time. For only over time will the structure emerge in its fullness, a reminder that the instantaneous has its value but that an extended engagement with the things of this world can generally prove more instructive and rewarding.

As the 1970s progressed, McCall's concerns as an artist moved from performance to film, whose aesthetics he began to investigate by divorcing it from its constituent parts of imagery, sound, and story, leaving mere beams of light that he manipulated in marvelously inventive ways. The later Poughkeepsie Project expresses that interest, since each new two meters of light resembles a still from an imageless film, projected slowly but deliberately onto the bridge in a rationally constructed sequence.

But the proposal suggests even more than this because McCall would transform the bridge from an industrial entity imposed on the landscape to an aestheticized object, making it, for all intents and purposes, a piece of sculpture. McCall achieves this transformation through light, the most immaterial of elements, emphasizing light's unique powers to alter matter and reveal truths. In that quest, McCall stands in a long line of artists who employed light for similar visual and metaphorical effect, including Caravaggio, Vermeer, and the Impressionists. Cole falls into this group, as his view of Storm King amply attests. Like Cole, McCall flirts with spectacle and risks the possibility that his exaltation of the commonplace could appear maudlin. As such, his proposal recalls Christo and Jeanne-Claude's outdoor events that temporarily transform environments and human constructs through artistic intervention. But unlike Christo and Jeanne-Claude's proposals, McCall's has staying power, for it concerns not so much wrapping things as the opposite—in this case, unveiling the bridge and exposing its physicality.

With his deep-seated doubts about the value of Jacksonian progress, Cole would never have approved of McCall's project, particularly with its highly technological underpinnings, just as McCall would never consider painting a picture of a mountain, no matter how magnificent. Yet both are inextricably linked to the ways in which the river and its offerings can remind us of the glories that surround us, and how art can immortalize human aspirations while drawing attention to its own unique language.

Following page: Anthony McCall, **Crossing the Hudson (April 12, the 295th night)**, 2009
Pencil on paper in three parts, 43 x 109¼ inches

CROSSING THE HUDSON (APRIL 12, THE 295TH NIGHT).
A ONE-YEAR CYCLE IN TWO SIX-MONTH PARTS:

—THE GRADUAL LIGHTING OF POUGHKEEPSIE RAILROAD BRIDGE,
STARTING FROM THE LEFT AND TRAVELLING TO THE RIGHT
UNTIL THE HALF—MILE SPAN IS COMPLETELY LIT
(JUNE 22 – DECEMBER 21, A SPEED OF 14.5 FEET PER NIGHT)

—THE GRADUAL UN-LIGHTING OF THE FULLY LIT BRIDGE,
STARTING FROM THE LEFT AND TRAVELLING TO THE RIGHT
UNTIL THE HALF—MILE SPAN IS COMPLETELY DARK
(DECEMBER 22 – JUNE 21, A SPEED OF 14.5 FEET PER NIGHT)

2009

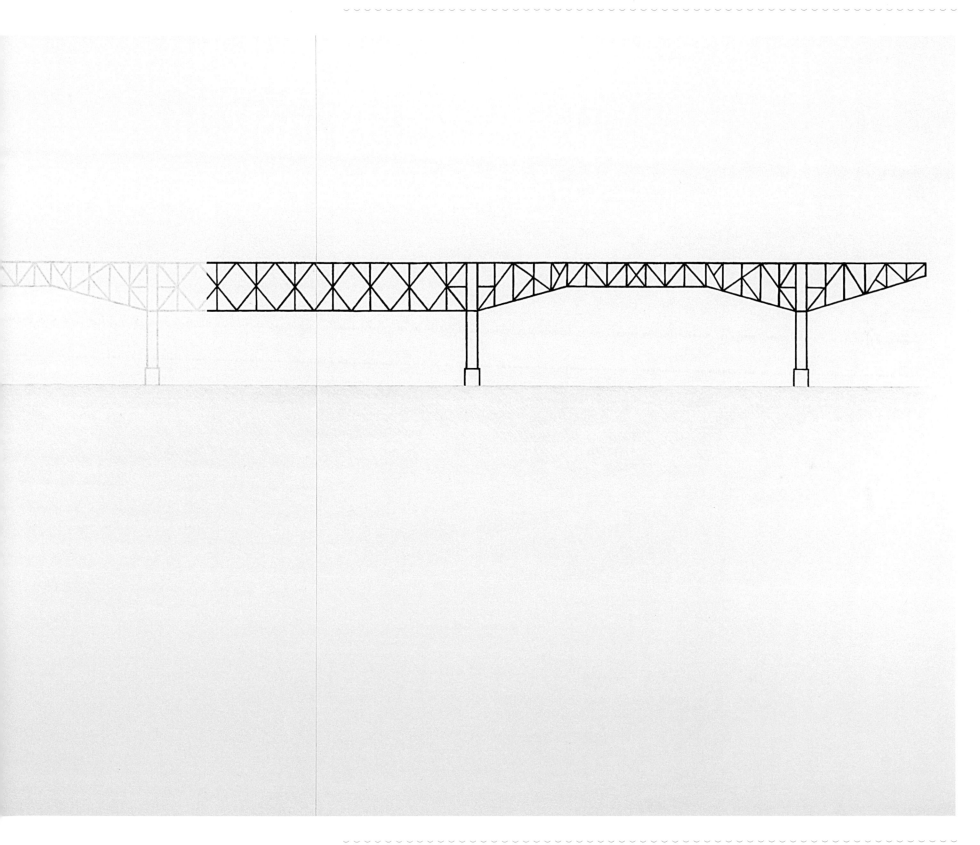

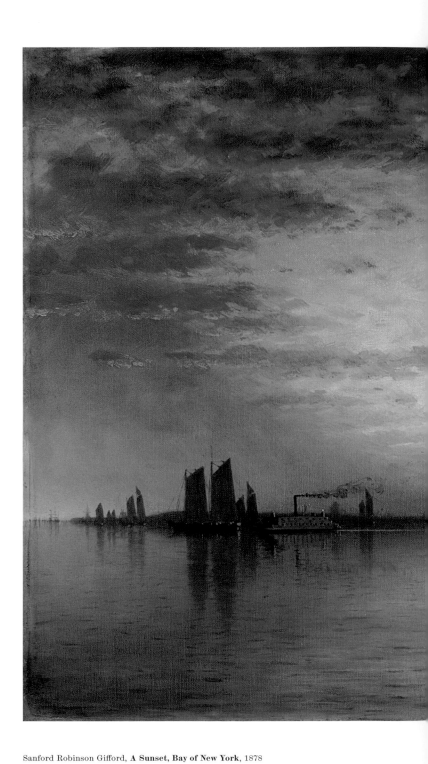

Sanford Robinson Gifford, **A Sunset, Bay of New York**, 1878
Oil on canvas, 20¾ x 40¾ inches

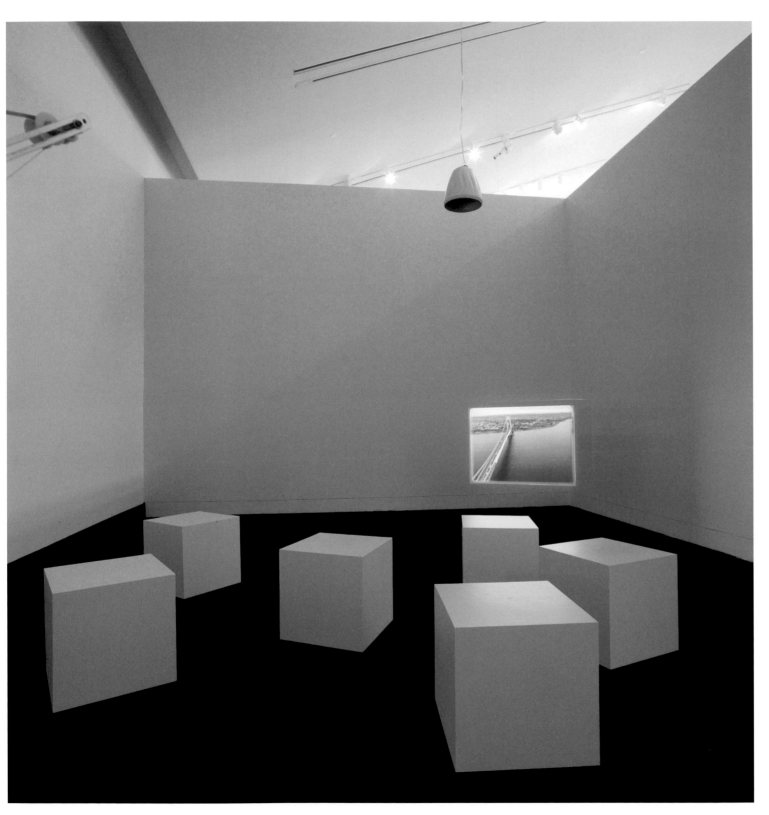

Matthew Buckingham, **Muhheakantuck—
Everything has a Name**, 2004
16mm film installation with sound
40 minutes

Installation view, *Lives of the Hudson*
Tang Museum, Skidmore College,
Saratoga Springs, New York

ALL OF THE ABOVE,
PALIMPSEST AND PEDAGOGY

Ginny Kollak

1.

We understand the world through our experience, and our experience of other people's experience.

October 1987, first grade. I remember taking my turn grinding dried corn kernels with a heavy river stone against a slab of rock with a shallow dimple in it. My teacher cooked the cornmeal we had ground with milk and water on a hotplate. She talked about longhouses and deerskin moccasins as she scooped spoonfuls into small dishes and drizzled their tops with maple syrup. It was delicious. I wanted to eat like an Indian all the time.

The memory has an aerial viewpoint. I see my six-year-old self from above, kneeling on the carpet in pink Oshkosh, head bent in concentration over my task—an image clearly produced in my own imagination. What does memory have to do with this omniscient vantage?

2.

The dream of vertical ascent and hovering flight is a dream of suspending time through distance—of cutting oneself off from ordinary measures of time—"surface time."

Matthew Buckingham's *Muhheakantuck—Everything Has a Name* is a sixteen-millimeter film shot from a helicopter as it takes a forty-minute voyage over the lower Hudson River. Buckingham captures the river's east bank from the Verrazano Narrows to just north of the Tappan Zee Bridge, then doubles back to survey the west bank south to Liberty and Ellis Islands, and the industrial ports of New Jersey. His journey has a measured pace that purposefully avoids the frenetic energy of contemporary travel, a stillness only occasionally interrupted by the intrusion of an ant-sized motorboat or a miniature train snaking beside the water. The flight is recorded in real-time, but its hovering aerial view successfully evades what the film's voice-over calls "surface time"—one among a number of elements that contribute to the film's uncanny sense of timelessness.

Muhheakantuck was produced in 2003, but the film's narration (voiced by the artist himself) describes events from a more distant past. In a neutral Midwestern accent—the dialect that air traffic controllers are trained to adopt for its straightforward

pronunciation—Buckingham recounts episodes from the ambiguously violent history of European colonization in the Hudson River Valley. One of this story's protagonists is Henry Hudson, whose journey the camera's eye retraces, north from the mouth of the river that would later bear his name. Employed by the Dutch East India Company, Hudson was searching for an alternative sea route from Europe to Asia: the elusive Northwest Passage. The desire to find this waterway was so strong that maps—another form of hovering omniscience—were invented that depicted it. These imaginary maps, in turn, inspired explorers to seek their fortunes by searching for their contents.

If cartography can turn the idea of a place into lines on a page, then these lines can also demarcate a space to be claimed—the act of inscribing can become an act of ownership. This contract is sealed when people, places, or things are given names.

3.

Everything has a name, or the potential to be named, but who does the naming when the unknown is falsely assumed not to exist?

The name given to the Hudson River by the Lenape, the people inhabiting the area when European explorers arrived, is "Muhheakantuck," which means "the river that flows in two directions." Indeed, the river is largely an estuary, with a tidal influence that reaches as far north as Troy, where a dam blocks further intermixing with the fresh water flowing south from the Adirondacks. Hudson didn't know this, of course, so when his crewmembers tasted salt in the river nearly 150 miles from the sea they were understandably encouraged—finding the Northwest Passage would mean wealth and glory for all of them. Perhaps these thoughts colored their interactions with the people who already lived along the river's shore, or perhaps that is giving too much of the benefit of the doubt to Hudson and his crew. Violence toward and exploitation of the Lenape and other tribes in the area was personal for early explorers—Buckingham tells us that Hudson and his crew kidnapped three natives in a display of dominance, plied others with alcohol, and killed at least ten others, one of whom had attempted to steal the first mate's shirts and pillow. Only later did the destruction of Indian tribes become systematic, with imported disease wiping out more than twenty thousand Lenape, and thousands more murdered in massacres planned and carried out by the colonizers. Their deaths left the land conveniently "empty," as one Dutch chronicler described the lower Hudson Valley.

A sense of emptiness is often what leads to naming, or renaming. The one who names thinks he or she is filling a place with meaning. The Dutch called the land they claimed after Hudson's voyage "New Netherland," while the British—after seizing what they believed was "sinfully" lying idle—called the same area "New York." But historical memory and a desire for commemoration can also drive the act of naming. Buckingham tells us that in the 1960s, in an act of reconciliation and recognition—or of profound callousness—the United States Army named its first fleet of assault helicopters for the Shawnee people. Back in the Hudson Valley, I grew up near Halfmoon, a

town named for the ship that Hudson sailed and, according to local legend, situated at the point at which the river became too shallow for him to navigate. My early education took place in a district named after the Iroquois word for "great plains," a phrase that appeared on a colonial charter from 1708. Changing names make people and places into palimpsests, with traces of the past still remaining present.

4.

It's easy to forget that the eye makes the horizon.

Paraphrasing Walter Benjamin, Buckingham has said that the vanishing point of history is the present, making thinking about the past an act of restaging, not of retrieval. But if places are thought of as stages for reimagining history, then what does it mean to stand in the same spot as an actor from long ago? Archaeology understands history as meaning embodied in physical layers of objects; perhaps social memory understands history as layers of people's experiences.

My experience of the Hudson is limited to traveling over or along it, crossing it on bridges near my home or following its curves on the train to New York City. From the train window, the river looks as if it were lapping against the sides of the car. It's easy to see the water flowing in both directions, as its earlier name declares, especially in late winter, when ice floes drift one way in the river's center and another along its sides. The view prompts an invented narrative: the moment that a Lenape chief stretched his arms over the water, described its uniqueness, and gave it a name. I think about canoes that might have circled in

the small coves that the train tracks have filled in. I think about river access and eminent domain. It is strange that my closeness to the river, as a train passenger, limits the access that others have to it.

In the 1960s and '70s educational films used a certain cheap color stock that has deteriorated over time, its color taking on a distinctive pink tone. In a strange twist, we now associate this decaying film with shortsighted notions of progress, since many of those movies took the form of pseudo-documentaries professing Cold War bravado about the supremacy of all things American—industry, technology, culture, and even landscapes. At the same time, the look of these films evokes the innocence of afternoons in an elementary school classroom, the fluorescent lights off and blinds drawn to create a makeshift cinema.

Buckingham printed *Muhheakantuck* in a saturated magenta color, in part to reference this film stock but also to "denaturalize" the viewer's experience, to prompt questions about site and situation, production and point of view. It is an implicating move, one that is unsettling as much as it is eye-opening. The same could be said for the filming angle of *Muhheakantuck*, which the artist has acknowledged is intentionally awkward, with its wide angle view that simultaneously looks straight down at the river and across to the horizon. Like attempting to map the unknown, it is a double surveillance that implies both mastery and uncertainty, and relates the viewer to both the "fictional, disembodied eye" of the cartographer and to the ghostly presence of what-once-was.

Matthew Buckingham, **Muhheakantuck—
Everything has a Name**, 2004 (detail of film)
16mm film installation with sound
40 minutes

37-2 Recto

John Marin, **Loading Dock, River View**, c.1900
Graphite on wove paper, 8½ x 10¾ inches

36-20 Recto

John Marin, **River Valley**, c.1900
Graphite on wove paper, 8⅜ x 10¾ inches

John Marin, **Hudson River near Alpine**, 1910
Watercolor on wove paper, 12⅝ x 18⅝ inches

Above, top: John Marin, **Mill Ruins Along the Hudson**, c. 1900
Graphite on wove paper, 7 x 10¼ inches

Above, bottom: John Marin, **Weehawken Grain Elevators and Tugs**, c. 1900
Graphite on wove paper, 8½ x 10¾ inches

John Marin, **Hudson River at Peekskill**, 1912
Watercolor on wove paper; laid down, sheet, irregular
edges, $15\frac{9}{16}$ x $18\frac{9}{16}$ inches

A DISTINCTLY MODERN SUBLIME

Kristen Boyle

Around the turn of the twentieth century a new generation of artists, including John Marin, sought to capture the ethos and aesthetic of the changing American landscape. Marin built upon the visual vocabulary that Thomas Cole, Frederick Church, Albert Bierstadt, Sanford Robinson Gifford, and myriad other Hudson River School artists had established in their idealized vistas of the Hudson Valley, New England, and the American west. The Hudson artists of the nineteenth century espoused the sublime, the belief that God alone was behind all that they saw in nature and they sought to capture this on their canvases. Marin's work in the twentieth century married the picturesque scenery with the frenetic energy of the man-made, thereby establishing a new aesthetic—a distinctly modern sublime.

Since the late 1880s, wherever he was, John Marin sketched. He passed his boyhood in Weehawken, New Jersey on the banks of the Hudson River and traveled to surrounding areas—Pennsylvania, Maine, New Hampshire, New York, and Massachusetts—where he composed some of his first watercolors. After studying at the Pennsylvania Academy of the Fine Arts in Philadelphia, he followed the path of many American artists of the era to Europe and painting excursions in Holland, Italy, and Belgium. Upon his return to New York City, in 1910, Marin turned his attention once again to the American landscape. By this time the twilight moods, pastoral pantheism, and allegory so prized by the Hudson River School artists had fallen out of favor as the public had turned its attention to the Impressionists and French artists of the Barbizon school. It was in this cultural context that Marin developed his distinctive style that earned him acclaim.

Marin employed the romantic notion of using nature to illustrate emotions, though in a manner unlike his artistic predecessors. He distinguished his work from the American landscapes of the Hudson River School by incorporating elements of Fauvism, Impressionism, and European Modernism with the avant-garde, cosmopolitan spirit of early twentieth-century New York. In his watercolors such as *Hudson River, Region of Peekskill*, Marin incorporated industrial, commercial, economic, and social elements into the scenery thus creating a new

sublime. His style highlights the magnitude of human achievement within the landscape. Homes, boats, docks, and suggestions of the kinetic energy of trains, city, and skyscrapers are united with the environment through his use of bold patterned color and repetition of form.

Marin observed the world with a "romance of detachment from the harsh economics of survival," one critic noted, "the ability to observe a tree, a boat, a wave, a sand-dune, grain elevator, or a skyscraper as though life's noblest music were enclosed in their straining forms."[1] Previously artists had reserved this elevated consideration and variety of observation for nature. However, Marin envisioned nature as man-made—a construct—that could be celebrated alongside other human creations. In his sketch *Hudson River, Schooner or 4 Master and Tug*, he achieved a balance between the picturesque Hudson River and the dynamic architectural landscape of New York. Marin completed a number of such sketches from the New Jersey side of the river depicting the twentieth-century city skyline with its bridges, steamboats, and cargo ships so prevalent on the lower Hudson.

Typically Marin sketched from nature, like the Impressionists, but used his own unique stylistic components. Around the time Marin executed *Hudson River at Peekskill*, and *Hudson River Near Alpine*, he was persistently moving toward a painterly

goal—"[an] integration of drawing and painting in such a manner that neither was distinguishable from the other in the usual sense. He used a color-line, painted rather than drawn over broadly washed-in areas."[2] These watercolors, painted wet into wet without underdrawing, are swift-color views— watercolor sketches of an ever-changing world.

The unique style and approach that Marin developed in Europe brought him notice in America. In the spring of 1909, before he returned from the Continent, the artist and gallerist Alfred Steiglitz curated a display of Marin's watercolors at his 291 gallery in New York City. Steiglitz provided a pulse for modernist thinking in New York; using 291 and two other galleries that he owned, to introduce cutting-edge European artwork to the American public and to pioneer avant-garde American artists such as Georgia O'Keeffe and Arthur Dove. When Marin returned to New York in 1910, the two began a close personal and professional friendship that lasted until Stieglitz's death in 1946. Over four decades Steiglitz hosted yearly exhibitions of Marin's watercolors, drawings, etchings, and paintings and tirelessly promoted his friend.

Marin's association with Steiglitz and his galleries brought him recognition as one of the artistic elite. Critics who reviewed Marin's early exhibitions focused primarily on his treatment of nature and use of color and light. William D. MacColl commented

1. Henry McBride et al. *John Marin; watercolors, oil paintings, etchings.* New York: Published For The Museum of Modern Art By Arno Press, 1966, page 21.

2. Reich, Sheldon. *John Marin: a stylistic analysis and catalogue raisonné.* Tucson: University of Arizona Press, 1970, page 40.

3. Fine, Ruth. *John Marin.* Washington: National Gallery of Art, 1990, page 103.

thus on Marin's 1910 exhibition of forty-three watercolors, twenty pastels, and ten etchings: "Veil beyond veil, and mist beyond iridescent mist, rise these tearful images, transfiguring all things within their reach, till heaven and earth, the sky, hills, lakes, the counters of all nature, seem compounded into one measureless and exhaustless film."[3] Others wrote of his European influences, or his extraordinary skill painting with watercolor that elevated the medium as one to be seriously considered. Few focused on his distinct blending of nature with the man-made.

Marin continued to represent the landscape in many evolutionary manifestations throughout his prolific artistic career. He completed much of his work in the areas surrounding New York where he spent a substantial part of the year, and in Maine where he spent almost every summer painting landscapes and seascapes. No matter the location of Marin's paintings, his themes remain constant. In his views of New York, Maine, or Europe one can always find a combination of nature and the man-made harmoniously existing in compositions that changed the face of American landscape painting and the way future generations of artists view the world.

John Marin, **Hudson River Schooner or 4 Master and Tug**, 1900
Black ink on wove paper, 11 x 10 inches

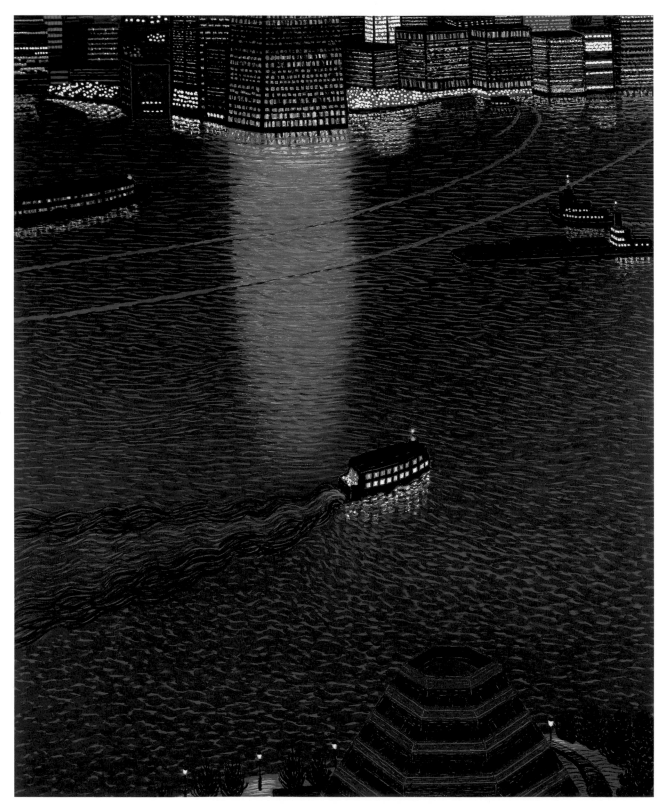

Yvonne Jacquette, **Hudson Crossings**, 2008
Oil on canvas, 65¼ x 53¼ inches

SEE WHAT IS THERE

Terence Diggory

See what is there. We are at the southern tip of Manhattan, looking down at the Hudson River just before it flows into Upper New York Bay. On the opposite shore stands Jersey City, with two of its landmarks, the Colgate clock and the Goldman Sachs tower, brightly illuminated against the dark night and dramatically reflected in the water of the river. The Manhattan shore seems strangely dark by comparison. The multi-tiered, hexagonal roof of the Museum of Jewish Heritage, meant to suggest the Star of David, can shine like a star—as we know from Yvonne Jacquette's earlier depictions of this scene, for instance, *Mixed Heights and Harbor from World Trade Center II* (1998). But now, in 2008, the lights on the museum roof are turned off. A cost-saving measure? Or a symbolic recognition of the shadow cast by the events of September 11, 2001? The World Trade Center had been Jacquette's vantage point for a series of works that marked a high point—literally—in her long-running project of depicting New York scenes from above. For *Hudson Crossings*, she employed a new vantage point, an apartment on the twenty-fifth floor of the Ritz-Carlton building,

whose construction had been delayed in the aftermath of the destruction of the World Trade Center.

Trace what is not there. In Jacquette's treatment, the river, a state of perpetual flow, serves as the ideal space for tracing evanescence—"crossings," as the title refers to them, that are also crossings-out. She emphasizes the activity of painting-over by not painting over the grayish-green ground color entirely, but subtly weaving it into the design. It provides not only the painting's tonal center, between cool blue and warm yellow, but also a linear element in the composition. Those wake lines that seem to mark the passage of a boat in the upper part of the composition in fact trace a path of exposed ground color, *not* marked by the passage of Jacquette's brush. Emptiness acquires the illusion of presence, a transformation that is fundamental to the way this painting works. The space of the river opens out as a void in the composition, which the river crosses crossing horizontally as powerfully as any vertical element within the composition crosses between the

river's banks. The banks themselves, rather than fixing the course of the river within solid boundaries, submit to its flow, descending into darkness at the bottom edge, or dissolving into shimmering light at the top. Jacquette's river moves through paradox as a void filled with activity, enlivened by the passage of the boats across the surface of the water, and by the freshness of touch that retains the sense of the brush having just crossed the painting's surface.

Dive in. In the tradition of modernist painting, Jacquette maintains the reality of the surface as the condition of the two-dimensional medium. Looking down on the scene from up high has the consequence of tilting the ground plane upward, helping to reconcile pictorial illusion with the painting as fact. The viewer is inclined to map the composition in terms of top and bottom rather than foreground and background. Yet this painting has a dimension of depth that is metaphorical, neither spatial nor even temporal. The big clock on the Jersey shore, for all its symbolic potential, is one of the facts of the scene; the movement of its hands has been effectively suspended as a condition of being in the painting. In contrast, the tower next to the clock surges up with metaphorical force. It refuses to be contained within the painting's limits, or alternatively, the painting cuts the tower off abruptly at its upper edge. Denied as fact, the tower as a whole appears only in reflection, a phantom image floating on the surface of the water. The building's form, which in fact tapers toward the top, is reflected accurately. However, presented as an image, it appears phallic. Whether in psychoanalytic terms, another connection to modernist tradition, or in tantric terms, connecting

to Jacquette's study of Tibetan Buddhism, a vast drama of desire is played out in the metaphorical depths of this painting, a drama that is simultaneously tragic and comic. A fantastic lingam of light floats toward a dark, multifoliate yoni, only to be interrupted by a ferry boat that transports us to, or from, a different plane of reality altogether. It can be seen as an awkward fact intruding on fantasy. But it can also be read as a countersign exposing the transient, metaphorical nature of all phenomena. Etymologically, meta-phor means to trans-fer or carry across; the root *–fer* reappears in the word "ferry."

Resurface. Finally, we see that what is there is not. There is no substantial depth beneath surface appearance. The weightiest structures of the world rest on nothing, as those massive buildings on the Jersey shore appear without a shore, merely floating on the river like the boats. These are "heavy" meanings, but Jacquette treats them lightly, with an air of detachment that has become virtually her personal signature, though it has some affinity with the general sensibility sometimes called postmodernist. Certainly, it is a mood neither of classical resignation nor of modernist abstraction but rather of playfulness, a willingness to engage with appearances for the pleasure that appearances as such can offer. In this sense we can truly speak of the "play of light" on the surface of the water, and it makes sense that the boats that move across that surface seem a little like toys. But the game that is being played here is not "make-believe" but "make-perceive." Having crossed over this painting by night, we return to our daily experience with eyes freshly disposed to see what is there.

Yvonne Jacquette, **Hudson Crossings**, 2008 (detail)
Oil on canvas, 65¼ x 53½ inches

THE HUMAN

RIVER

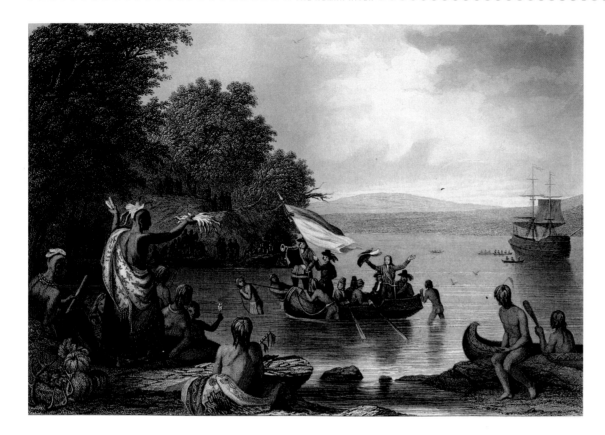

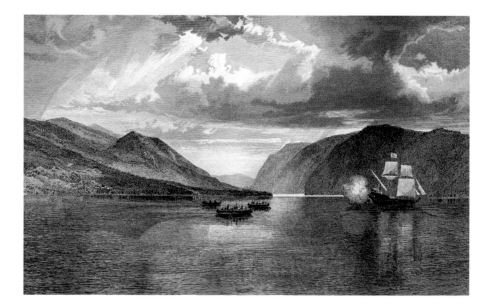

Top: Robert W. Wier, **Landing of Hendrick Hudson**, 1866
From *History of The United States from the Earliest
Period to the Administration of President Johnson, Volume 1*,
J.A. Spencer, D.D., 5 x 7½ inches

Bottom: Thomas Moran (R. Hinshelwood), **The Half Moon
at The Highlands**, n.d.
Print, 6¾ x 10 inches

The arrival of Henry Hudson on the 4th. Sept. 1609.

The New York Historical Society

Instituted in the year of our Lord one thousand eight hundred and four

Have elected Gerard Stuyvesant a Resident Life Member

In Testimony of which we have affixed our hands and the Seal of the Society this 15th day of Jan'y 1850.

From the Hall of the Society.

John Russell Bartlett For. Cor. Sec'y
James W. Beekman Dom. Cor. Sec'y
Andrew Warner Rec. Secretary

S. Bradish President
Thomas De Witt Vice President
Frederic de Peyster 2 Vice President.

Asher B. Durand, **New-York Historical Society Membership Certificate**, 1850 (detail)
Ink on paper, 15 x 12¾ inches overall

Left to right: James and Ralph Clews, **Picturesque Views Near Fort Miller, Hudson River**, c.1829–1836
Transfer-printed earthenware, 9 inches diameter

Unknown, **Fulton Plate**, c.1820
Transfer-printed earthenware, 10⅝ inches diameter

James and Ralph Clews, **Picturesque View Near Fishkill, Hudson River**, c.1829–36
Transfer-printed earthenware, 10¼ inches diameter

Left to right: Andrew Stevenson, **New York from Weehawk**, c. 1825
Transfer-printed earthenware, 16 x 20⅝ inches diameter

Enoch Wood, **Albany, New York plate**, c. 1819–1830
Transfer-printed earthenware, 9¾ inches diameter

James and Ralph Clews, **Picturesque Views Near
Jessups Landing, Hudson River**, c.1829-1836
Transfer-printed earthenware, 10⅜ inches diameter

Enoch Wood, **Chief Justice Marshall plate**, c.1825-32
Transfer-printed earthenware, 8¼ inches diameter

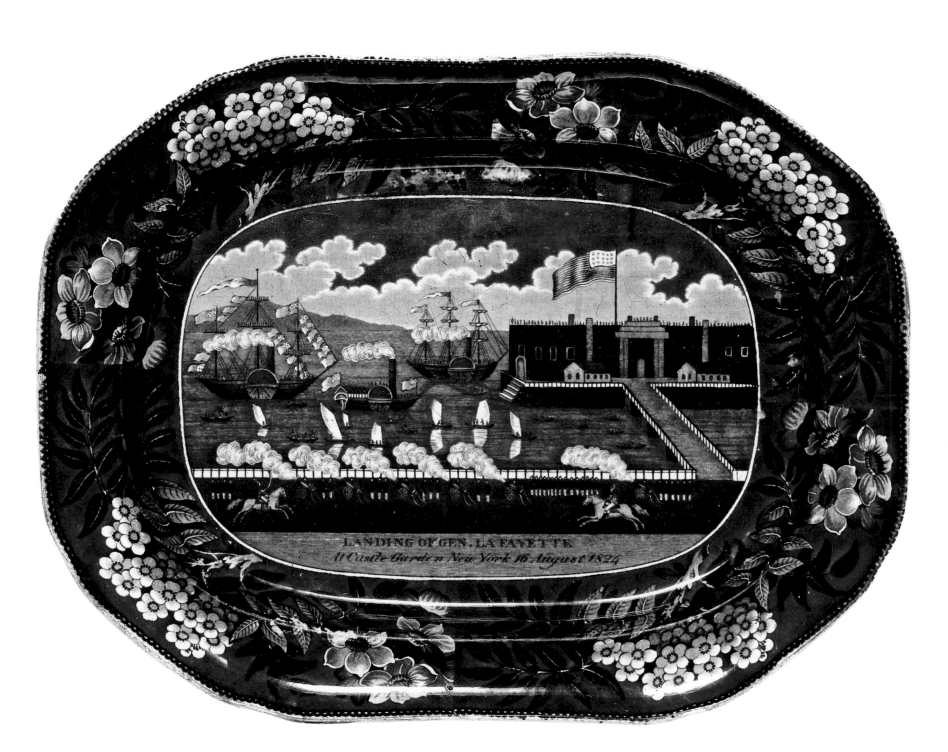

Unknown, **Landing of Gen. Lafayette at Castle Garden**, New York, c. 1824
Transfer-printed earthenware, 13 x 17 inches

MEMENTOES OF THE
DEMOCRATIC EXPERIMENT

Tom Lewis

On the morning of Sunday, August 15, 1824, the packet ship *Cadmus*, thirty-one days out of Le Havre, passed into the Narrows of New York harbor. From Fort Lafayette on the Brooklyn side of the water came the report of thirteen guns fired in salute of the ship's famous passenger, the one whose personal valor, integrity, and idealism had become the abiding symbol of the good will and spiritual solidarity of America and France. After an absence of more than four decades, Marie-Joseph-Paul-Yves-Roch-Gilbert du Motier de Lafayette, the last surviving major general of the American Revolution, was returning to tour the nation whose democracy he had labored to secure.

The general spent his first night in America as a guest of Vice President Daniel Tompkins on Staten Island. Late the following morning he boarded the great steamboat *Chancellor Livingston*, which led a flotilla of boats and ships across the harbor to Castle Garden at the foot of Manhattan Island. Reports of cannon fired from the surrounding forts, including those manned by a group of militiamen named the "Lafayette Guard," punctured the air. From the shore he heard "the unceasing shouts and the congratulations of fifty thousand freemen." It was said that on Greenwich Street that afternoon, seats in the upper windows of houses overlooking the route of the general's grand parade to his hotel sold for as much as four dollars.

For the next 392 days Lafayette would travel through the United States as the "Nation's Guest." He would spend forty-two days in the Hudson Valley, more than in any other place save the capital, Washington, D.C.

The tour had all the trappings of a royal progress. Flanked by a phalanx of attendants and dignitaries, the general covered thousands of miles by water and land as he visited each of the twenty-four states of the union. The nation of grateful citizens treated him to ceremonies and elaborate celebrations, banquets and laudatory speeches, parades and endless pomp. Citizens of the democratic nation never quite forgot Lafayette's noble lineage that went back to Gilbert de La Fayette, a general who served under Joan of Arc; more often than not they addressed him with the most undemocratic of titles, "Marquis."

Everywhere he went, Lafayette touched American affections, and in the case of veterans and those

who had lived through the War of Independence, the chords of memory. He reminded them of a richer, more glorious past—the time of Washington, Jefferson, Hamilton, Franklin—and enabled them to suppress memories of the losses incurred in the War of 1812. His journey up the Hudson that fall on the steamboat James Kent, recalled these earlier triumphs. At West Point the cadets and generals feted him with a grand dinner in the mess; at Newburgh "at least ten thousand persons" greeted him; at Poughkeepsie, the town's leading citizen, Colonel Henry A. Livingston, welcomed the "country's benefactor and friend"; at Catskill and Hudson, Kingston and Greenbush, Albany and Troy, there were similar parades, memorial arches, and speeches. Day and night, in rain and fog, cloud or sunshine, citizens lined both banks of the river for the thrill of seeing Lafayette's boat pass by.

Many who greeted the general were veterans. Some had been with him at West Point when Arnold proved himself a traitor; some had been encamped at New Windsor when he was there with Washington; some had been in the Virginia campaign and fought alongside him at Yorktown in his victory over General Charles Cornwallis. Whenever the thick smoke from the stack of the James Kent appeared on the horizon, they raised their guns, muskets and long rifles, many carried in the Revolution, and fired a lusty salute.

Indeed, the journey was a nostalgic one for Lafayette, too. The general recalled his learning of Arnold's defection ("gloom and distrust seemed to pervade every mind"); he exchanged memories with a soldier who had been wounded at Monmouth, and to whom he had given two guineas so that he might have

a nurse ("to you, sir...I owe my life,"); and with another veteran the general remembered the story of the hapless major who had slipped through the ice on the river off Newburgh when on an outing with some local girls ("an eccentric, but an excellent man").

Lafayette's visit proved to be a boon for the decorative arts in America. Shortly after his arrival, artists produced engravings, paintings, snuff boxes, handkerchiefs, medals—early American souvenirs, mementoes created to commemorate the return of one whose extraordinary valor in the nation's War of Independence had become legend. Americans understood the importance of their democratic experiment and its place in history, as well as the civilization they were bringing to the land. Since they regarded Lafayette's contribution to their independence as a significant part of their singular story, his visit became a moment that they must record.

The visit also brought profit to the potteries of Staffordshire in the West Midlands of England. From about 1815, the year when hostilities with Great Britain ended, Staffordshire potters with names like Wood, Clews, and Stevenson had been exporting their wares to the United States. They decorated them with American scenes, usually rendered in blue, including many of the Hudson River Valley. Views of cities and towns such as Fishkill, Poughkeepsie, Troy, and Albany, as well as the Military Academy at West Point became popular with American consumers. Sometimes resorting to pirated images, they drew from artists like William Guy Wall, Asher B.

Durand, and especially William Henry Bartlett, whose illustrations in N. P. Willis's *American Scenery* proved especially attractive. The transfer process, a method of imprinting the ink from an engraving onto fired, unglazed ceramics through the medium of tissue paper, that had been developed in the mid-eighteenth century, enabled Staffordshire factories to become primitive pottery xerox machines. They could produce the same image tens, even hundreds of thousands of times over. By the 1820's the potters were shipping barrels filled with plates, platters, cups, saucers, creamers, and pitchers to New York, Philadelphia, and Baltimore. Lafayette's visit to America gave the Staffordshire potters a whole new set of images for their wares.

The pottery operated by the brothers James and Ralph Clews produced some of the most dramatic Lafayette designs. Earlier they had captured American interest by producing the States Series, scalloped plates and platters, graced with a floral border on the rim that was interlaced with the names of the various states. The allegorical figures of America and Independence appeared at the center flanking a historic landmark like the White House. To commemorate Lafayette's visit, the brothers produced several designs, including a profile of the general's face. The most successful design, however, incorporated an engraving by Samuel Maverick entitled "LANDING OF GEN. LA FAYETTE At Castle Garden New York 16th August 1824." The Clews brothers transferred it onto complete dinner services. (Maverick had intended his engraving for a snuffbox decoration; he would see it pirated and copied many times over.) The Clews pottery produced its Lafayette pattern with remarkable speed. It is likely

that plates commemorating his visit went on sale at John Greenfield's China Store, 77 Pearl Street, New York, even before Lafayette left the country in September 1825.

Maverick's engraving fit almost seamlessly onto the platters and plates that the Clews pottery produced. The ordered scene depicts a tableau vivant. Two horses in the foreground frame the dramatic event. Militia men stationed at six cannon fire their volleys of welcome to the *Chancellor Livingston* carrying Lafayette, the smoke from their barrels complements the plumes from the stacks of the steamboats in the middle distance and the cotton-like cumulus clouds in the southern sky.

Maverick also included numerous visually mnemonic cues that would resonate in early nineteenth-century American minds. Few looking at the three steamboats dominating the other craft in the river—the six Hudson River sloops and the lesser vessels—would fail to remember that the first working steamboats had begun service on the Hudson River just seventeen years earlier; indeed, though Maverick did not name it, the very boat carrying Lafayette had been named in honor of the general's late friend, Robert Livingston, whose financial support had made steam travel possible. Those who saw Maverick's engraving would remember too that originally Castle Garden off the southernmost tip of Manhattan had been one of more than a dozen forts built earlier in the century to defend New York from the British. It is more than likely they would know that earlier in 1824 city officials had turned the fort into a beer garden and restaurant and constructed the short promenade that Maverick

depicted to connect it with the island. Although James and Ralph Clews probably did not make these associations, they certainly knew they had an image that would transfer very well onto their plates and platters, and that the white of the clouds, smoke, and promenade railing would make a superb contrast with the cobalt blue glaze.

In June 1825, ten months after he landed in the United States, the general and his party arrived in the newly established town of Lockport, New York, where the Erie Canal was nearing completion. After some unusual welcoming ceremonies, including the discharge of cannon filled with little pieces of stone cut from the canal bed, Lafayette stepped onto the deck of a waiting canal boat for a trip that eventually would lead him to Albany and the Hudson River. The general was also stepping into America's future, for the Erie Canal, the "work of giants," so his private secretary called it, was "tightening the bonds of the American Union" and "spread[ing] life and plenty into the wilderness," would transform the Hudson Valley and the nation. And within a year, the potters of Staffordshire, always ready to convert American's desire for mementoes of their democratic experiment into capital, would place images of this great engineering work onto their transfer ware.

Shaun O'Boyle, **Hudson River and Storm King Mountain**
from the Frank Bannerman Residence, Bannerman's Island, 2005
Pigment on paper, 10½ x 17 inches

Archibald Robertson, **View of the Hudson at
West Point with a Block House**, 1802–13
Watercolor, black ink, and graphite on paper, 13½ x 16¼ inches

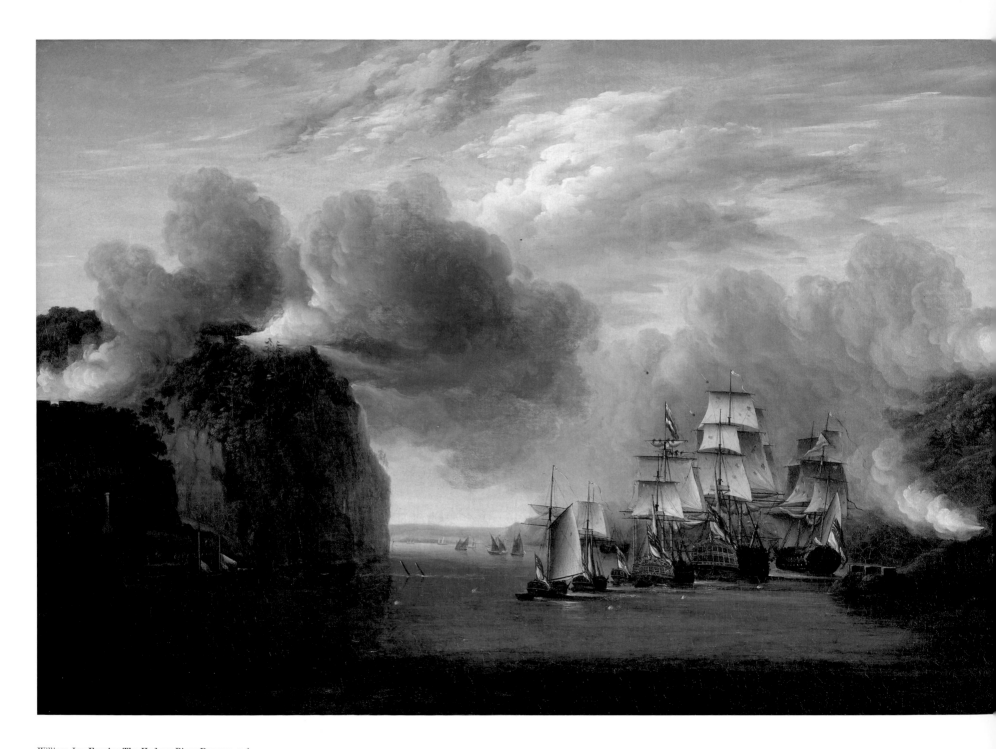

William Joy, **Forcing The Hudson River Passage**, n.d.
Oil on canvas, 28⅛ x 46¼ inches

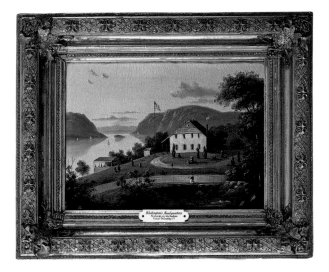

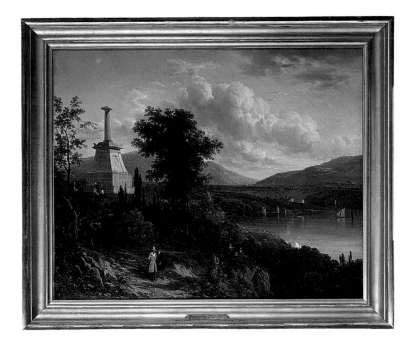

Victor DeGrailly, **Washington's Headquarters. Newburgh-on-Hudson**, n.d.
Oil on canvas, 20 x 23 inches

Victor DeGrailly, **Monument to Kosciuszko at West Point**, 1844
Oil on canvas, 28 x 33½ inches

Hudson River Steamer "C.W. Morse at Night" New York, 1917
Postcard, 3½ x 5½ inches

138:—GRANT'S TOMB AND HUDSON RIVER BY MOONLIGHT, NEW YORK.

Grant's Tomb and Hudson River by Moonlight, 1938
Postcard, 3½ x 5½ inches

Alan Michelson, **Shattemuc**, 2009 (still)
HD video with sound, 30:48 minutes

ALAN MICHELSON'S *SHATTEMUC*

Ian Berry

Brooding and insistent guitar music fills the gallery like a film score from a contemporary Western. The gorgeous sound of something lonely, it pulls us like a tractor beam to find its source, behind a heavy black curtain that beckons us to enter. As our eyes adjust to the theater-like space, we see a dark, saturated video image that gently moves along the banks of the Hudson River.

A square-shaped light illuminates the river. It focuses on the high-contrast bright green of the tree line, then on a light tower, a fallen tree, a bridge support, and it continues to capture details along the river's edge in a seamless steady motion. What is the light searching for? What is lost? What is resisting discovery?

The beam of light uncovers surprises in the water, like the rusty hulk of a barge patiently waiting for another day's labor. Amid the moorings of abandoned docks, other buildings enter the light, then retreat in the same measured rhythm. The space feels mysterious and ghostly—like something lurking behind that stand of pines, or looming on top of those rock faces. Who has come here before us? Whose ghosts haunt these woods? The soundtrack pulls more conceptual triggers. The work hints that all may not be what it seems on the surface.

The installation is the work of Six Nations artist Alan Michelson. Michelson has lived near the river in New York City for over twenty years, making artworks that combine Native American traditions with historical research, media experimentation, and conceptual art strategies. Apache composer Laura Ortman wrote the haunting soundtrack and performed it on electric guitar. Michelson's museum installation combines both images and music in a constructed room in the gallery.

The video begins with the light trained on the wooded banks of the Hudson at Hook Mountain. Michelson's focus on this dramatic, craggy geology connects the river today with the painterly landscape traditions of the Hudson River School, who also cropped views of nature to enhance symbolic effect. The scene continues to the more industrial shoreline near Haverstraw, the site of mining operations and brick factories and the present site of a rock quarry, gypsum plant, and coal-burning power station. The video ends with the searchlight pointed upriver, trained on the Hudson itself.

The title of the piece, *Shattemuc*, is the Algonquin word for the Hudson River. Like Muhheakantuck, the Lenape word for the river, Mohegan, its Iroquois name,

or Cohatateah, Oiogue, or Sanatatea, saying its name asserts that we remember other ways of telling this river's story. Naming is a way of containing and owning the history of a place. Erecting monuments is another. Many monuments attempt to claim a piece of the Hudson's history: Karl Bitter's bronze portrait of English explorer Henry Hudson atop a three-hundred-foot column in the Bronx; a portrait of Polish colonel Thaddeus Kosciuszko overlooking the river at West Point; a circle of the Great Chain links that blocked river passage at Anthony's Nose during the Revolutionary War; or John Duncan's immense tomb to Ulysses S. Grant at Morningside Heights.

Early twentieth-century nighttime steamboat tours featured these types of historic attraction along the river. As the steamboat pilots trained their lights on these waterside monuments they reinforced a one-sided story of power and ownership. This video courses a similar evening path, but its light reveals missing monuments. Or does it shine on another kind of monument? In either case the artist is telling a very different story of these places.

Precedents for this kind of conceptual tour could be Robert Smithson's 1967 influential *Artforum* article *A Tour of the Monuments of Passaic*, or public art pioneers Kate Ericson and Mel Ziegler's 1986 piece for New York's Central Park, *If You Would See the Monument, Look Around*. In this work postcards placed in the park encouraged visitors to look for bronzed tools of the sort used by the park's mainte-nance crew. While hunting for those elusive tools, they would see the park itself as a work of art. The greatest monument, it turned out, already existed—the park itself. Michelson may be suggesting something similar here—that the river is its own best monument.

Michelson has created other river panoramas, the closest precursor being the installation *Mespat* (2001), for which he recorded video of the shoreline of Newtown Creek from a boat. The work brought attention to the polluted waterway that separates Brooklyn from Queens, a place once home to the Lenape. Like *Mespat*, *Shattemuc* also records a river and uncovers an alternative to the dominant history, but in this new work Michelson's use of abstraction makes the work's conclusions open-ended and far-reaching.

Shattemuc records the Hudson shoreline using light from a marine searchlight mounted on the cabin roof of a refurbished former New York City Police launch. The rectangular light casts a grainy diagonal beam from upper right to lower left in the video frame. Moths and mosquitoes regularly whiz by. The position of the light, which appears to come from high above, works symbolically, as if its rays originated from some spiritual source. Michelson uses the jarring, intrusive police searchlight to illuminate locations that on their surface seem far less ominous and aggressive. Could these be crime scenes? And of what kinds of wrongdoing?

At one point in the thirty-one-minute video, the music fades away under the image of the river. In the silence we feel as though we still can hear Ortman's guitar and the water lapping against the sides of Michelson's boat. This sound memory carries along the geological and human history often invisible to us—histories that Michelson carefully surveys along the river's banks. A lighthouse stands watch, a dock bobs ever so gently, and through kitchen windows yellow lamps illuminate tables and chairs, sites where we imagine people telling and retelling tales of this river—this place where many stories are buried and dreams of the future are born.

Alan Michelson, **Shattemuc**, 2009 (stills)
HD video with sound, 30:48 minutes

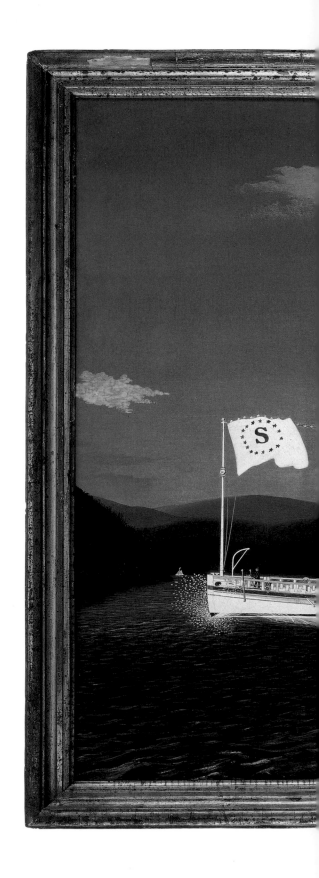

Postcards, 3½ x 5½ inches, undated

Opposite: James Bard, **Syracuse**, 1857
Oil on canvas, 34 x 55½ inches

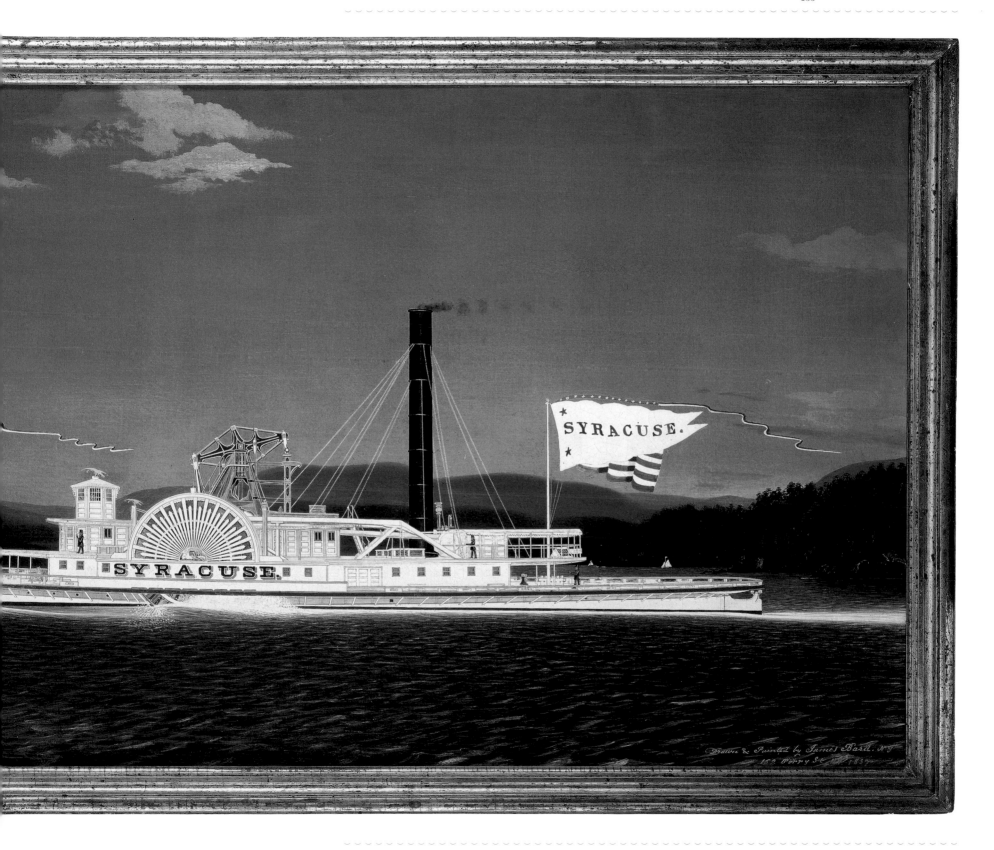

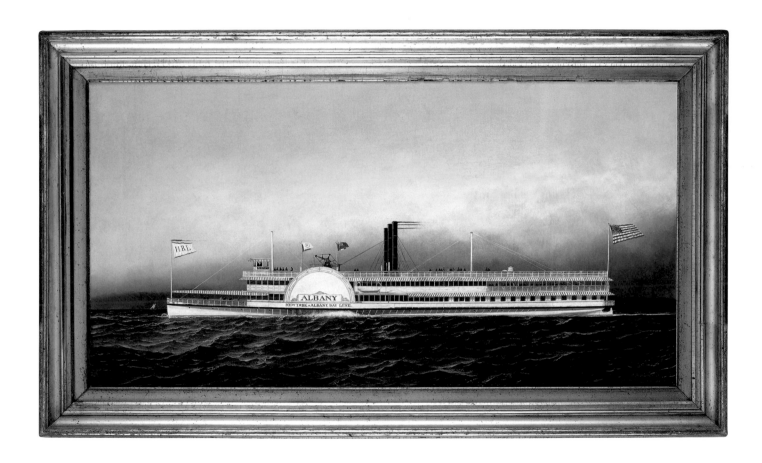

Antonio Jacobsen, **The Albany**, 1883
Oil on canvas, 34 x 57 inches

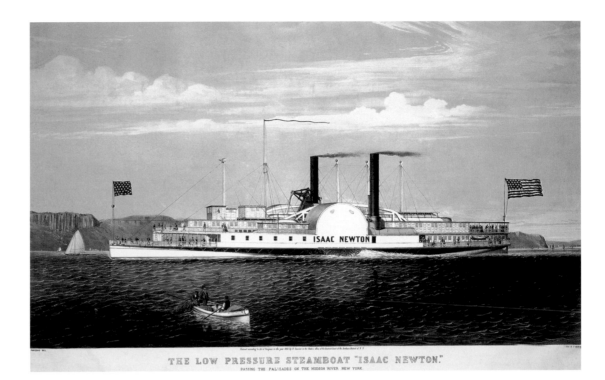

THE LOW PRESSURE STEAMBOAT "ISAAC NEWTON."
PASSING THE PALISADES ON THE HUDSON RIVER NEW YORK.

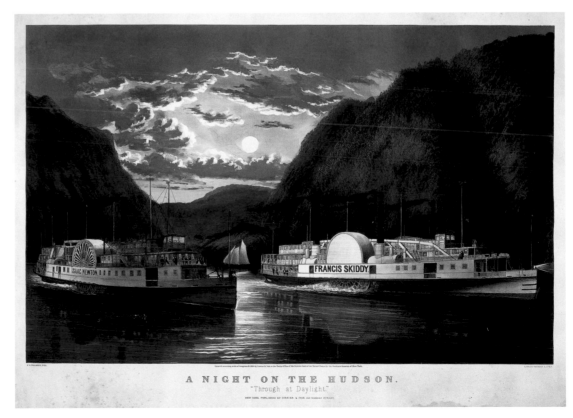

A NIGHT ON THE HUDSON.
"Through at Daylight."
NEW YORK, PUBLISHED BY CURRIER & IVES 125 NASSAU STREET.

Top: Charles Parson, Nathaniel Currier, Lithographer and Publisher, **The Low Pressure Steamboat, Isaac Newton**, 1855
Hand-colored lithograph, 27 x 59½ inches

Bottom: Fannie E. Palmer, Currier & Ives Lithographers and Publisher, **A Night on the Hudson**, 1864
Hand-colored lithograph, 17¼ x 28 inches

1882—Landing of "The Albany", Kingston Point, N.Y.

Wie will be down to-morrow, Friday,
on the train that gets there 2:18.
N. M.

Top: Postcard, 3½ x 5½ inches

Bottom: Unknown Artist, **Upper Deck of a Day-liner, Hudson River**, 1944
Contemporary digital reproduction, 8 x 10 inches

Pilot Wheel from the Mary Powell, 1861
101 x 98½ x 29 inches with base

Installation view, *Lives of the Hudson*
Tang Museum, Skidmore College, Saratoga Springs,
New York

NEW EDITION
PRICE ONE DOLLAR
SOLD ON HUDSON RIVER DAY LINE STEAMERS FOR 50 CENTS

BRYANT UNION PUBLISHING CO.

PRINTED BY THE A. V. HAIGHT COMPANY

81 FULTON STREET

NEW YORK

SENT POSTPAID ON RECEIPT OF PRIC

Pages 138–145: Wallace Bruce, **Panorama of The Hudson—From New York to Albany**, 1906
Softcover map book, $6\frac{3}{4}$ x 11 x $\frac{1}{4}$ inches

my mother tells me that I must travel because travel broadens, and because she and my father have traveled, but I don't see that they have been broadened, because they still argue with one another for no reason that I can discern; apparently, however, my desire to remain safely in my

MY MOTHER TELLS ME THAT I MUST TRAVEL

Rick Moody

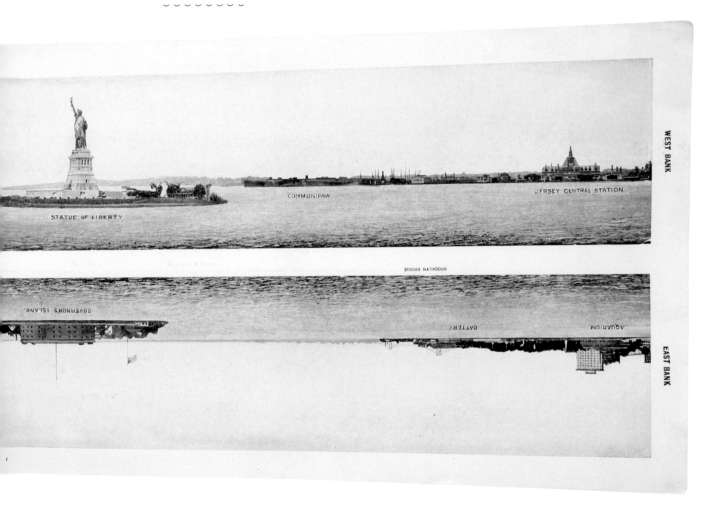

STATUE OF LIBERTY · COMMUNIPAW · JERSEY CENTRAL STATION · WEST BANK

GOVERNOR'S ISLAND · BROOKLYN BRIDGE · BATTERY · AQUARIUM · EAST BANK

Poughkeepsie Pumping Station or the town of Yonkers (from the Dutch for *young heir*), who would rather sing and dance to raucous music and drink up their parents' brandy in solitude, and who at a mere fifteen years' age should be ready to assume the role of a man, fight in the wars or what have you, as long as there are young men who just take, take, from the largesse of parents, take good will, take prospects, take life's blood, there will be the beautiful and bracing and stirring cruises, ending as they begin, my mother tells me, and, further,

bedchamber on days both pleasing and overcast does not meet with their approval, though I may on occasion allow my governess to open the shutters so that I am able to see far across the river to the other state that is known as New Jersey; I may have erred in speaking aloud on the beauty of the Palisades, because in this way was born the notion that we should undertake a proper trip upon the waterway, and so I now come to find myself on the *Hendrick Hudson*, a steam ship, which makes the trip up and back to the capital

for as long as there are going to be such young persons as myself who want nothing to do with the you may surmise my stratagem to survive unto the very last part of the journey of the *Hendrick Hudson*, centers of industry, as my father would have it, but I do not remark on these sights, as I am in pain, which is as nerves, the pain lasts for a great long time and obscures a number of notable sights, military installations, only a poultice of some kind, or a dram, and as I know my mother carries such things, she can nurse my sore

of the state; and this then is to improve the wind in my lungs and likewise to broaden me; for example, I will
be able to see such wonders as the Erie-Lackawanna rail terminus in the town called Weehawken, where,
I have been told by a certain acquaintance, namely the concierge in the building where we live, that there are
in these parts many roughnecks from far away lands; and then further on up the riverbanks, for we have
only ventured an hour now, I see the legendary Palisades closer than ever I have, for I have mostly seen them

my mother intervenes in these generational quarrelings, and asks why it is that my father cannot treat his
boy as his own son and heir, who will one day, when it should suit him, take the reins of the family enterprise,
and this difference of opinion between my two parents, over the merits of their only son, lasts well
through towns called, I am told, Tivoli and Rhinebeck, and then further, though I tell them to please be
silent now, as the incessant noise is causing me to have such a horrible pain in my head that I think

through my spyglass; these are nothing but a hide-out for deadly bears, the kind that would steal away your son and carry him to faraway places where there are as yet no railroads, not to mention newfangled contraptions, for example, the motor car; naturally, I attempted to persuade my mother (as my father will not address me directly except when chastising) that I am not of strong enough mettle to battle the riptides and cross-currents, nor the waves besides, and the foul sea air of the New York Harbor will only weaken my

to me that despite my inability to swim, never having been properly instructed, I can very well grab fast to some floating bit of the *Hendrick Hudson*, I could toss overboard a life ring and I could jettison myself over the side, floating out to one of those islands, for what is an island but folly of some young turk, who like me can find no peace in the rank civilization of the new century, and wants only to retire from the privations of civilization to some castle, there to ponder the deepest of all philosophies, and naturally

lungs and cause further sickness; but she would have no part of my discussions, but I do continue trying on board, clear to the Hook Mountains, which are, I should add, more than a little impressive what with their flavors of wildness; my father disquisitions (he is the disquisitioning type) on some feature of Washington's campaign through this or that village, and he keeps right on historicizing until noontime, when we are just about to the municipality of West Point, and because I have determined only to

nation, and when I reply that the case is just the opposite, why then (because if there is not to b chastisement then there shall be no discussion at all) I am no son of his, and the menu of my high crimes begins, how I don't wish to meet the young ladies of society, how instead I remain in my chambers, reading books all the day long, and this lecture is the very western wind that buffets the *Hendrick Hudson* as far as Sunnyside island, or one of the other islands that stipple this portion of the great waterway, and it occurs

gaze upon the *far shore* on the way up river, the western shore, I see something of this place, while my father tells all who will listen that I am nothing but an ungrateful young mule who can express no joy about a bracing and scenic journey, while I meanwhile worry that I shall suffer effects of the sun; and so we pass the hours until half past three, when we do finally come upon those Catskill Mountains, so infamous, and it is observed by some well-meaning ship's mate or ensign that the mountains were called after a goblin

this I learn in the brief overnight we have there, before the ship sets sail again, before I am permitted to gaze on the other riverbank, upon the *east side*, port side, which is to say that I gaze in the direction of New England and therefore at all the oldest places in this land, which I should remark mean precious little to me, because I am interested in what is *new*; now my father asks me if I do not care to remain this morning seated on deck where I can witness, as he puts it, the most historical and oldest places in our sovereign

that ate the children of the natives; this news affects me so that I insist upon going below decks, diagnosing paroxysm of the intestine, and there I stay for a time, thinking about the awful qualities of empty spaces and how they are landscapes in need of taming, if only for their fearsomeness; my father ever preaches on a related gospel, that a landscape needs to be brought under dominion, and its opportunity for the production of capital enterprises needs be fully exploited, and it pleases me to mount this imitation of

the paternal rhetoric, because I am given to imitation, you see; the Catskill emptiness ought have the likeness of man written upon it, I say, in likeness of my father, or so I think until I come to disembark with the passengers and crew of the *Hendrick Hudson*—to the city of Albany, to the gateway, if you will, to all the neglected northern part of our nation, and from there to the icy wastes of Canada, which have a seat in my own feverish dreams, the icy wastes; do you know, Albany has a quite splendid seat of government,

Postcards, 3½ x 5 inches each

Mid-Hudson Traffic Bridge, Poughkeepsie

HOOK MOUNTAIN, (HUDSON RIVER), NYACK

VIEW OF THE ROAD OPPOSITE BEAR MOUNTAIN PARK, BEAR MOUNTAIN

VIEW FROM THE HENDRICK HUDSON DRIVE—WEST SIDE OF RIVER

RIVERSIDE DRIVE, GEORGE WASHINGTON BRIDGE AND HUDSON RIVER AT NIGHT, NEW YORK CITY

Steamer Hendrick Hudson at Albany

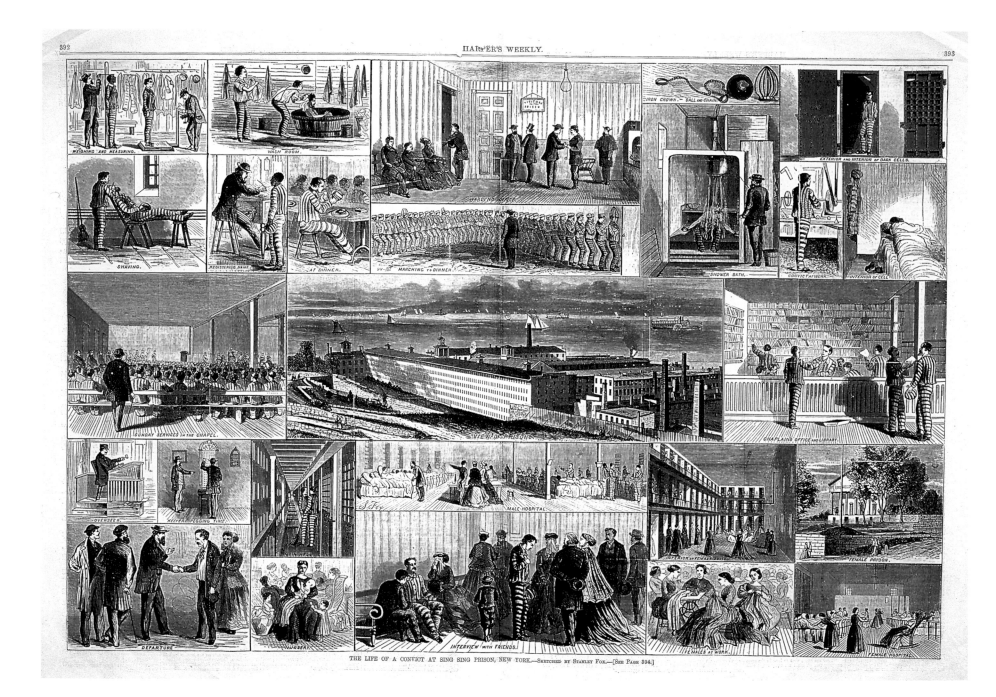

Stanley Fox, **The Life of a Convict at Sing Sing Prison**, New York, 1867
Harper's Weekly, June 22, 1867, pages 392–393, Newsprint, 16 x 22 inches

UP THE RIVER:
TOURING SING SING

Mimi Hellman

1. See Roger Panetta, "Up the River: A History of Sing Sing Prison in the Nineteenth Century," Ph.D. dissertation, City University of New York, 1999; David J. Rothman, "Perfecting the Prison: United States, 1789–1865," in Norval Morris and David J. Rothman, eds., *The Oxford History of the Prison: The Practice of Punishment in Western Society* (New York and Oxford: Oxford University Press, 1995), 111–129. See also Tom Lewis, *The Hudson: A History* (New Haven and London: Yale University Press, 2005), 220–223. The foundational text for the theoretical study of incarceration is Michel Foucault, *Discipline and Punish: The Birth of the Prison*, trans. Alan Sheridan (New York: Pantheon, 1977).

2. Indeed, the same year that this image appeared, social reformers Enoch Cobb Wines and Theodore William Dwight published an influential exposé of the appalling conditions at prisons across the United States; see *Report on the Prisons and Reformatories of the United States and Canada*, Made to the Legislature of New York, January 1867 (repr., New York: AMS Press, 1973).

3. The spread, designed by Stanley Fox, is followed by a short written summary of its contents, but no sustained written interpretation (*Harper's Weekly: A Journal of Civilization*, vol. 11 [1867], 394).

Celebration came easily in the visual culture of the Hudson during the nineteenth century: the river's natural beauty, political resonance, and practical uses made it the ultimate American icon. But some aspects of this great symbol and resource demanded special representational care. A double-page spread published in a June 1867 issue of *Harper's Weekly* features what might seem like a surprising subject for a popular magazine: convict life at Mount Pleasant prison in Ossining, New York, generally known as Sing Sing.[1] Built in the 1820s on the east bank of the Hudson, the facility housed over a thousand convicts, many sent "up the river" from New York City. By the 1860s it was a target of widespread criticism because of overcrowding, disease, and torture, and area newspapers contained frequent accounts of rioting and escapes.[2] But the *Harper's* spread offers the public an idealized prison—a beautifully situated, orderly institution where criminals are rehabilitated according to middle-class norms. Its visual strategies produce a kind of tourist experience, transforming one of the most problematic features of the Hudson River landscape into a fascinating yet unthreatening attraction.[3]

The central scene, a view of the riverside site, anchors the spread both visually and conceptually. The rhyming expanses of architecture and river convey a sense of grandeur and tranquility, and the water is dotted with the sailboats and steamers used by tourists and residents of local mansions. In the foreground, strolling figures develop the theme of leisure while a passing train signals the promise of industrialization. Sing Sing resembles a modern factory more than a high-security fortress: the elevated viewpoint diminishes the enclosing walls, and the buildings' clean lines suggest order and efficiency. The prison was indeed a kind of factory, for inmates quarried marble and produced various goods at a considerable (and controversial) profit to the state. But the image shows no men hauling stone-laden carts and no commercial ships. Although the topography is more institutional than natural, pictorial conventions place this scene firmly within the

tradition of picturesque imagery that shaped much of the visual culture of the Hudson.[4] Compare an 1837 view of the village of Ossining near the prison. Both compositions are dynamic yet contained, with diagonals stabilized by broad horizons, and human activity framed by placid water and untroubled sky. Surveying these harmonious vistas, the viewer assumes a position of almost divine mastery.

The central image of the *Harper's* spread sets the tone for the rest of the plate, where signs of suffering are carefully contained and ultimately overtaken by a narrative of rehabilitation. Corporal punishment at Sing Sing was frequent and brutal, often involving a knotted leather cat-o'-nine-tails. In this pictorial prison, however, the whip is nowhere in sight and the dehumanizing regimentation of lockstep marching— required for all inmate movement—is compressed into a narrow panel between the more spacious views of the site and the warden's office (top center). The only explicit image of punishment, the "shower bath" (top right), suppresses the horror of this sometimes fatal suffocation procedure by emphasizing the rational geometry of the apparatus and hiding the victim's distress beneath a rush of water. In the small panel directly above, two restraining devices, a ball and chain and "iron crown," are arranged in a tidy still life, like dishes on a cupboard shelf. Similarly, labor is not arduous mass toil under the surveillance of armed guards, but rather an act of diligent attention. The upright composure of a man working a lathe (top right) mirrors that of the guard in the adjacent torture scene, as if their roles were somehow

similar, while a cluster of sewing women inmates (bottom right) exemplifies ladylike decorum.

The workings of authority are underplayed throughout the spread. The warden's office (top center), where one might expect a commanding display of control, could belong to any well-run business. The guards supervising the lockstep and shower bath are unmenacing, their relaxed poses suggesting those of mere bystanders; the one in the foreground of the chapel scene (center left), leaning on his cane, would fit perfectly in a contemporary print of visitors strolling the streets of fashionable Saratoga Springs. The minutely rendered duties of overseer and keeper (bottom left) are administrative rather than punitive, and the matrons in the women's quarters (bottom right) are indistinguishable from their charges. The only official who takes up a commanding gesture appears in the men's hospital (bottom center), where his action conveys an order to heal, not abuse.

Ultimately, this imagery constructs a reformist vision of wrongdoers rehabilitated through productive activity in an orderly environment. Three of the largest panels feature communal activities and interactions that promote spiritual, intellectual, and moral values: a chapel service (center left), reading and conversation in a library free of guards (center right), and family visitation (bottom center). In the visitation scene, weeping women and a small child suggest that criminality damages families, and the man at the center of the composition—perhaps the most visually prominent prisoner in the entire spread— adopts a posture of remorse. The emphasis on family values is clinched in the image of a convict's

4. For an introduction to the visual conventions of picturesque imagery, see John Conron, *American Picturesque* (University Park: Pennsylvania State University Press, 2000), 1–16.

Thomas Nast, **Sketches Among the Catskill Mountains**, 1866
Harper's Weekly, July 21, 1866, Newsprint, 16 x 21½ inches

departure (bottom left). The successfully disciplined prisoner's stoop is the only sign of his ordeal, and the warden's gesture of advice or blessing belies the brutality of his real-life counterparts. The former inmate is accompanied by a woman who will presumably facilitate his social assimilation, and the surrounding images of both officials and prisoners fulfilling their duties invoke the work ethic that will complement his embrace of normative domesticity.[5] Even more suggestively, the adjacent view of the nursery for children of female convicts depicts a seated woman with an infant and toddler, figuring Victorian domestic ideals in a format that resonates with the iconography of the Virgin and Child.[6]

Harper's thus invited its readers to tour Sing Sing from the safety of their homes, and to exercise both voyeurism and righteousness in contemplating what the magazine called "the hard way of the transgressor" and the facility's successful management by the state. A more titillating version of this experience was available at the prison itself, where for an entrance fee visitors could be escorted through the facility.[7] But the magazine offered a safer and less morally dubious opportunity to master a notorious world miniaturized and ordered through representation. Interestingly, *Harper's* used the device of the partitioned spread to survey many aspects of American life, from agricultural productivity to racial injustice.[8] An 1866 feature on the pleasures and challenges of tourism in the Catskills employs remarkably similar visual and thematic devices: a central, picturesque view of a clean-lined waterside building; a range of purposeful activities unfolding in various spaces; a temporal cycle from arrival to departure. Both plates invite exploration and deliver a kind of vicarious excitement, but ultimately their compartmentalized curiosities produce not a new understanding of the world, but rather an affirmation of middle-class values in a nation still recovering from the Civil War.

The pictorial tour of Sing Sing resonates with the literary conceits of essayist and illustrator Benson Lossing in his 1866 book *The Hudson, from the Wilderness to the Sea*.[9] Lossing praises the beauty of site, "immersed in a thin purple mist" on the day he visited, and the "excellent quality" of the marble "quarried and wrought diligently" by inmates. He regards the prisoners as unfortunate victims of social ills and, as a case study, offers a quintessentially Victorian tale about "the wreck of an innocent and beautiful girl" whose only crime was vulnerability to the corruption of others. "Reformation, not merely punishment, is the great aim," he declares, of "one of the best conducted penitentiaries in the world." This is precisely the message of the *Harper's* spread as well. Amid debates about the social causes and effects of criminality and widespread criticism of America's penal system, this neatly packaged account of a notorious Hudson Valley institution both reassured its audience and discouraged them from wondering what might really be happening "up the river."

5. The possibility of rehabilitation through work, education, spiritual counsel, and fair treatment was promoted by various nineteenth-century prison reformers, including Wines and Dwight in their report of 1867.

6. *Harper's Weekly* was filled with visual and verbal representations of ideal Victorian domesticity and gender roles. In the 1867 volume alone, readers found illustrations entitled "Mother's Kiss" (January 5, 5) and "The Mother and her Babe" (August 24, cover); an illustrated poem, "Sweet Home," praising a "blissful, holy place/Where perfect love and peace are found" and "Man, despite his fallen race,/Some trace of Eden still can see" (February 23, 113); and, interestingly, a reproduction of a painting of the Virgin and Child by the seventeenth-century Spanish painter Murillo (December 28, 824). The Sing Sing feature is followed by the poem "In Strawberry Time," a sentimental account of summer courtship.

7. Wines and Dwight condemn this practice as "evil" compared with the rehabilitative effects of visits with family and friends (*Report on the Prisons and Reformatories*, 218).

8. In 1867, similarly organized double-page spreads variously commemorated the Civil War (dedication of cemetery at Antietam [October 5, 632–33]); condemned postbellum corruption (racism in the South [March 23, 184–5]); celebrated American productivity, strength, and leisure (newsboys in New York [May 18, 312–13], a ship in New York harbor [July 20, 456–7], a Harvard-Yale regatta [August 3, 488–9], farming [August 10, 504–5], an agricultural fair [September 21, 600–1]); and explored the dark side of modern life (the plights of city dwellers [January 26, 56–7 and April 20, 248–9]).

9. Benson J. Lossing, *The Hudson, from the Wilderness to the Sea* (1866; repr., Port Washington, NY and London: Kennikat, 1972), 296–303. Interestingly, Lossing's illustration of Sing Sing depicts the prison from the same angle used in the *Harper's* spread.

ICE-YACHTING ON THE HUDSON.—Drawn by J. O. Davidson.—[See Page 94.]

A BARGE PARTY ON THE HUDSON BY MOONLIGHT.—Drawn by J. O. Davidson.—[See Page 799.]

NEW YORK.—ICE-YACHTING AT ROOSEVELT'S POINT, ON THE HUDSON—THE CHAMPION SLOOP "NORTHERN LIGHT."
FROM A SKETCH BY A STAFF ARTIST.—SEE PAGE 411.

Clockwise from top left: J.O. Davidson, **Ice Yachting on the Hudson**, 1879
Harper's Weekly, February 1, 1879, page 89, Newsprint, 10 x 14½ inches;
J.O. Davidson, **Barge Party on the Hudson by Moonlight**, 1889
Harper's Weekly, October 5, 1889, page 800, Newsprint, 12⅜ x 9¾ inches;
Unknown, **New York—Ice-Yachting At Roosevelt's Point, on the Hudson—
The Champion Sloop "Northern Light,"** n.d., Print, 9½ x 7 inches

Unknown, **Outing on the Hudson**, c. 1875
Oil on cardboard, 19 x 24 inches

THE FATE OF PLEASURE

Peg Boyers

Hardly native and far from naked, these dignified
loungers by the Hudson stroll in their Sunday best,
white as the lilies in the foreground, white
as the sails on the little boats below
navigating the river, white as the scentless smoke
pluming up from the passing steamboat. In this Sunday idyll

the mill's emissions across the way seem to our idle
onlookers harmless, improbably elegant, dignified.
Such feathery streams of benign smoke
are sure signs of a singular prosperity. All the best
families know this. No need to consider what below
the smoke burns or what beneath the river's crisp white

crests gathers and congeals. Above, the white
crests and the complacent sense of an afternoon idyll
in the park where leisure reigns are all that matter. Below
the presiding sycamore a boy crouches, rather undignified
but engaged in addressing a cat trying her best
to look like a dog. Why notice the covert smoke

from his Southern cousin facing the tree? Discreet with his smoke,
he turns away so it dissolves without a trace into the white
clouds above. His father is fresh from Havana with cigars and sugar, the best
available. New cargo will replace the old: runaways enjoying their newfound idyll
make easy marks. He lures them in with lies, promises of protection, a dignified
life. He'll keep a few, chain the rest. The catch of the day he'll stash below

necessarily confined to reside below
in the dank unlit hull, their skin darker than smoke,
dark as their master's satin top hat, upright and dignified
on his proud Southern head, dark even as his shiny patent boots. His white
masterly jaw under a full, black mustache stays clenched against all idle-
ness, though today he'll spend with his Yankee wife the best

hours of the day, strolling without purpose among the best
families of the faultless town. His mind strays to the cargo below,
the price it will fetch in Charleston; he smiles at the way his idle
son hides his new habit, blowing into the sycamore the smoke
from the *puro* he stole from the Havana cache, his white
shirt immaculate, his wiles instinctual, integral as gloves to his dignified

Sunday best. Though it is the Sabbath and the mill across the river below is idle,
its spindles still, our languorous strollers ignore the anomolous smoke
spreading—relentless, white—across the sky on this dignified day of rest.

William J. Bennett, **Troy, taken from the
West Bank of the Hudson**, 1838
Hand-colored aquatint, 25½ x 35½ inches

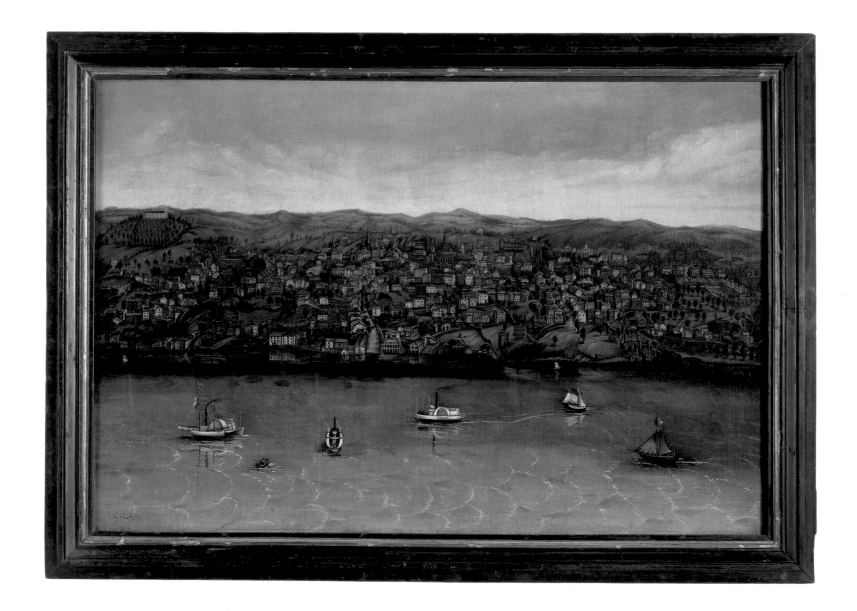

J.M. Evans, **Poughkeepsie**, New York, c. 1870
Oil on canvas, 28 x 42½ inches

Opposite: Bradley Castellanos, **American Paradise**, 2009
Oil, acrylic, photo collage, and resin, 66 x 73 inches

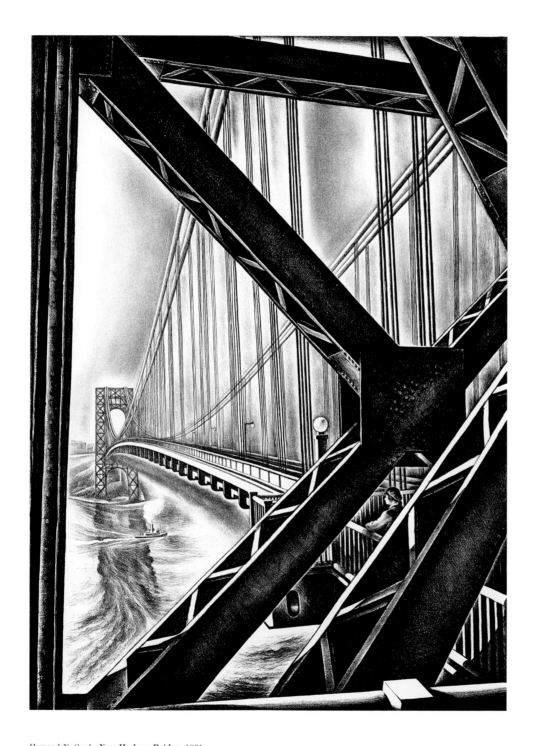

Howard N. Cook, **New Hudson Bridge**, 1931
Lithograph on paper, 17⅝ x 13¹¹⁄₁₆ inches

HOWARD COOK'S
GEORGE WASHINGTON BRIDGE

Phillip Lopate

Among the marvels of post-1929 Art Deco New York, when the Great Depression halted all but a few construction projects (including the Empire State Building and Rockefeller Center), none was more conspicuous than the George Washington Bridge. It had taken five years and a million rivets to build, and had cost the lives of twelve men. Spanning the noble, ample Hudson River from Washington Heights uptown, to the Palisades cliffs in New Jersey, it was (and remains) the only bridge connecting Manhattan to the continental mainland. At the time the largest suspension bridge ever attempted (4,760 feet), it had been conceived from the first as a toll facility that would pay for itself: automobiles and horse-drawn carriages were initially charged fifty cents, bicycles twenty-five cents, pedestrians ten cents, and shuttle bus riders a nickel. It opened on October 25, 1931, a year ahead of schedule, still without a name (candidates included the Palisades Bridge, the Fort Lee Bridge, the Paradise Bridge, the People's Bridge, and the Prosperity Bridge, before a consensus coalesced

around naming it for the father of the country); this powerful lithograph by Howard Cook, also dated 1931, originally titled *New Hudson Bridge*, must have been made shortly after its opening.

Howard N. Cook (1901–1980) grew up in Springfield, Massachusetts, studied for a few years at the Art Students League of New York, kicked around the world doing odd jobs, including ship's quartermaster and magazine illustrator, all the while teaching himself to master every aspect of printmaking. He became equally proficient in woodcuts, etchings, and lithographs, and did all parts of the process himself except for lithography, where he left the final step to a master printer.

The 1920s and '30s were an exciting time in the field of graphic arts, as American printmakers strove to free themselves from traditional European subjects and techniques, and to take on themes that reflected a more national consciousness. Cook, who ended up settling with his wife, the artist Barbara Latham, in Taos, New Mexico, made numerous prints of Southwest landscapes, coal miners, weather-beaten farmers and Mexican peasants (he was influenced

by the Mexican mural movement and embraced the
Works Progress Administration aesthetic of art
for the people). One of his strongest series was strictly
urban, paying tribute to what he called "the endearing
serrated skyline of the most exciting modern city in
the world." Faced with the mammoth built
environment of New York City, Cook seemed both
mesmerized and appalled. (He called one street scene
Soaring New York, another, simply *The Dictator*.)
These studies of looming skyscrapers and bridges,
power plants, and Wall Street canyons were all
made, with a few exceptions, between 1928 and 1937,
and executed with considerable graphic power.

His lithograph of the George Washington Bridge
stands at the convergence of a fertile period in
American printmaking and a glorious apotheosis of
American-engineered public works. The eye is
drawn immediately to the dark triangular nexus of
girders crossing in the foreground, then swept
via perspective along the diagonal pedestrian
walkway to the more subtly gray-toned tower in the
background, after which it plunges to the water,
where the bridge tower's reflected shadow resembles
an inverted tree or the up-thrust swirl of some
pagan underwater deity. Only after returning to the
black, somewhat sinister—or at any rate brooding—
structural beams in the foreground does one
notice, between two parallel girders, the lone figure of
a woman, her arm resting on the railing. This is "B"
of the title, as Cook customarily referred to his wife,
Barbara. After pausing, perhaps to wonder what
the woman is making of all this, the spectator's eye is
free to wander vertically along the cable wires to
the overcast sky. The glance is thus driven to carom

sharply and warily, the way it often does in New York,
from low to high and side to side. It is a dynamic
composition, very alive, clashing and restless, a
Hudson River view as different as possible in effect
from the tranquil landscapes of receding vistas
achieved by the nineteenth-century Hudson School
of painters. It is also very different from the classic
Joseph Stella painting of the Brooklyn Bridge, which
invites us into the structure as though entering
a cathedral—or from Cook's own frontal, arched
treatment of the Brooklyn Bridge in his 1949
lithograph.

Here, the girders in the foreground, unclad, confront
us with the naked, unapologetic power of steel.
Their absence of decorative masonry was much
remarked on when the George Washington Bridge first
opened in 1931. The GW's creator and chief engineer,
the Swiss-born Othmar Ammann, unarguably the
greatest bridge-builder of the twentieth century, went
on to design, in the New York region alone, the
Triborough, the Bronx-Whitestone, the Bayonne, the
Throgs Neck and the Verrazano-Narrows Bridges,
and served as a key consultant on the Golden Gate
Bridge and other spans across America. But
he had actually hoped that the George Washington,
Ammann's first major suspension bridge, would
be clad with stone in the Gothicized manner of the
Brooklyn Bridge. Ammann, who liked to consider
himself an artist, and resisted the popular stereotype
of the engineer as a dull, slide-rule type, was keen
on stone cladding because he thought it would make
the public better appreciate his bridge's beauty.

The architect Cass Gilbert was commissioned to come up with stone adornments, and his designs were even published, but budget constraints forced these plans to be dropped. The fortuitously non-gussied result, light, graceful and strong, a haiku of sleek, streamlined steel that perfectly embodied the modernist principles of "form follows function" and "architectural honesty," sent Le Corbusier and Mies van der Rohe into raptures. Le Corbusier declared it "the most beautiful bridge in the world," and in the end Ammann himself came to accept gratefully the world's compliments for his inadvertently austere aesthetic as well as his engineering achievement.

Just as Ammann, the master builder, resented hierarchical distinctions between artist and engineer, so Howard Cook, the master printmaker, labored in the face of the spurious dichotomies in status between fine art and illustration, and fine art and graphic art. In his later years Cook would turn exclusively to painting murals and oils, though his prints continued to be valued and acquired by museum collections.

The artist recalled toward the end of his life, in a 1978 interview, how much trouble the tonal values had caused him at the time. "Do you know my lithograph of the George Washington Bridge with the one little figure in it? The bridge was drawn with all the supporting wires, and in between those wires was a very light tone. But I overdid the tone in drawing it, so that it came out almost black. George [George Miller, the New York lithographic printer whom Cook used] had me sit down with a needle—I don't know for how long, more than a week probably—and pick that all out." The effort was worth it; the resulting

range of tonal values could not be more dramatic or virile. There is a frankly muscular appeal, to the bridge which this lithograph captures, and which the critic Camille Paglia also noted: "When I cross the George Washington Bridge...I think: men have done this. Construction is a sublime male poetry."

Cook was certainly not alone in his fascination with industrial infrastructure. The machine, and the metropolitan streetscape it made possible, held a romance for many American visual artists in the first half of the twentieth century: one thinks of Charles Sheeler's Precisionist images, Lewis Hine's photographs of workers aloft amid the Empire State Building's scaffolding, Berenice Abbott's Cubist New York skyscrapers shot at clashing oblique angles, as well as Joseph Stella, John Sloan, Abraham Walkowitz, Stuart Davis, Rudy Burckhardt, and the Manhattan of a thousand-and-one movies. There is, in this heroicizing of the Machine Age's erections, a strand of American optimism that now feels a little poignant and quaint. Not so the George Washington Bridge, which has not dated in the slightest: though its Brancusi-like compositional purity was marred just a tad by the addition of the lower deck in 1962, it continues to be the busiest bridge in the world, and one of the most efficient, profitable, sturdy and lovely.

NOTE: I am indebted to two books—*The Graphic Work of Howard Cook*, a catalogue raisonné by Betty and Douglas Duffy, with an essay by Janet A. Flint (Bethesda: Bethesda Art Gallery, 1984), and *The George Washington Bridge: Poetry in Steel* by Michael Aaron (New Brunswick: Rivergate, 2008)—for many facts and quotations, and to the insights of my daughter Lily.

Opposite: Margaret Cogswell, **Hudson Weather Fugues Project**, 2009
Mixed media, Dimensions variable, Installation view, *Lives of the Hudson*,
Tang Museum, Skidmore College, Saratoga Springs, New York

Above: Margaret Cogswell, **"When the war was on you couldn't
fish in the harbor of New York City...so that meant a lot of fish come up
here..."** (Frank Parslow, shad fisherman)
Video still from *Hudson River Fugues*, 2009

Margaret Cogswell, "...and then the English come and they didn't know
how to spell—they thought the Dutch made a mistake. They
spelled it different so they changed it..." (Frank Parslow, shad fisherman)
Video still from *Hudson River Fugues*, 2009

ON FIRST AVENUE
AND SIXTH STREET: FUGUE

Tom Sleigh

There are days the whole world gets down on all fours;
 if you're twenty or sixty, you'd do it in an alley,
 bodies thrown together—
and when it's over, one or both of you stumbling
 out into afternoon, ghosting
 through air it goes
 on and on…
The absence that starts to shine on Atlantic Avenue,
 the crazy drive-by
 joy that turns the speakers so loud the car
 vibrates now becomes years later
a story you tell your child who grows up to be a Veejay
 in a dance club
 over in Williamsburg.
The East River where you used to walk in Carl Schurz Park
 looks like it drags
into the current's weave the Domino Sugar Factory,
silo architecture on fire in the oily spangle
that joins the Hudson upstream at Spuyten Duyvil.

 The world gets down on all fours
 and that's you
yelling your head off as a boy, pounding your mitt,
 the grass not quite grown in because it's April
and the odors wafting up are dogshit and leafrot,
 spunk buried in winter muck
 releasing head clearing
effluvium, sky overarcing the batting cage
 and chainlink backstop, home plate's white diamond
making a satisfying thump womp when you pound
 your bat three times as you step up to the plate:
 out there in the river
a pirate was flung from the yardarm,
 and that's where the giant ape
clung, beating his chest bloodied by machine guns
 of the gnat-sized Curtiss Helldivers
 his giant, seamed hand
 bats from the sky.
Or the mushroom blast looms up in the boxed-in screen
 and radiation transmogrifies
 crabs become the size
of boxcars that charge you from their cave
 where they discuss your fate
in the voices of mad scientists
 they've just eaten.

This is the day when the world

gets down on all fours, and you and she lie out on the city beach,

sun dazzle in the shallows, tinflash on the far swell

as the thieving Parking Meter Czar

slashes his wrists

upstairs while talking to his shrink,

his wife listening in

too late on the extension downstairs...for the wife

a tragedy,

but for the two of you chuckling

at the headline,

Corrupt Meter Man Expires,

weren't you happier

back then, tuned in to radio waves beamed out across the universe,

the song's last word reversed

the first word alien ears would hear, *whole lotta love*

evol attol elohw

the radio bubble widening 100 light years through space

broadcasting Led Zeppelin, Cream, Zappa's

"Weasels Rip My Flesh"

inspiring your own vodka-fueled arias

never heard in the high clamshell hall

listening to the woman without

a shadow

sing to the unborn children singing

in the frying pan their lovely sorrow at not being born:

don't let yourself be turned

to stone

like the Emperor who can only be saved

if his wife, Empress of the Spirits,

gets down on all fours

and finds a human woman who will sell to her her shadow:

the composer

said this opera was his "Child of woe,"

and you yourself staring down

like the giant ape, surprised to find your hand

empty, beast to her beauty,

are swaying, falling

through skyscraper horizons

to a woman's voice

singing you to sleep half a century ago

where you're floating downstream among bulrushes and cattails

toward your rendezvous with Pharaoh's

daughter who fades

into the Domino Sugar Factory's glow

as sun

tangled in bridge cables

portions out currents quarreling into zones

blazing up like gas flames

on the little gas stove in your walkup on First Avenue

above the Ukrainian beauty parlor where you first felt

the world getting down on all fours and you followed along

in your dog's instinct for pleasure—

it seemed like it would last

forever, didn't it, her reading out from the paper

and the two of you laughing together

until you both

lost your shadows and were condemned to walk

among the spirits who cry out to you like cats wawling

in the weed-clumped frozen garden down below.

Now, the Empress and Emperor sing their final duet

in praise of the unborn, drowning out

the cats as the river

brims over,

reflecting the schooner *Tyger*

shooting flames from topmast to bowsprit,

the hull listing,

sinking into it's own smoking

hiss and onrush

of waters

buried under fill buried under

the fallen towers

never dreamed of by the Empress or Emperor

who sing not to vaporized wisps

of DNA

but to spirits crowding into starry vestibules.

And there you are with your crew, wintering over

as you build the Restless

and in the first spring wind launch her through

Hell Gate into the great bay

beyond, sailing up

as far as the River of Red Hills

before crossing the wide ocean to your house in Old Wall Street

you and your wife called The Two Hooded Crows

and where you lie down in your bed

alone because she died while you were at sea, and you only

found out the moment you came ashore—

and that first night

after twenty-five years together, you dream

of furred beasts slinking

through your campsite,

your human smell fading into musk and scat.

THE WORKING

RIVER

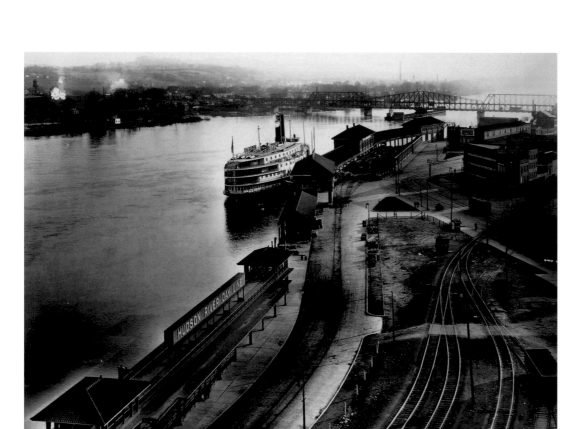

Unknown Artist, **Steamboat at the Dock, Hudson River Dayline**, c.1915
Photograph, 8 x 10 inches

Opposite: Unknown Artist, **Sunnyside from the Hudson**, c.1860
Oil on canvas, 30 x 40¼ inches

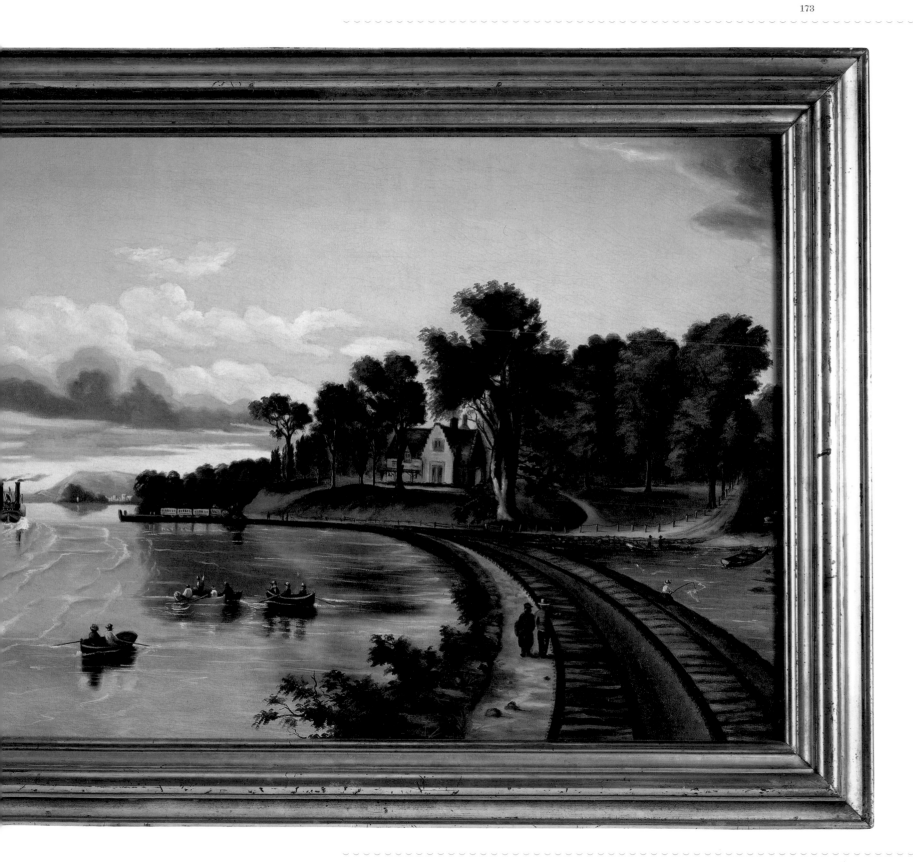

MANY THINGS

Robert Jones

The Hudson River is many things to many people. It is at once a vast watershed, an important part of America's past, a potential water source for those along its path, a river to be cleaned up, a valley for new technology, a source of recreation, and a scenic wonder.

The river begins its journey on the slopes of Mt. Marcy in New York's Adirondack Mountains, about 4300 feet above sea level. Along its 315 mile path south to New York's harbor and the Atlantic Ocean, about 64 tributaries, including the waters of the Mohawk River, add to its flow. They drain a vast watershed that reaches beyond New York's borders into Vermont, Massachusetts, New Jersey and Connecticut. The northern half of the river above Troy flows through the largely forested upper reaches of the Adirondacks For its final 150 miles below Troy the river becomes a broad and deep tidal estuary. Development on the banks of this lower half has contributed more directly to the nation's history and economy.

The Hudson Valley is the home to cities both large and small. More than eight million people live in New York City at the southern outlet of the river while just a handful live in the historic village of Tahawus (a.k.a. Adirondac) in the town of Newcomb near the river's northern beginnings.

Inhabited by the Mohawks and Algonquins before them, the Dutch were the first Europeans to "discover" the river that came to be named after the explorer, Henry Hudson, in the early seventeenth century. He hoped that it would become a lucrative trade route leading to the Pacific Ocean and China. Not finding a trade route to the Far East, early merchants instead used the river to facilitate the exchange of beaver pelts with Native Americans near its shores. Soon after trade with the indigenous population began the lower Hudson Valley became more valued for its agricultural potential, particularly since the land possessed characteristics similar to those of the settlers' homelands. In 1664 the Dutch yielded control of the entire lower Hudson Valley to the British.

In the late eighteenth century, the Hudson River played a pivotal role in the Revolutionary War. Both the British and Americans believed that control of the river was key to success; many historians mark the turning point in the war as the defeat of the British at Bemis Heights, near the present day Town of Saratoga.

Michael Light, **Elizabeth Marine Terminal Looking North, $149 Billion in 2006 Cargo, Newark Airport at Left, NJ**, 2007
Pigment print on aluminum, 40 x 50 inches

In the early nineteenth century, the Hudson again played key roles in the nation's development. It became the home of the nation's first military academy at West Point, near George Washington's former military headquarters. Steamboat travel had its origins in this river, thanks to Robert Fulton and Robert Livingston. The Erie Canal connecting the Hudson River with the Great Lakes changed the economy of the young nation by enabling New England to develop its manufacturing and the Midwest to become the source of agricultural products. With the trade brought by the canal New York City became the financial headquarters of the country. Though the nation's capital had moved to the banks of the Potomac River in 1800, the functional capital of the growing nation remained at the mouth of the Hudson.

The Hudson's tributaries played a crucial role in the development of the valley in the nineteenth century. Their waters turned countless mills and tanning became one of the first major industries. Today there are a dozen cities with a population of at least 10,000 on the shores of the Hudson River, while smaller industrial cities flourished along its many tributaries. The Hudson Valley also became a mecca for a series of health retreats during the nineteenth century. The healing waters and fresh air of resorts like Saratoga Springs, attracted city dwellers and others in need of the therapeutic powers of nature. The beauty of the valley led to it becoming the home or second home for wealthy businessmen and their families, not to mention future and former Presidents.

Beginning in 1825 artists like Thomas Cole, Asher B. Durand, and Frederick Church, among others, found inspiration and a uniquely American landscape in the Hudson River Valley. While they celebrated the land's ineffable natural beauty, they feared its destruction by human settlements and industries. By the late nineteenth century New York State's politicians acted. They placed much of the upper Hudson's watershed into the Adirondack Park and declared its lands to be forever wild.

By the mid twentieth century, industrial wastes, generally chemical pollution from the very businesses which had enabled the valley to grow and flourish, threatened the Hudson's survival. Concern for the valley's ecology led to the modern environmental movement that for the last half century has worked to reverse the damage done to the river. Organizations like Scenic Hudson, Clearwater, the Hudson River Fisherman's Association, and the Beacon Institute are seeking to restore the waters and land so that future generations may enjoy their benefits.

Today the Hudson is home to new industries brought about by technological change. "Tech Valley," as it has recently come to be known, stretches through the northern part of the lower Hudson. The upper Hudson is now being prepared to become a source of clean drinking water as well as an abundant water source for high-tech manufacturing in Saratoga County.

The Hudson has thus changed with the times—a trading route, a turning point in the creation of the new nation, a power source for early industry and its financing and now a fresh water source for the twenty-first century. The river will no doubt undergo many future changes as well.

Seneca Ray Stoddard, **Untitled**, n.d.
Albumen print (stereograph), 3⅜ x 3 inches

Unknown, **Hudson River Railroad Bridge, Poughkeepsie, New York**, 1876
Black ink on card, 14⅛ x 19¾ inches

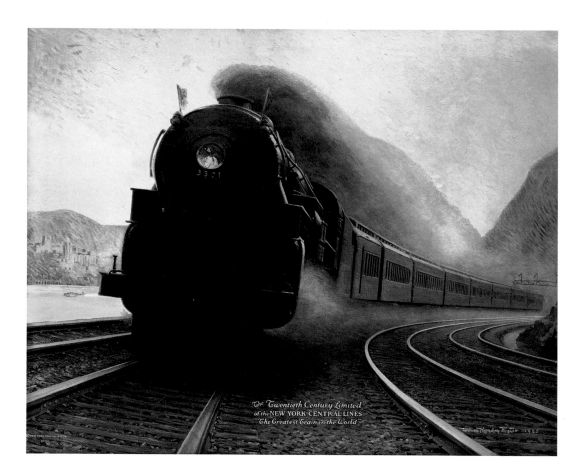

William H. Foster, **The 20th-Century Limited**, 1922
Chromolithograph, $22\frac{1}{2}$ x $27\frac{1}{2}$ inches

Opposite: Bruce Mitchell, **Hudson River Nocturne**, 1937
Gouache on cardboard, $19\frac{11}{16}$ x 30 inches

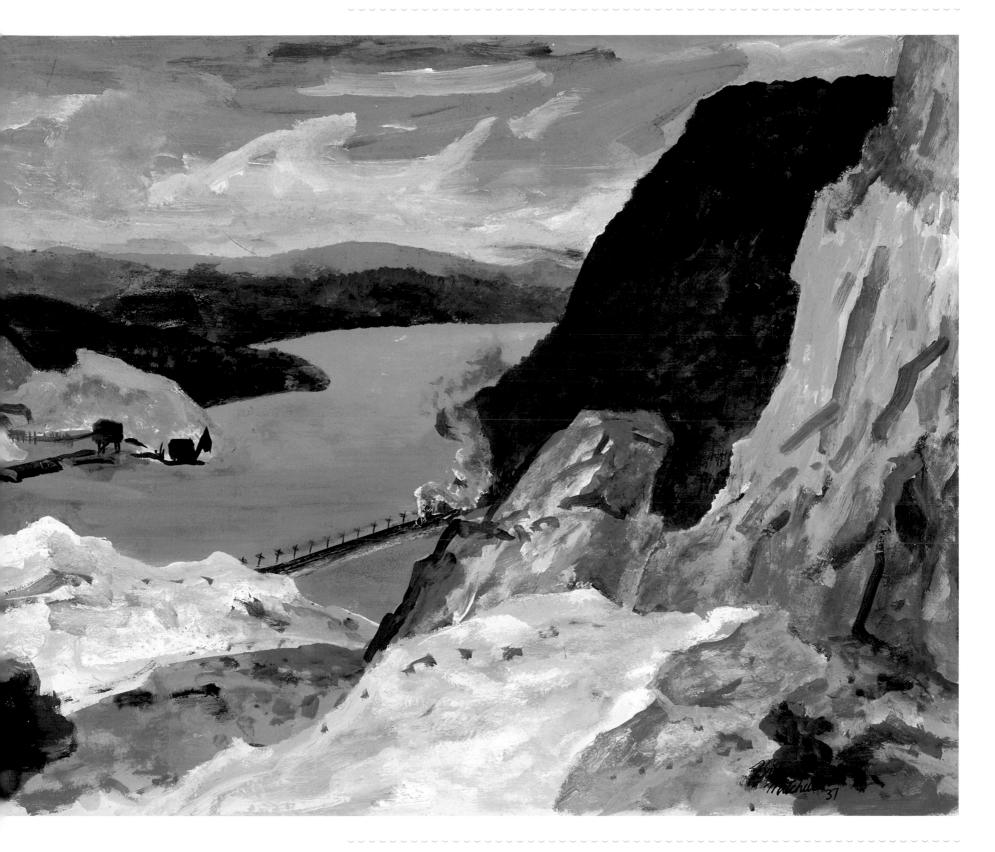

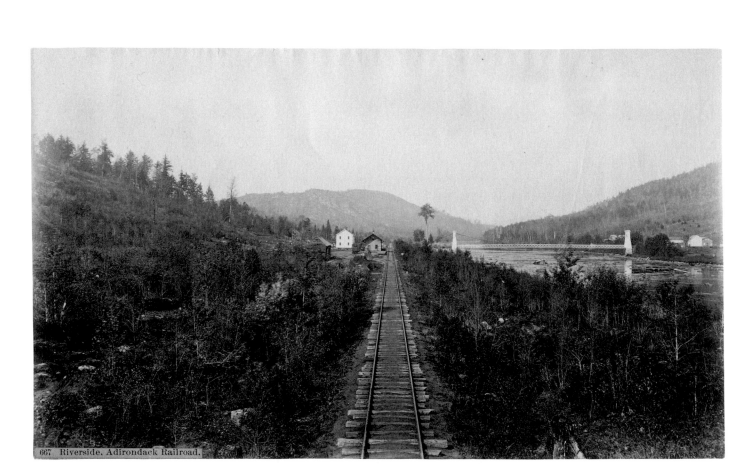

667 Riverside. Adirondack Railroad.

Seneca Ray Stoddard, **Riverside, Adirondack Railroad**, c. 1880
Albumen print, 7⅜ x 4¼ inches

ALONGSIDE A RIVER

John Stilgoe

Railroads snuggle alongside rivers. *Alongside* connotes more than simple adjacency. The word defines not only a more or less static, roughly parallel arrangement, as in phrases like "cottages along the river," but kinetic ones too: maps represent rivers and railroads as static lines, but rivers flow and, in flowing, carry lines, typically of steamships like those of the vanished Hudson River Day Line. Railroads flow too, carrying sequences of trains, some since the 1930s called streamliners, operating on main lines, sometimes so closely spaced as to seem moving lines atop the lines paralleling rivers. Viewers on hills at Peekskill, Manitou, and elsewhere once saw trains as dashed lines punctuated by smoke, but understood roads as the paths of plodding teams and wagons, then of sputtering horseless carriages. Deep in vernacular usage lingers the American notion that rivers and railroads flow steadily, an understanding born in the early confluence of river, steamboat, and railroad thinking, especially in the valley of the Hudson. *Alongside* connotes parallel activity, especially smooth side-by-side motion through time: the word designates "keeping pace with" as well as adjacency. The Hudson always flows and the trains always sweep alongside, though sometimes pausing at Riverside and other stations where they become as stationary as a Hudson River steamer once paused alongside a wharf.

Railroads follow rivers because steel wheels atop steel rails lose traction on even gentle inclines. Grades much above four per cent limit ordinary railroad operation: indeed, grades half that require helper locomotives and delicate downhill braking, which substantially raise operating costs. Early in the nineteenth century, civil engineers, financiers, and the educated general public confronted rapid technological innovation interrupted by technological restraint. The Erie Canal and its competitors moved individual canal boats vertically in locks as well as horizontally in built channels, but nascent railroading demonstrated that trains change levels by ascending and descending grades, preferably extremely gentle ones. Raising and lowering entire trains on giant elevators seemed nonsensical at the start.

Again language records an old and fundamental concept. Rural people and seamen still call the handle of a pail a bail: bailing out a leaking boat means holding the bail upright, flipping the pail rim first into the water so it fills instantly, then yanking up the full pail and flipping it overboard upside down. Early nineteenth-century engineers emphasized what farmers and teamsters knew firsthand: upright or lying flat along the pail rim, the bail remains the same length. A road meandering around a hill might be the same length as one going up and over the crest, but the flat road tired horses far less than a sloped one. Civil engineers emphasized that the iron horse required even more gentle routing, preferably in valleys alongside rivers, albeit on its own bed.

Rivers flow in beds. Drought typically exposes part of the bed as water levels drop, although in estuaries it often changes levels only slightly. Constant erosion alternating with deposition produces a wide range of aggradation and dissection, including the oxbow formations Thomas Cole and other painters depicted. Rivers typically produce flat-topped gravel-and-rock terraces survey engineers find almost perfect for railroad rights-of-way, the legal route along which civil engineers design the well-drained, crushed rock bed which supports the rock ballast holding wood ties in place. Terraces, rights of way, and roadbeds lie alongside rivers but never at river edges: always they are slightly above all but rare flooding.

Hudson Valley trains debuted after the opening of the Erie Canal and the proving of the steamboat, just enough later that Albany had become the gateway to the west. The railroad companies, which eventually merged into the New York Central system, at first

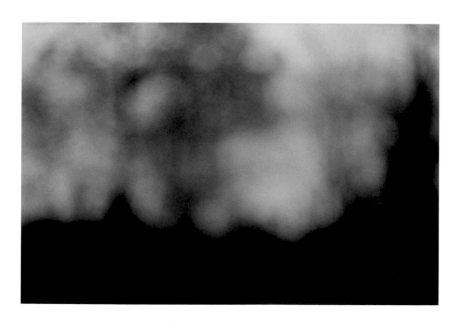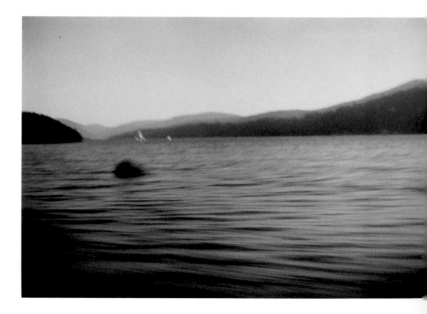

Left to right: Maxine Henryson, **Spring Again, EVERYDAY;
River, EVERYDAY; Cloud, EVERYDAY; Mountain, EVERYDAY**, 1999
Extacolor print, 20 x 24¼ inches each

followed the westward movement by running north from New York City, along the eastern shore of the Hudson, often atop terraces providing a near-level route to just beyond Albany. Topography facilitated the route, but macroeconomics dictated it: railroad-company profitability lay in the burgeoning prosperity wrought by the Erie Canal. The great thrust westward, especially the post-1830s movement, reached from New England and New York City, through Albany, to Buffalo, Cleveland, and other cities on a line reaching to Chicago. In circumventing most of the Appalachian chain, especially the Alleghenies, the line became famous in advertising extolling its water-level route, so smooth passengers slept all night undisturbed by the bouncing and jerking the New York Central System insisted afflicted competitor trains operating via Pittsburgh.

North of the great westward curve at Albany, an entire region drifted into relative somnolence, split from New England by Lake Champlain and no longer intimately connected to Hudson Valley traffic below the Albany railroad bridge. Only after trains had crossed the High Plains to several Pacific Coast points did railroad financiers acquire vast acreage north of Saratoga Springs and build a short line terminating at North Creek. The Adirondack Railroad reached its northern terminus in 1871, giving its backers direct transportation into their half-million acres of paradise. Decades after mainline trains swept from New York and Boston to Chicago via Albany, the rich opened a simple line into the heart of a great, almost pristine wilderness within easy railroad reach of great metropolitan areas. While never an especially prosperous railroad (or branch of a larger entity), the Adirondack carried first-class passenger cars and

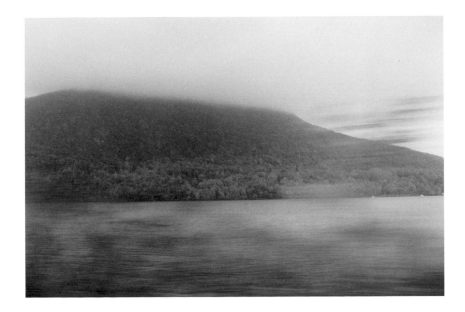

the private cars of the very rich over its single track paralleling the Hudson. Riverside (eventually renamed Riparius to end postal-delivery confusion) appears here in its first incarnation, in a view depicting not only a road suspension bridge and a logged-over hillside, but also a lonely station along a simply built railroad. The uneven crosstie edges announce a lightly traveled, inexpensively built railroad, one likely to dead end at a lumber camp or mine. But the scene betrays, unless the viewer considers the suspension bridge that brought such capital investment to such a wild, almost forlorn place, and remembers that while a 747 cannot land at a rural airport, any railroad station can accommodate first-class cars, even the private cars of the very wealthy.

Wilderness paradise lay to the north of the passengers aboard 1920s luxury trains like New York Central's *Twentieth Century Limited*, here depicted in a painting for a company calendar, racing south alongside the Hudson atop the meticulously kept, four-track water-level route that gave so many eastward-bound passengers their first view of the Hudson Valley. That view still shapes national and global understanding of the Hudson, the mainline railroad view south of Albany, sweeping away from the valley north of that city, where trains left the river terraces for the long run to Chicago, curving as a bail curves atop the rim of a pail. Ordinary haste, power, and wealth flowed along the four-track main, but extraordinary power and wealth flowed lazily over the single-track line alongside the Hudson to Riverside and finally to a creek also called the Hudson.

Left to right: Maxine Henryson, **Treetops, EVERYDAY**; **Castle, EVERYDAY**; **Winter, EVERYDAY**; **Still Light, EVERYDAY**, 1999 Extacolor print, 20 x 24¼ inches each

572 HARPER'S WEEKLY. AUGUST 20, 1881.

NEGRO LABORERS AT WORK UNDER THE "STORM KING," HUDSON RIVER.—Drawn by John Alexander.—[See Page 574.]

John Alexander, **Negro Laborers At Work Under the "Storm King," Hudson River**, 1881
Harper's Weekly, August 20, 1881, page 572, Newsprint, 16 x 10½ inches

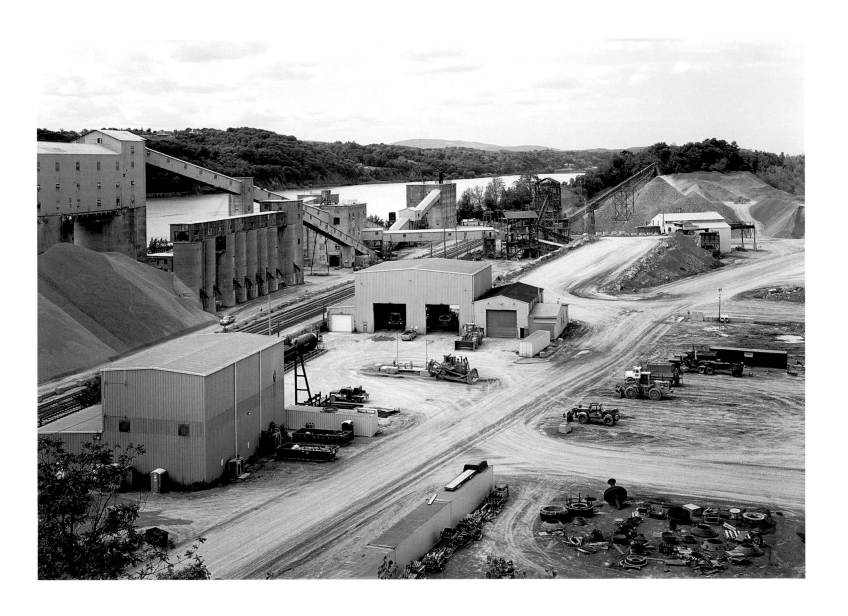

An-My Lê, **Trap Rock (Parts Depot)**, 2006
Archival pigment print, 26½ x 38 inches

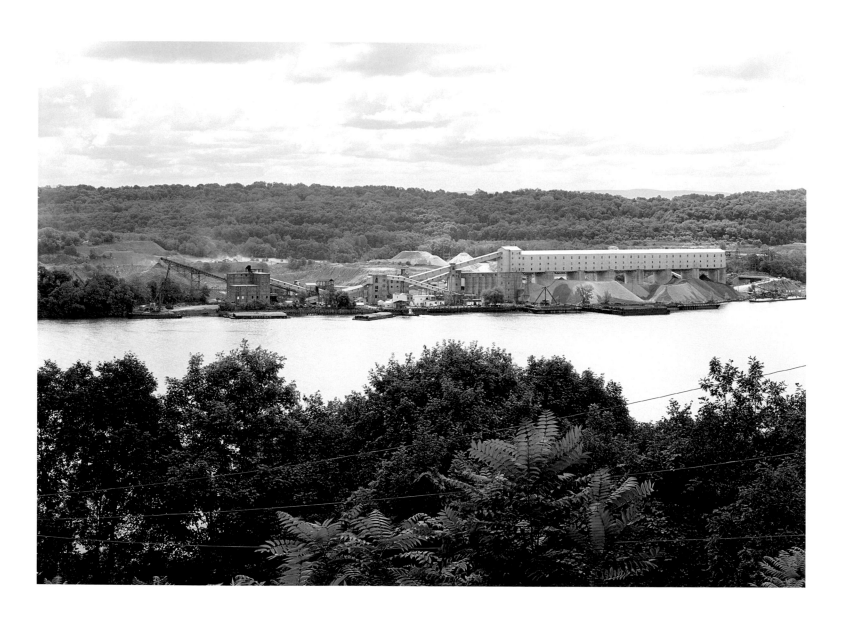

An-My Lê, **Trap Rock (Plant)**, 2006
Archival pigment print, 26½ x 38 inches

MEDITATION ON THE TRAIN ALONG THE HUDSON RIVER, AN ELEGY OF REMEMBRANCE

Carolyn Forché

From the station window, through the sunlit birches growing very near the tracks I saw that there was still snow, and thin ice around the trunks of firs. I was waiting for a late train, the tracks were silent, and another silence gleamed along them. The arms of the railway crossing were raised and the platform was empty. I went outside despite the cold to sit on the bench and read the Russian poet Joseph Brodsky's advice—to himself as much as to others— "If you cast over a poem a certain magic veil that removes adjectives and verbs, when you remove the veil the paper still should be dark with nouns."

Here are my nouns: ice, ash, rock, river, loss.

This is the first time I have taken this train since before my friend, Daniel, died. The last time I rode this train I was traveling to see him without knowing it was the last time. The train stopped during that trip somewhere along the river and was stalled so long that I was late for another event, and so had several hours with Daniel that I wouldn't otherwise have had.

I looked down at Joseph's language and when I looked up, we were shuffling beside the broken river in a wild snow. The ice had calved along the banks and resembled shards of broken windows covered with lye. Water for Joseph was *collected time*. A river of gray light.

The nouns are ice, ash, time, rock, river, loss.

As we pulled into a station along the way the world was like a toy snow-globe that had been shaken: warehouses no longer visible in the swirl, stone banks, highway underpass, John's pub, little black-windowed houses perched close to the tracks, rattle-boned and abandoned.

How alone I am in this, my friend. We are beside a frozen river, as snow is lifted from its surface so that it seems the river is issuing smoke, and this snow is an ash purer than human remains. I know this because I have seen and held human remains. And here is where the river breaks up, one slab of ice submerged, another swirling downstream. Nothing but ink will save the dead from oblivion.

The last white roses I brought to you were beautiful for days, you had said. When I closed the door I didn't know, you see, that it would be for the last time. But it was the first time you hadn't felt well enough to walk with me down to the street.

Further south, the river has loosened itself, and the ice remaining resembles quartz. We are at another station, stopping. Here there is a steeple rising out of the woods. A radiance of chiseled ice, blue tarps over summer boats. It will be spring soon.

We are miles from the dark tunnels beneath the city, but still along the water, now completely thawed and wind-shuffled, tufted with white caps and blue with cliffs on the other side. Wet, black, river-smoothed rock beside us and above a map of clouds.

A little further on, *collected time* passes between riverbanks of ruin, here where the trap rock was blasted and clawed from the banks, staircases of dolomite leading toward then away from the water, quarried to become roads, railroad ballast beneath us, headstones for the dead. Ghost silos rise now from

a stillness of snow, walled light and gray light, pumice and slate. We pass through as we would through a winter siege. Cry of ice, agony of cut stone, and scattered through the snow, our refuse. This is where the river has written of human life: in the emptiness of geologic time our flickering moment.

You stand in the wind of memory and wave for the last time.

Ice, soul and loss.

It is almost the tunnel.

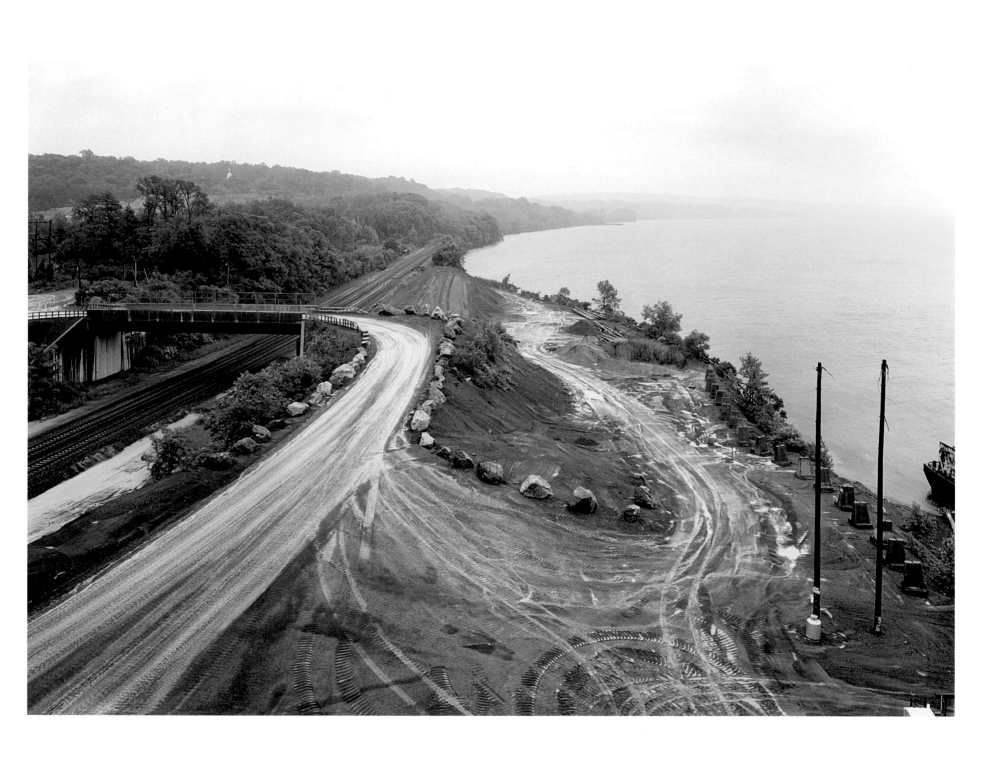

An-My Lê, **Trap Rock** (**Hudson River 1**), 2006
Archival pigment print, 26½ x 38 inches

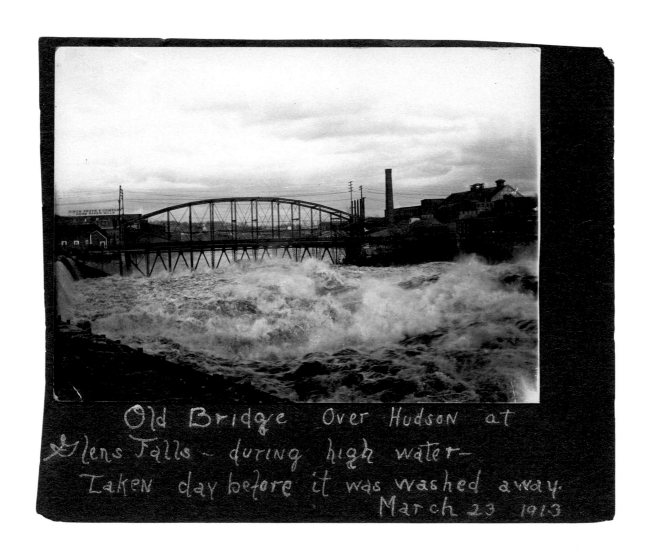

Old Bridge Over Hudson at
Glens Falls – during high water –
Taken day before it was washed away.
March 23 1913

Unknown Artist, **Old Bridge Over Hudson at Glens Falls during high water—
Taken day before it was washed away**, March 23, 1913
Black and white photograph mounted on paper, 4⅝ x 3⅞ inches

A BRIDGE IS UNNATURAL TO A RIVER

Fred LeBrun

The Hudson, most of the time, seems to tolerate the occasional bridge. And a dam or two to hold back the flow for some purpose of profit, and over centuries man's endless tinkering, building and redirection along the banks. Even in the twenty-first century, long after the ages of sail and steam have gone to sepia and our regional vitality is less tied to actual commerce on the river as it was a century or even two centuries ago, railroads, highways, and the brawny arms of urban industry still instinctively cling to the river like children attached to their mother's apron.

Appropriately so, since these towns and cities exist because of the river. It is their reason for being. The Hudson, whether the true river up from the Federal Dam in Troy to Mt. Marcy or the 150-mile estuary below the dam to New York City, has most of the time offered a predictable, tractable highway and a beckoning corridor, the same primary asset for the region that first attracted Dutch business interests four hundred years ago.

But every ten years, or fifty, or hundred, we see quite a different Hudson, the mirror opposite of nurturing, tolerant, and predictable. When adverse weather patterns align just so and the order of magnitude of flood waters pouring out of the steep decline of the eastern Adirondacks reaches a certain pitch, the Hudson becomes uncontrollable, a churning, destructive force unimaginable any other time. House-sized boulders are carried down stream, trees are scoured from the banks, dams are breached, bridges swept away, and all the fragile tinkerings of man on the banks in town after town for the better part of 300 miles are suddenly made very vulnerable. Lives and fortunes are lost.

The flood of late March 1913, remains the worst in recorded history for the Hudson, topping the previous record set in 1859 by more than a foot. New York saw it coming, even in those early days of weather forecasting. The storm tracked across Indiana and Ohio, killing more than twelve hundred and leaving those states underwater. Western New York and the Mohawk Valley followed suit. The city of Amsterdam lost a major bridge.

At ten p.m. on Thursday March 27, after days of continuous heavy rains, the 250-foot skeleton steel suspension bridge linking Glens Falls to South Glens Falls—the main thoroughfare—shuddered, then quickly slid into the foaming waters and disappeared. Three people had just stepped off the bridge at the southern end when it gave way. No life was lost.

Accounts in the newspapers of the day concluded what made the fatal difference was the pounding the bridge took from up to 300,000 logs that had escaped from various upstream booms that failed. A boom is a floated pen or corral created by logs linked end to end by chains and then anchored to pilings. The runaway logs pushed by the raging waters acted like pile drivers and battered the bridge down. More than forty thousand of those same escaped logs a few miles downstream crammed against comparable bridges at Fort Edward and Hudson Falls, and nearly brought those down as well. But luckily they held. Luckier still, is that the so-called Big Boom a few miles upstream from the bridge, holding an estimated million logs, did not fail, nor did the state dam just below it. Otherwise the destruction down river could have been far worse. Many more bridges would have failed. Oldtimers noted that the disaster, bad as it was, benefitted from an unusually early ice-out and melt of the snow pack up in the mountains. If the flood had occurred a few weeks earlier, the volume of water would have been much greater.

Regardless, descriptions of the damage extending from Glens Falls, roughly the northern terminus of the industrial Hudson, down to Albany, are horrific and surreal, even to the most vivid modern imagination. Parts of every town and city along the way lay under water, of course, but that was the least of it. Trolley lines and many criss-crossing railroad connections were dead. A century ago, the region's population was concentrated closer to the river than now and relied far more on public transportation, two factors that increased the misery over what we would experience today. With the turbines under water, electricity, provided by Adirondack Power out of Spier Falls, on the Hudson between Corinth and Glens Falls, went dark all the way down to Albany.

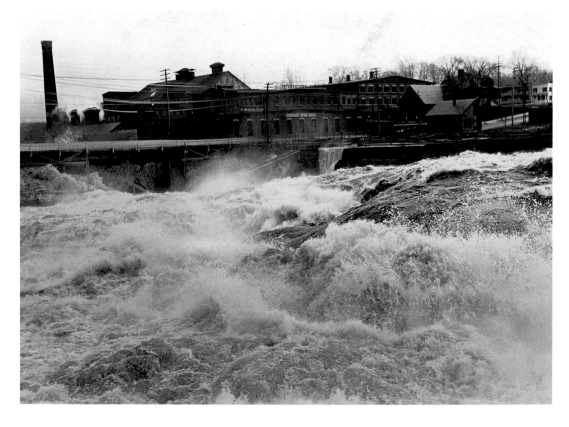

Unknown Artist, **1913 Flood**
Black and white photograph on postcard stock, 5⅞ x 3½ inches

In Troy, collar factories sent home 25,000 workers when the water rose at their feet. American Locomotive in Schenectady ordered out another three thousand for the same reason, in an age when no work meant no pay.

The raging waters and mayhem that followed stranded tens of thousands for days with no food, no heat, no electricity and bad water all around them. The threat of a typhoid epidemic from backed sewers was very real. The order went out to boil all water, although few could. To magnify the misery, the temperature dropped from nearly sixty degrees to below freezing in less than twenty-four hours. The annual spring flood they were used to, but nothing like this. It was weeks

Unknown Artist, **Linemen Working After Bridge Went Out in High Water**, 1913
Black and white photograph, 9¼ x 7½ inches

before homeowners and businesses along the river scooped out the mud, dried out their establishments and returned to some semblance of normal life.

Fortunately, only a few deaths and no epidemic resulted directly from this flood, Still, the property loss was staggering: two million dollars in damages in Troy, at least one million in Albany, and comparable pain all the way up to Glens Falls.

From the start European settlers on the banks of the river underestimated the Hudson's power to destroy. The first Dutch settlers after Henry Hudson's exploration built Fort Nassau, at the site of present-day Albany, on what they thought to be safe enough high ground. The next spring, a flexing Hudson put it well under water. The fort was abandoned. Then, from time to time, unpredictably for over three hundred years, the river would show its dark and ugly side and make matchsticks of the best endeavors of those who lived and worked along its banks. They put up with the occasional setbacks from these freshets, as they were termed, as the price of proximity to the other, nurturing Hudson. Eventually, keener minds realized regular destructive floods were not necessarily inevitable.

Even the ultimate flood of 1913, though, could not convince lawmakers to create a long-discussed reservoir on the Sacandaga River for flood control.

"It may be of interest to know that if the proposed dam at Conklingville on the Sacandaga River had been

built, that the worst features of the present flood would have been avoided as the reservoir back of the dam would have, under present conditions, taken care of the surplus water," W. A. Buttrick, general manager of Adirondack Power, told the Knickerbocker Press of Albany, the day after the Glens Falls bridge collapsed.

Yet not until nearly a decade later, after three back to back flash floods, did lawmakers finally act. The New York State Legislature created the groundwork for the Great Sacandaga Reservoir in 1922. Eight years later it became a reality, built for twelve million dollars with no state taxpayer money involved. Twenty-six beneficiaries and municipalities routinely assaulted by a flooding Hudson, from the Ford Motor Company at Green Island to paper companies as far north as Glens Falls, and including cities like Troy and Albany, pooled resources to build and maintain Sacandaga, an investment that has paid for itself many times over.

Just as Buttrick predicted, the river has been better behaved since 1930. Occasionally, we do get our feet a little wet after a spring freshet, but nothing compared to the flood of 1913 that brought the region to its knees.

Even so, the Sacandaga may not always save us. The long view and common sense suggest the river might still come up with a five-hundred- or thousand-year flood to dwarf all others in destructive power, on a scale that would make even Noah blink. Why should we assume the worst the Hudson can do is behind us?

Not that there is a thing we can do about it. This stoic resignation we share with our predecessors, who nearly a century ago stood near the failing, thirteen-year-old steel bridge in Glens Falls as the impossible metamorphosed into the inevitable, and the groaning structure melted into the frothy water. No matter what the century, the river is always the river, and we merely the watchers, small and helpless.

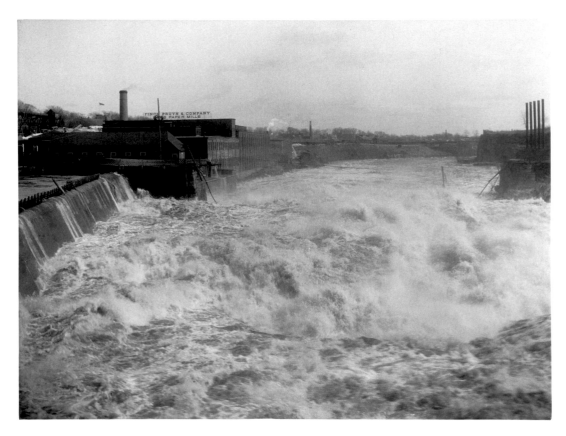

Unknown Artist, **River and the Finch, Pruyn & Co. paper mill**, n.d.
Mounted black and white photographic print, 9½ x 7¼ inches

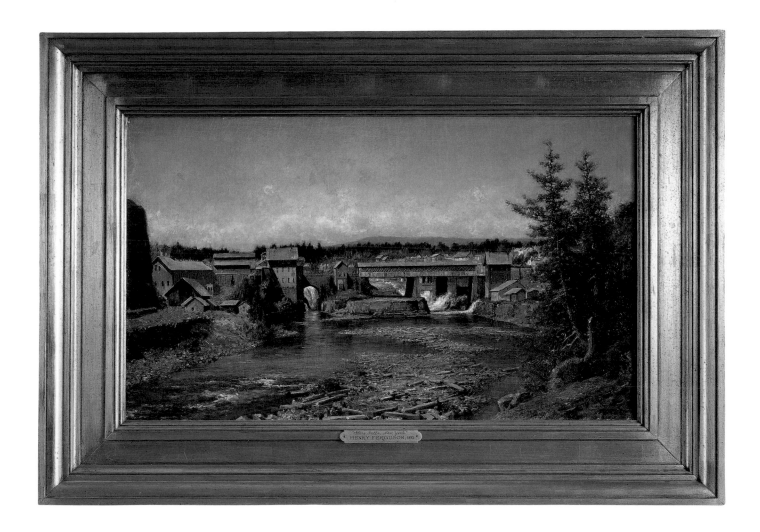

Henry Augustus Ferguson, **Glens Falls, New York**, 1882
Oil on canvas, 15 x 26 inches

Peter Hutton, **Stills from *Time and Tide***, 1998–2000
16mm film, 35 minutes

Peter Hutton, **Stills from** *Two Rivers*, 2001–2002
16mm film, 45 minutes

Following page:
Charles Herbert Moore, **Morning Over New York**, c.1859
Oil on canvas, 11⅞ x 30 inches

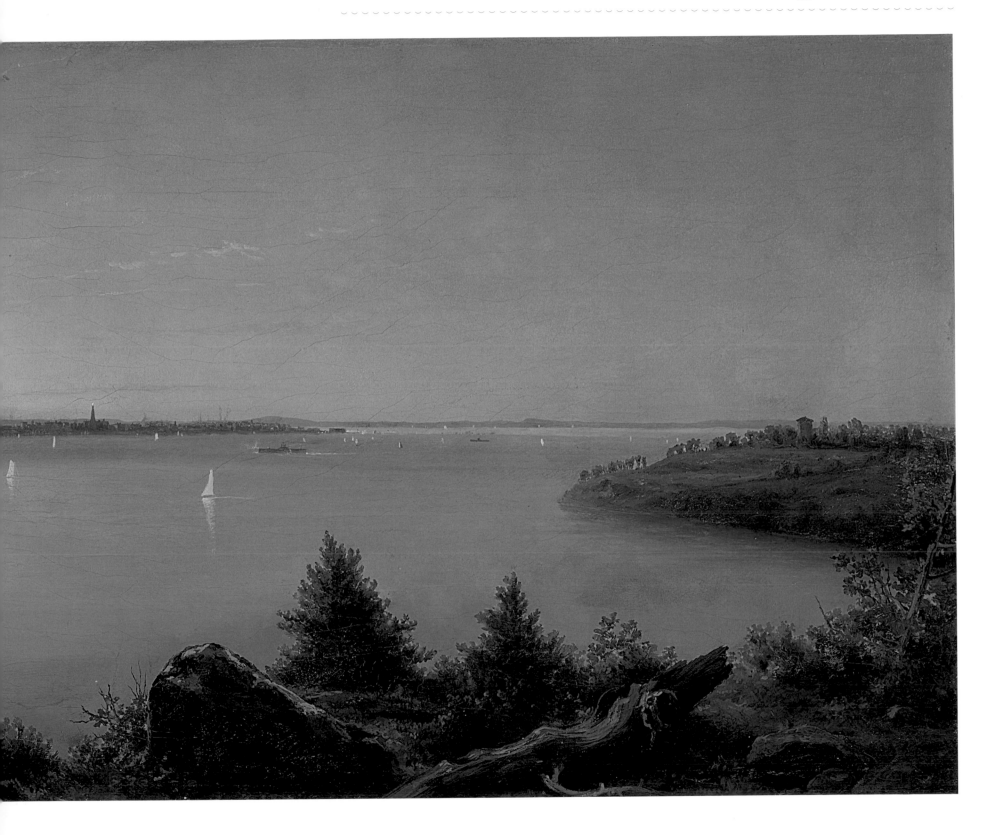

CONTRIBUTORS

Ian Berry is Associate Director and the Susan Rabinowitz Malloy '45 Curator of the Frances Young Tang Teaching Museum and Art Gallery at Skidmore College. A specialist in contemporary art, Berry has organized over fifty museum exhibitions. Recent publications include *Kara Walker: Narratives of a Negress*; *America Starts Here: Kate Ericson and Mel Ziegler*; *Fred Tomaselli*; and *Tim Rollins and K.O.S.: A History*.

Peg Boyers teaches creative writing at Skidmore College and is executive editor of the literary journal *Salmagundi*. She is author of two volumes of poems, *Hard Bread* and *Honey With Tobacco*, both published by the University of Chicago Press.

Kristen Boyle is Curatorial Assistant for Special Projects at the Tang Museum and a 2003 graduate of Skidmore College. Before returning to Skidmore in 2006, Boyle worked as curatorial assistant at the Albright-Knox Art Gallery in Buffalo, New York.

Akiko Busch is the author of *Geography of Home: Writings on Where We Live* and *The Uncommon Life of Common Objects: Essays on Design and the Everyday*. Her most recent book, *Nine Ways to Cross a River*, is a collection of essays about swimming across American rivers. A former contributing editor at *Metropolis* magazine, she teaches at New York's School of the Visual Arts.

Kathryn Davis is Senior Fiction Writer in the Writing Program in Arts & Sciences at Washington University in St. Louis. Her books include *The Walking Tour*, *Versailles*, and *The Thin Place*.

Terence Diggory is Professor of English at Skidmore College. His many publications on art and literature include *William Carlos Williams and the Ethics of Painting* and, most recently, *The Scene of My Selves: New Work on New York School Poets*, co-edited with Stephen Paul Miller.

Carolyn Forché is the author of four books of poetry: *Blue Hour*; *The Angel of History*; *The Country Between Us*; and *Gathering the Tribes*; and editor of *Against Forgetting: Twentieth-Century Poetry of Witness*. She is Professor of English at Georgetown University, where she holds the Lannan Foundation Endowed Chair.

Judy Halstead, Professor of Chemistry at Skidmore College, is author or co-author of numerous scientific articles. She is currently working on the development and refinement of analytical techniques for the determination of trace levels of pollutants in natural waters.

Mimi Hellman is Associate Professor of Art History at Skidmore College. She writes essays and articles about visual and material culture between the seventeenth and nineteenth centuries, including interior design and furniture and the cultural history of coffee, tea, and chocolate.

Lawrence Hott is an Emmy-award winning documentary film producer. His films for PBS include *Imagining Robert: My Brother, Madness, and Survival*; *The Harriman Alaska Expedition Retraced*; *Through Deaf Eyes*; and *Niagara Falls*, which was broadcast nationally in 2006.

Bob Jones is Chair of the Department of Economics at Skidmore College. He also serves on the advisory committee for the college's Geographical Information Systems (GIS) Center for Interdisciplinary Research. Jones uses maps as a way to describe conditions such as unemployment and population, and how location and ethnicity affect earnings.

Karen Kellogg is Associate Professor and Director of the Environmental Studies Program at Skidmore College. She is a specialist on water systems, and her recent publications include articles in the *African Journal of Ecology* and *Marine Biology*. Kellogg is also Director of the Water Resources Initiative at Skidmore.

Ginny Kollak was Curatorial Assistant at the Tang Museum from 2004 to 2008. She organized the exhibitions *Somnambulist/Fabulist*; *Stripes*; and *Things Remain* (co-organized with Kristen Boyle) at the Tang and *The Office for Parafictional Research Presents Headless: Work by Goldin+Senneby* at the Center for Curatorial Studies, Bard College.

Fred LeBrun has been a regular columnist for over forty years at the Albany *Times Union*. He has written numerous articles on the Hudson River and its environment including "Hudson River Chronicles," which recounts an eighteen-day trip downriver from Mount Marcy to New York Harbor in 1998.

Tom Lewis is Professor of English at Skidmore College and author of *The Hudson: A History*. His other books include *Divided Highways: The Interstate Highway System and the Transformation of American Life* and *Empire of the Air: The Men Who Made Radio*, both of which became award-winning documentaries.

Phillip Lopate is the author of *Waterfront*; *Portrait of My Body*; *Confessions of Summer*; *Against Joie de Vivre*; *Being with Children*; *Totally, Tenderly, Tragically*; and *Getting Personal: Selected Writings*. He is also the editor of *The Art of the Personal Essay*. Lopate holds the John Cranford Adams Chair at Hofstra University and also teaches in the MFA graduate programs at Columbia, the New School, and Bennington College.

Rick Moody is a novelist and short story writer. His books include *Purple America*, *Garden State*, *The Diviners*, and *The Ice Storm*, which was made into a feature film. He is the author of three acclaimed volumes of short fiction, *Demonology*, *The Ring of Brightest Angels Around Heaven*, and *Right Livelihoods*. Moody's memoir *The Black Veil* won the PEN/Martha Albrand Award for the Art of the Memoir.

Greg Pfitzer is the Douglas Family Chair in American Culture, History, and Literary and Interdisciplinary Studies at Skidmore College. His books include *Samuel Eliot Morison's Historical World*; *Picturing the Past: Illustrated Histories and the Role of Visual Literacy in the American Imagination, 1840–1900*; and *Popular History and the Literary Marketplace, 1840–1920*.

Rik Scarce is Associate Professor of Sociology at Skidmore College. His recent publications include *Eco-Warriors: Understanding the Radical Environmental Movement* and *Fishy Business: Salmon, Biology, and the Social Construction of Nature*. His sociology research includes the intersection of environment and politics.

Tom Sleigh is the author of seven books of poetry, including *Far Side of the Earth*, named an Honor Book by the Massachusetts Society for the Book, and *Space Walk*, winner of the Kingsley Tufts Award. Sleigh is Program Director and Senior Poet in the MFA Program in Creative Writing at Hunter College.

John R. Stilgoe is Orchard Professor in the History of Landscape at Harvard University. He is an award-winning teacher and author of more than a dozen books, including *Train Time: Railroads and the Imminent Reshaping of the United States Landscape*; *Landscape and Images*; and *Outside Lies Magic: Discovering History and Inspiration in Ordinary Places*.

Paul Hayes Tucker teaches art history at the University of Massachusetts. He has served on the faculties of New York University's Institute of Fine Arts, Williams College, and the University of California, Santa Barbara. In addition to his many books, including *The Impressionists at Argenteuil*; *Monet in the Twentieth Century*; *Manet's Le Déjeuner sur l'herbe*; and *Monet in the Nineties: The Series Paintings*, Tucker has served as guest curator for several important museum exhibitions.

John Stoney, **A View from West Point**, 2009
Colored pencil on rag paper, 41 x 30 inches

Bob Braine and Leslie C. Reed
Murderers Creek Resist Curtains, 2009 (detail)
Toxicodendron radicans (Poison Ivy)
Indigo dye on muslin, 150 x 72 inches overall

WORKS IN THE EXHIBITION

PAINTING AND SCULPTURE

JAMES BARD
Syracuse, 1857
Oil on canvas, 29½ x 51½ inches
Albany Institute of History and Art, New York
Gift of William Gorham Rice

ALBERT BIERSTADT
On the Hudson River Near Irvington, n.d.
Oil on board, 7¼ x 12¼ inches
The Berkshire Museum, Pittsfield,
Massachusetts

BOB BRAINE & LESLIE C. REED
Alliaria petiolata (Garlic-mustard), 2009
Watercolor on paper, butternut frame
16⅝ x 13⅛ inches
Courtesy of the artists

**Brick Row Planter, Mayone
Woodland**, 2009
Salvaged Atlas & Mayone Bros.' Bricks,
woodland plants, mortar, soil
20 x 70 x 28 inches (planter)
44 x 70 x 28 inches (with plants)
Courtesy of the artists

**Clemantis virginiana (Virgen's
bower)**, 2009
Watercolor on paper, butternut frame
16⅝ x 13⅛ inches
Courtesy of the artists

**Dryopteris intermedia (Evergreen
woodfern)**, 2009
Watercolor on paper, butternut frame
16⅝ x 13⅛ inches
Courtesy of the artists

Hemerocallis fulva (Orange daylily), 2009
Watercolor on paper, butternut frame
16⅝ x 13⅛ inches
Courtesy of the artists

**Hudson River Fish Mount, Alosa
sapidissima (American Shad)**, 2009
Epoxy, autobody paint GM925A Crocus
Cream, butternut, 10 x 24 x 4½ inches
Courtesy of the artists

**Hudson River Fish Mount,
Cyprinus carpio (Carp)**, 2009
Toilet paper, butternut, 14 x 33½ x 6 inches
Courtesy of the artists

**Hudson River Fish Mount, Ictalurus
punctatus (Catfish)**, 2009
Road salt, plaster, butternut
12¾ x 28¼ x 3¼ inches
Courtesy of the artists

**Hudson River Fish Mount, Morone
saxatilis (Striped Bass)**, 2009
Hudson River sediment, polymer, butternut
15¼ x 37¼ x 6 inches
Courtesy of the artists

Lindera benzoin (Spicebush), 2009
Watercolor on paper, butternut frame
16⅝ x 13⅛ inches
Courtesy of the artists

**Maianthemum stellatum (Star
flower)**, 2009
Watercolor on paper, butternut frame
16⅝ x 13⅛ inches
Courtesy of the artists

**Murderers Creek Resist Curtains,
Toxicodendron radicans
(Poison Ivy)**, 2009
Indigo dye on muslin, 150 x 72 inches each
installation dimensions variable
Courtesy the artists

Osmorhiza longistylis (Anise root), 2009
Watercolor on paper, butternut frame
16⅝ x 13⅛ inches
Courtesy of the artists

Rosa multiflora (Multiflora rose), 2009
Watercolor on paper, butternut frame
16⅝ x 13⅛ inches
Courtesy of the artists

**Symphyotrichum lateriflorus
(Calico aster)**, 2009
Watercolor on paper, butternut frame
16⅝ x 13⅛ inches
Courtesy of the artists

**Tectonic Plate Entrance Mat #1,
Brick Row the Hudson River
and Murderers Creek, Non-georectified
cartographic view**, 2009
Digital image printed on nylon and rubber
67½ x 145 inches
Courtesy of the artists

**Tectonic Plate Entrance Mat #2
Sleepy Hollow Res Oblique View
looking South East**, 2009
Digital image printed on nylon and rubber
67½ x 145 inches
Courtesy of the artists

~ ~ ~

BRADLEY CASTELLANOS
American Paradise, 2009
Oil, acrylic, photo collage, and resin
66 x 73 inches
Collection of Mark and Sarah
Buller, New York

~ ~ ~

THOMAS COLE
Storm King of the Hudson, c. 1825–1827
Oil on Canvas, 23 x 31¼ inches
Ball State University Museum of Art at Ball
State University, Muncie, Indiana
Frank C. Ball Collection, Gift of the Ball
Brothers Foundation

~ ~ ~

VICTOR DEGRAILLY
**Monument to Kosciuszko at
West Point**, 1844
Oil on canvas, 28 x 33½ inches
Fruitlands Museum, Harvard, Massachusetts

**Washington's Headquarters, Newburgh-
on-Hudson**, n.d.
Oil on canvas, 20 x 23 inches
Fruitlands Museum, Harvard, Massachusetts

West Point, n.d.
Oil on canvas, 27 x 34 inches
Fruitlands Museum, Harvard, Massachusetts

~ ~ ~

THOMAS DOUGHTY
View on the Hudson in Autumn, 1850
Oil on canvas, 34⅜ x 48½ inches
Corcoran Gallery of Art, Washington, D.C.
Gift of William Wilson Corcoran

**View of the Hudson River Valley
Near Tivoli**, 1841
Oil on canvas, 19⅝ x 29¼ inches
Herbert F. Johnson Museum of Art, Cornell
University, Ithaca, New York
Acquired through the Membership
Purchase Fund

~ ~ ~

J.M. EVANS
Poughkeepsie, New York, c. 1870
Oil on canvas, 28 x 42½ inches
Fenimore Art Museum, Cooperstown,
New York
Gift of Stephen C. Clark

~ ~ ~

SANFORD ROBINSON GIFFORD
A Sunset, Bay of New York, 1878
Oil on canvas, 20¾ x 40¾ inches
Everson Museum of Art, Syracuse, New York
Museum Purchase 72.26

~ ~ ~

JAMES MCDOUGAL HART
**View from Hazelwood, Albany
in the Distance**, 1850
Oil on canvas, 22½ x 26¼ inches
Lyman Allyn Art Museum, New London,
Connecticut

~ ~ ~

YVONNE JACQUETTE
Hudson Crossings, 2008
Oil on canvas, 65¼ x 53½ inches
Courtesy of the artist and
DC Moore Gallery, New York

~ ~ ~

KYSA JOHNSON
**blow up 95—the molecular structure
of environmental pollutants
ethane, methane, propane, hexane,
bonzero and aerolein after Cole's
American Lake Scene**, 2008
Chalk, Chinese white, and blackboard
paint on panel, 48 x 36 inches
Courtesy of the artist and Morgan
Lehman, New York

~ ~ ~

WILLIAM JOY
Forcing The Hudson River Passage, n.d.
Oil on canvas, 28½ x 46¼ inches
The New-York Historical Society, New York
Gift of the Travelers Insurance Company

~ ~ ~

JASON MIDDLEBROOK
**Pine Bench with 50 Miles of the
Hudson River #1**, 2009
Pine and steel, 19 x 22 x 127 inches
Courtesy of the artist and Sara Meltzer
Gallery, New York

**Pine Bench with 50 Miles of the
Hudson River #2**, 2009
Pine and steel, 20 x 18 x 99 inches
Courtesy of the artist and Sara Meltzer
Gallery, New York

**Pine Bench with 50 Miles of the
Hudson River #3**, 2009
Pine and steel, 18½ x 19 x 72 inches
Courtesy of the artist and Sara Meltzer
Gallery, New York

**Pine Bench with 50 Miles of the
Hudson River #4**, 2009
Pine and steel, 19 x 21 x 93 inches
Courtesy of the artist and Sara Meltzer
Gallery, New York

**Pine Bench with 50 Miles of the
Hudson River #5**, 2009
Pine and steel, 19 x 21 x 93 inches
Courtesy of the artist and Sara Meltzer
Gallery, New York

~ ~ ~

BRUCE MITCHELL
Hudson River Nocturne, 1937
Gouache on cardboard, 19¹¹⁄₁₆ x 30 inches
Munson-Williams-Proctor Arts Institute,
Utica, New York
Edward W. Root Bequest

~ ~ ~

CHARLES HERBERT MOORE
Morning Over New York, c. 1859
Oil on canvas, 11⅞ x 30 inches
The Frances Lehman Loeb Art Center,
Vassar College, Poughkeepsie, New York
Gift of Matthew Vassar

The Upper Palisades, 1860
Oil on canvas, 12 x 20⅛ inches
The Frances Lehman Loeb Art Center,
Vassar College, Poughkeepsie, New York
Gift of Matthew Vassar

~ ~ ~

PAVEL PETROVICH SVININ
**Shad Fisherman on the Shore of
the Hudson River**, c. 1811–1813
Watercolor on off-white wove paper
10 x 15½ inches
The Metropolitan Museum of Art,
Rogers Fund, 1942

~ ~ ~

UNKNOWN
Outing on the Hudson, c. 1875
Oil on cardboard, 19 x 24 inches
Abby Aldrich Rockefeller Folk Art Museum
The Colonial Williamsburg Foundation,
Williamsburg, Virginia

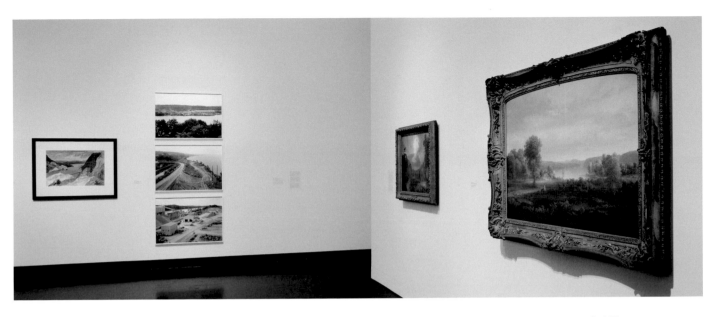

UNKNOWN
Sunnyside from the Hudson, c. 1860
Oil on canvas, 24¹⁄₁₆ x 34¹⁄₁₆ inches
Historic Hudson Valley, Tarrytown, New York

UNKNOWN (AFTER WILLIAM H. BARTLETT)
View Near Anthony's Nose (Hudson Highlands), c. 1850
Oil on canvas, 21⅞ x 27⅛ inches
Munson-Williams-Proctor Arts Institute,
Utica, New York
Owen D. Young Collection, Gift
of Mrs. Josephine Young Case and
Mr. Richard Young

DRAWINGS AND PHOTOGRAPHS

MAXINE HENRYSON
Treetops, EVERYDAY, 1999
Extacolor print, 20 x 24¼ inches
Courtesy of the artist

Spring Again, EVERYDAY, 1999
Extacolor print, 20 x 24¼ inches
Courtesy of the artist

Still Light, EVERYDAY, 1999
Extacolor print, 20 x 24¼ inches
Courtesy of the artist

Side Waters, EVERYDAY, 1999
Extacolor print, 20 x 24¼ inches
Courtesy of the artist

Castle, EVERYDAY, 1999
Extacolor print, 20 x 24¼ inches
Courtesy of the artist

Winter, EVERYDAY, 1999
Extacolor print, 20 x 24¼ inches
Courtesy of the artist

Mountain, EVERYDAY, 1999
Extacolor print, 20 x 24¼ inches
Courtesy of the artist

Cloud, EVERYDAY, 1999
Extacolor print, 20 x 24¼ inches
Courtesy of the artist

AN-MY LÊ
Trap Rock (Hudson River 1), 2006
Archival pigment print, 25¾ x 37¼ inches
Courtesy of the artist and Murray Guy
Gallery, New York

Trap Rock (Parts Depot), 2006
Archival pigment print, 25¾ x 37¼ inches
Courtesy of the artist and Murray Guy
Gallery, New York

Trap Rock (Plant), 2006
Archival pigment print, 25¾ x 37¼ inches
Courtesy of the artist and Murray Guy
Gallery, New York

MICHAEL LIGHT
Bellman's Creek Marsh Looking North, I-95 and Overpook Creek at Left, Ridgefield, NJ, 2007
Pigment print on aluminum
38⅜ x 48⅜ inches
Courtesy of the artist and Hosfelt Gallery,
San Francisco

Elizabeth Marine Terminal Looking North, $149 Billion in 2006 Cargo, Newark Airport at Left, NJ, 2007
Pigment print on aluminum
38⅜ x 48⅜ inches
Courtesy the artist and Hosfelt Gallery,
San Francisco

JOHN MARIN
Hudson River near Alpine, 1910
Watercolor on wove paper
12⁵⁄₁₆ x 18⅜ inches
National Gallery of Art, Washington, D.C.
Gift of John Marin, Jr. 1986

Hudson River, Region of Peekskill, 1910
Watercolor on wove paper, 13¹³⁄₁₆ x 15 inches
National Gallery of Art, Washington, D.C.
Gift of John Marin, Jr.

Hudson River at Peekskill, 1912
Watercolor on wove paper
15⁹⁄₁₆ x 18⁹⁄₁₆ inches
National Gallery of Art, Washington, D.C.
Gift of John Marin, Jr.

Hudson River Schooner or 4 Master and Tug, 1900
Black ink on wove paper, 11 x 10 inches
National Gallery of Art, Washington, D.C.
Gift of Norma B. Marin, 2005

Loading Dock, River View, c. 1900
Graphite on wove paper, 8½ x 10¾ inches
National Gallery of Art, Washington, D.C.
Gift of Norma B. Marin, 2005

Mill Ruins Along the Hudson, c. 1900
Graphite on wove paper, 7 x 10¼ inches
National Gallery of Art, Washington, D.C.
Gift of Norma B. Marin, 2005

River Valley, c. 1900
Graphite on wove paper, 10¾ x 8½ inches
National Gallery of Art, Washington, D.C.
Gift of Norma B. Marin, 2005

Installation View, *Lives of the Hudson*
Tang Museum, Skidmore College, Saratoga Springs,
New York

Schooner at Dock, c. 1900
Black pen and ink on wove paper,
8½ x 10¾ inches
National Gallery of Art, Washington, D.C.
Gift of Norma B. Marin, 2005

**Weehawken Grain Elevators
and Tugs**, c. 1900
Graphite on wove paper, 8½ x 10¾ inches
National Gallery of Art, Washington, D.C.
Gift of Norma B. Marin, 2005

JASON MIDDLEBROOK
Log Jam on the Hudson, 2009
Graphite on paper, 55½ x 88 inches
Courtesy of the artist and
Sara Meltzer Gallery, New York

ARCHIBALD ROBERTSON
**View of the Hudson at West Point
with a Block House**, 1802–1813
Watercolor, black ink, and graphite on paper,
13⅛ x 16¼ inches
The New-York Historical Society, New York
Permanent loan from the Beekman
Family Association

SENECA RAY STODDARD
**Down The River from Bridge,
Glens Falls**, n.d.
Photographic stereograph, 4 x 7 inches
The Chapman Historical Museum,
Glens Falls, New York

A Jam, Luzerne Falls, c. 1880
Mounted albumen print, 4¼ x 7½ inches
The Chapman Historical Museum,
Glens Falls, New York

Glens Falls, Under the Arch, n.d.
Albumen print, 4¼ x 7⅜ inches
The Chapman Historical Museum,
Glens Falls, New York

Lake Tear of the Clouds, n.d.
Albumen print, 6½ x 8⅛ inches
The Chapman Historical Museum,
Glens Falls, New York

**Logs Washed over the Dam West
of the Bridge**, n.d.
Photographic stereograph, 3¼ x 6½ inches
The Chapman Historical Museum,
Glens Falls, New York

Riverside, Adirondack Railroad, c. 1880
Albumen print, 4¼ x 7⅜ inches
The Chapman Historical Museum,
Glens Falls, New York

Untitled, n.d.
Albumen print, 4¼ x 7¼ inches
The Chapman Historical Museum,
Glens Falls, New York

Untitled, n.d.
Albumen print (stereograph), 3⅝ x 3 inches
The Chapman Historical Museum,
Glens Falls, New York

UNKNOWN
1913 Flood, 1913
Black and White photograph
on postcard stock, 5⅜ x 3½ inches
The Chapman Historical Museum,
Glens Falls, New York

UNKNOWN
**Hudson River Railroad Bridge,
Poughkeepsie, New York**, 1876
Black ink on card, 14⅛ x 19¼ inches
The New-York Historical Society, New York
Gift of Samuel T. Shaw Collection

UNKNOWN
**Linemen Working After Bridge Went
Out in High Water**, 1913
Black and white photograph, 9¼ x 7½ inches
The Chapman Historical Museum,
Glens Falls, New York

UNKNOWN
**Old Bridge Over Hudson at Glens Falls
during high water—Taken day before it
was washed away**, March 23, 1913
Black and white photograph mounted on
paper, 4⅝ x 3⅜ inches
The Chapman Historical Museum,
Glens Falls, New York

PRINTS AND EPHEMERA

JOHN ALEXANDER
**Negro Laborers At Work Under
the "Storm King," Hudson River**
Harper's Weekly, August 20, 1881
Newsprint, 16 x 10½ inches
Lyrical Ballad Bookstore,
Saratoga Springs, New York

ATTRIBUTED TO WILLIAM H. BARTLETT
**Entrance to the Highlands Near
Anthony's Nose, Hudson River**, c. 1839
Graphite and watercolor on paper
7⅛ x 11¹⁵⁄₁₆ inches
Munson-Williams-Proctor Arts Institute,
Utica, New York
Owen D. Young Collection, Gift
of Mrs. Josephine Young Case and
Mr. Richard Young

WILLIAM H. BARTLETT
Bridge at Glens Fall. (On the Hudson), n.d.

**Crow-Nest, from Bull Hill.
(Hudson River)**, n.d.

**Hudson Highlands. (View from
Bull Hill)**, n.d.

**Light House near Caldwell's Landing.
(Hudson River)**, n.d.

Peekskill Landing. (Hudson River), n.d.

The Palisades—Hudson River, n.d.

**Undercliff Near Cold-Spring. (The Seat
of General George P. Morris)**, n.d.

**View from Fort Putnam.
(Hudson River)**, n.d.

View from Hyde Park. (Hudson River), n.d.

View from Mount Ida. (Near Troy), n.d.

**View from Ruggle's House Newburgh.
(Hudson River)**, n.d.

**View from West Point.
(Hudson River)**, n.d.

All Bartlett engravings:
Hand-colored engraving, 4⅝ x 6⅞ inches
The Frances Young Tang Teaching Museum
and Art Gallery at Skidmore College,
Saratoga Springs, New York

HOWARD BRESLIN
Shad Run, 1955
Book, 8½ x 6 x 1 inches
The Frances Young Tang Teaching Museum
and Art Gallery at Skidmore College,
Saratoga Springs, New York

WALLACE BRUCE
Panorama of The Hudson— From New York to Albany, 1906
Book, 6¼ x 11 x ¼ inches
The Frances Young Tang Teaching Museum and Art Gallery at Skidmore College, Saratoga Springs, New York

~ ~ ~

HOWARD N. COOK
New Hudson Bridge, 1931
Lithograph on paper, 17⅝ x 13¹¹⁄₁₆ inches
Munson-Williams-Proctor Arts Institute, Utica, New York
Gift of Edward W. Root

· · · · · ·

J.O. DAVIDSON
Barge Party on the Hudson by Moonlight, October 5, 1889
Harper's Weekly, Page 800
Newsprint, 12¾ x 9¾ inches
Lyrical Ballad Bookstore, Saratoga Springs, New York

Ice Yachting on the Hudson, February 1, 1879
Harper's Weekly, Page 89
Newsprint, 14½ x 10 inches
Lyrical Ballad Bookstore, Saratoga Springs, New York

~ ~ ~

ASHER B. DURAND
New-York Historical Society Membership Certificate, Gerard Stuyvesant, July 18, 1850
Ink on paper, 15 x 12¾ inches
The New-York Historical Society, New York

~ ~ ~

STANLEY FOX
The Life of a Convict at Sing Sing Prison, New York, June 22, 1867
Harper's Weekly, Pages 392–393
Newsprint, 16 x 22 inches
Lyrical Ballad Bookstore, Saratoga Springs, New York

~ ~ ~

WILLIAM F. LINK
Hudson By Daylight Map: From New York Bay to the Head of Tide Water, c. 1878
Foldout Map, 108 x 5½ inches
Lyrical Ballad Bookstore, Saratoga Springs, New York

The Hudson By Daylight, 1878
Book, 6¼ x 5 x ¼ inches
Lyrical Ballad Bookstore, Saratoga Springs, New York

~ ~ ~

REGINALD MARSH
Swimming in the Hudson, n.d.
Etching on paper, 10¹⁄₁₆ x 13¼ inches
Munson-Williams-Proctor Arts Institute, Utica, New York
Museum Purchase

~ ~ ~

THOMAS MORAN (R. HINSHELWOOD)
The Half Moon at The Highlands, n.d.
Newsprint, 6¾ x 10 inches
Private Collection

~ ~ ~

THOMAS NAST
Sketches Among the Catskill Mountains
Harper's Weekly, July 21, 1866
Newsprint, 16 x 21½ inches
Private Collection

~ ~ ~

JULIAN RIX
Destruction of Forests of the Adirondacks, December 6, 1884
Harper's Weekly, Pages 802–803
Newsprint, 16 x 22 inches
Lyrical Ballad Bookstore, Saratoga Springs, New York

~ ~ ~

UNKNOWN
Albany, N.Y. Steamboat Landing, n.d.
Postcard, 3½ x 5½ inches
Lyrical Ballad Bookstore, Saratoga Springs, New York

~ ~ ~

UNKNOWN
Along The Banks of The Hudson, n.d.
Postcard, 3½ x 5½ inches
Lyrical Ballad Bookstore, Saratoga Springs, New York

~ ~ ~

UNKNOWN
Day Boat Steamer, Leaving Dock at Albany, NY, n.d.
Postcard, 3½ x 5½ inches
Lyrical Ballad Bookstore, Saratoga Springs, New York

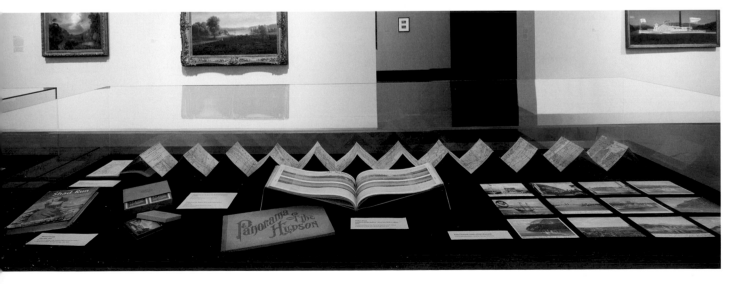

Installation View, *Lives of the Hudson*
Tang Museum, Skidmore College, Saratoga Springs, New York

UNKNOWN
Day Line Steamer on The Hudson, n.d.
Postcard, 3½ x 5½ inches
Lyrical Ballad Bookstore, Saratoga
Springs, New York

UNKNOWN
**Grant's Tomb and Hudson River
by Moonlight**, 1938
Postcard, 3½ x 5½ inches
The Frances Young Tang Teaching Museum
and Art Gallery at Skidmore College,
Saratoga Springs, New York

UNKNOWN
**Highlands of the Hudson,
New York Central System**, c. 1920
Playing cards, 4 x 2½ inches
Albany Institute of History and Art, New York
Gift of Jean R. Morris

UNKNOWN
**Hudson River Steamer "C.W. Morse
at Night" New York**, 1917
Postcard, 3½ x 5½ inches
The Frances Young Tang Teaching Museum
and Art Gallery at Skidmore College,
Saratoga Springs, New York

UNKNOWN
**In September 1609, Henry Hudson,
Sailing in the "Half Moon,"
discovered the Hudson River**, n.d.
Postcard, 3½ x 5½ inches
Lyrical Ballad Bookstore, Saratoga
Springs, New York

UNKNOWN
**Landing of "The Albany,"
Kingston Point, New York**, 1882
Postcard, 3½ x 5½ inches
Lyrical Ballad Bookstore,
Saratoga Springs, New York

UNKNOWN
**New York—Ice-Yachting At Roosevelt's
Point, on the Hudson—The
Champion Sloop "Northern Light,"** n.d.
Print, 9½ x 7 inches
Lyrical Ballad Bookstore,
Saratoga Springs, New York

UNKNOWN
Panorama Albany, N.Y., n.d.
Postcard, 3½ x 5½ inches
Lyrical Ballad Bookstore,
Saratoga Springs, New York

UNKNOWN
**The Palisades of the Hudson River,
New York**, n.d.
Postcard, 3½ x 5½ inches
Lyrical Ballad Bookstore,
Saratoga Springs, New York

UNKNOWN
**Str. "New York" Off for a
River Trip, Albany, New York**, n.d.
Postcard, 3½ x 5½ inches
Lyrical Ballad Bookstore,
Saratoga Springs, New York

UNKNOWN
**Steamer "Hendrick Hudson"
The Magnificent New Steamer of the
Hudson River, Day Line**, n.d.
Postcard, 3½ x 5½ inches
Lyrical Ballad Bookstore,
Saratoga Springs, New York

UNKNOWN
Steamer "Mary Powell," n.d.
Postcard, 3½ x 5½ inches
Lyrical Ballad Bookstore,
Saratoga Springs, New York

UNKNOWN
**Steamer "Robert Fulton" of the
Hudson River Day Line operating
between the cities of Albany and
New York; Speed 25 miles an hour**, n.d.
Postcard, 3½ x 5½ inches
Lyrical Ballad Bookstore,
Saratoga Springs, New York

UNKNOWN
**Palisades of the Hudson,
New York Central System**, c. 1920
Playing cards, 4 x 5 inches
Albany Institute of History and Art, New York
Gift of Jean R. Morris

ROBERT W. WIER
Landing of Hendrick Hudson, 1866
From *History of The United States
from the Earliest Period to the
Administration of President Johnson,
Volume 1*, J.A. Spencer, D.D.
5 x 7½ inches
Private Collection

MATTHEW BUCKINGHAM
**Muhheakantuck—Everything
has a Name**, 2004
16mm film installation with
sound, 40 minutes
Courtesy of the artist and Murray Guy
Gallery, New York

MARGARET COGSWELL
Hudson River Fugues, 2009
Mixed media
Courtesy of the artist

PETER HUTTON
Time and Tide, 1998–2000
16mm film, 35 minutes
Courtesy of the artist

Two Rivers, 2001–2002
16mm film, 45 minutes
Courtesy of the artist

Study of a River, 1996–1997
16mm film, 16 minutes
Courtesy of the artist

ANNEA LOCKWOOD
A Sound Map of the Hudson, 1982
Sound installation, 71 minutes 30 seconds
Courtesy of the artist

ALAN MICHELSON
Shattemuc, 2009
HD video with sound, 30 minutes
and 48 seconds
Original music by Laura Ortman
Courtesy of the artist

JOHN STONEY
For your love, 2009
HD video loop, five minutes
Courtesy of the artist
and Pierogi, Brooklyn, New York

HISTORICAL OBJECTS

Cabinet, c. 1900
Wood and glass, 100 x 75 x 21 inches
Brookside Museum, Saratoga County
Historical Society, Ballston Spa, New York

~ ~ ~

JAMES AND RALPH CLEWS
**Picturesque Views Near Fort
Miller, Hudson River**, c. 1829–1836
Transfer-printed earthenware
9 inches diameter
Albany Institute of History and Art,
Albany, New York
Bequest of James Ten Eyck

**Picturesque Views Near Jessups
Landing, Hudson River**, c. 1829–1836
Transfer-printed earthenware
10⅜ inches diameter
Albany Institute of History and Art,
Albany, New York
Bequest of James Ten Eyck

**Picturesque Views Troy from
Mount Ida, Hudson River**, c. 1829–1836
Transfer-printed earthenware
10½ inches diameter
Albany Institute of History and Art,
Albany, New York
Bequest of James Ten Eyck

~ ~ ~

ANDREW STEVENSON
New York from Weehawk, c. 1825
Transfer-printed earthenware
16 x 20⅝ inches diameter
Albany Institute of History and Art,
Albany, New York
Bequest of James Ten Eyck

~ ~ ~

UNKNOWN
Pilot Wheel from the Mary Powell, 1861
101 x 98½ x 29 inches with base
Senate House State Historic Site, Kingston,
New York and New York State Office of
Parks, Recreation and Historic Preservation

~ ~ ~

UNKNOWN
Fulton Plate, c. 1820
Transfer-printed earthenware
10⅜ inches diameter
Albany Institute of History and Art,
Albany, New York
Bequest of James Ten Eyck

~ ~ ~

UNKNOWN
**Landing of Gen. Lafayette at Castle
Garden, New York**, c. 1824
Transfer-printed earthenware
13 x 17 inches diameter
Albany Institute of History and Art,
Albany, New York
Gift of C. Otto von Kienbusch

~ ~ ~

ENOCH WOOD & SONS
Pine Orchard House, Catskill Mountains,
c. 1825–1832
Transfer-printed earthenware
10¼ inches diameter
Albany Institute of History and Art,
Albany, New York

~ ~ ~

ENOCH WOOD
Albany, New York plate, c. 1819–1830
Transfer-printed earthenware
9⅞ inches diameter
Albany Institute of History and Art,
Albany, New York

Chief Justice Marshall plate, c. 1825–1832
Transfer-printed earthenware
8⅛ inches diameter
Albany Institute of History and Art,
Albany, New York

SELECTED FURTHER READING

Avery, Kevin J., and Franklin Kelly, eds. *Hudson River School Visions: The Landscapes of Sanford R. Gifford*. Exhibition catalogue. New York: The Metropolitan Museum of Art, 2003.

Bloemink, Barbara, Sarah Burns, Gail S. Davidson, Karal Ann Marling, and Floramae Mccarron-Cates. *Frederic Church, Winslow Homer, and Thomas Moran: Tourism and the American Landscape*. Exhibition catalogue. New York: Bulfinch Press, 2006.

Boyle, Robert H. *The Hudson River: A Natural and Unnnatural History*. New York: Norton, 1969.

Busch, Akiko. *Nine Ways to Cross a River: Midstream Reflections on Swimming and Getting There From Here*. New York: Bloomsbury, 2007.

Carmer, Carl Lamson. *The Hudson*. New York: Farrar & Rinehart, Inc., 1939.

Cronin, John, and Robert F. Kennedy, Jr. *The Riverkeepers: Two Activists Fight to Reclaim Our Environment as a Basic Human Right*. New York: Scribner, 1997.

Dunwell, Frances F. *The Hudson: America's River*. New York: Columbia University Press, 2008.

———. *The Hudson River Highlands*. New York: Columbia University Press, 1991.

Ellis, Amy, Elizabeth Mankin Kornhauser, and Maureen Miesmer. *Hudson River School: Masterworks from the Wadsworth Atheneum Museum of Art*. Exhibition catalogue. New Haven: Yale University Press; Hartford: Wadsworth Atheneum Museum of Art, 2003.

Faberman, Hilarie, ed. *Aerial Muse: The Art of Yvonne Jacquette*. Exhibition catalogue. New York: Hudson Hills Press, 2002.

Phillips, Sandra S., and Linda Weintraub, eds. *Charmed Places: Hudson River Artists and Their Houses, Studios, and Vistas*. New York: Edith C. Blum Art Institute, Bard College, and Vassar College Art Gallery, 1988.

Forist, Brian E., Roger G. Panetta, and Stephen P. Stanne. *The Hudson: An Illustrated Guide to the Living River*. New Brunswick, New Jersey: Rutgers University Press, 1996.

Howat, John K. *The Hudson River And Its Painters*. New Jersey: Viking Press, 1972.

Coolidge, Matthew, and Sarah Simons. *Up River: Man-Made Sites of Interest on the Hudson from the Battery to Troy*. New York: Blast Books, 2008.

Jason Middlebrook. Siena, Italy: Palazzo delle Papesse Centro Arte Contemporanea, 2003.

Kisselburgh, John W. *Shadows of the Half Moon*. New York: Vantage Press, 1972.

Kreuger, Anders, ed. *Matthew Buckingham: Messages from the Unseen*. Malmö: Lunds Konsthall, 2006.

Kwon, Miwon, ed. *Watershed: The Hudson Valley Art Project*. New York: Minetta Brook, 2002.

Lewis, Tom. *The Hudson: A History*. New Haven: Yale University Press, 2005.

Lopate, Phillip. *Waterfront: A Walk Around Manhattan*. New York: Anchor Books, 2005.

McShine, Kynaston, ed. *The Natural Paradise: Painting in America, 1800–1950*. Exhibition catalogue. New York: Museum of Modern Art, 1976.

Michelon, Olivier. *Anthony McCall: Éléments pour une Rétrospective, 1972–1979/2003* [Elements for a Retrospective]. Exhibition catalogue. Blou, France: Monografik Editions, 2007.

O'Toole, Judith H. *Different Views in Hudson River School Painting*. New York: Columbia University Press, 2005.

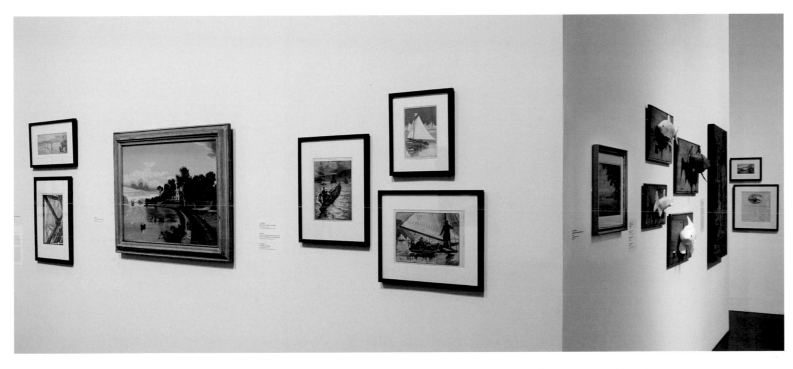

Olson, Roberta J. M. *Drawn By New York: Six Centuries of Watercolors and Drawings at the New-York Historical Society*. New York: New York Historical Society; London: in association with D. Giles Ltd., 2008.

Pfitzer, Gregory M. *Popular History and the Literary Marketplace, 1840–1920*. Amherst: University of Massachusetts Press, 2008.

Rothenberg, David, and Marta Ulvaeus, eds. *Writing on Water*. Cambridge, Massachusetts: MIT Press, 2002.

Sanderson, Eric W. *Mannahatta: A Natural History of New York City*. New York: Abrams, 2009.

Simpson, Jeffrey. *The Hudson River, 1850–1918: A Photographic Portrait*. Tarrytown, New York: Sleepy Hollow Press, 1981.

Stilgoe, John R. *Landscape And Images*. Charlottesville: University Of Virginia Press, 2005.

Symmes, Marilyn F. *Impressions of New York: Prints from the New-York Historical Society*. New York: Princeton Architectural Press in collaboration with the New-York Historical Society, 2005.

Peluso, Anthony J. *The Bard Brothers: Painting America Under Steam and Sail*. New York: Harry N Abrams in collaboration with the Mariners' Museum, 1997.

Wilstach, Paul. *Hudson River Landings*. Indianapolis: The Bobbs-Merrill Company, 1933.

Woodward, Richard B. *An-My Lê: Small Wars*. New York: Aperture, 2005.

Installation View, *Lives of the Hudson*
Tang Museum, Skidmore College, Saratoga Springs, New York

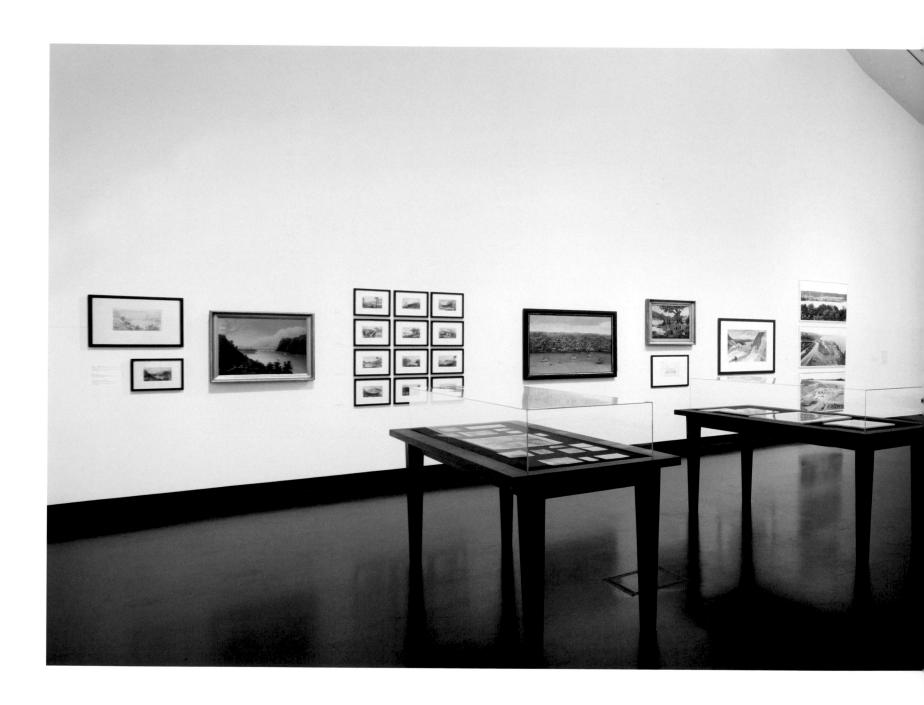

Installation View, *Lives of the Hudson*
Tang Museum, Skidmore College, Saratoga Springs,
New York

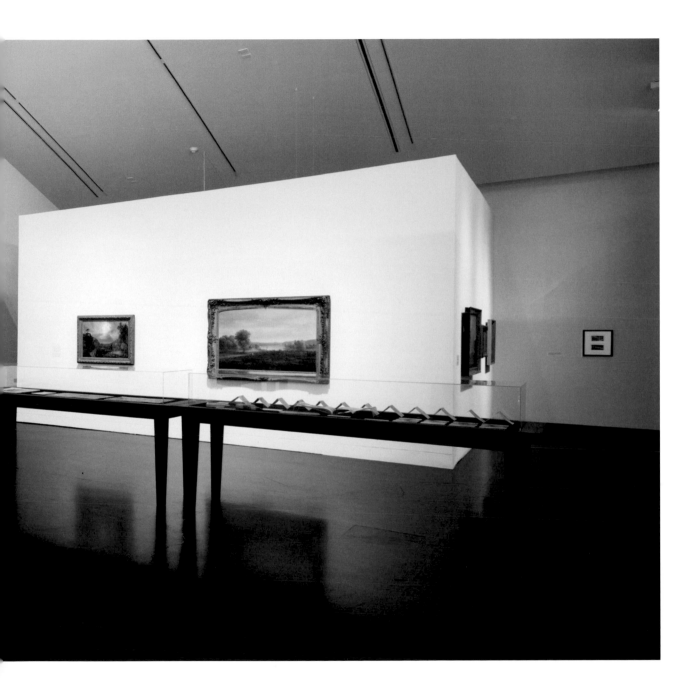

DIRECTOR'S AFTERWORD

In bringing together two hundred years of art and objects with a span of writers that includes poets, novelists, academics, and journalists, *Lives of the Hudson* perfectly embodies the Tang Museum's mission to push the boundaries of contemporary exhibition practice and the publications that accompany them. This book, like the exhibition it complements, explores historical intersections of visual culture, material objects, art, and oral history in open-ended, speculative, and at times playful ways. Yet neither book nor exhibition fits easily into conventional categories of the museum, literary, or academic worlds. This book no more represents a traditional art catalogue or literary anthology than the exhibition aimed simply to offer a group art show about the Hudson River. Rather, both book and exhibition seek a hybrid voice and a multifaceted vision of how each might evoke history and investigate the present-day river.

My deliberate use of the subjunctive case here gets at the goal of projects such as *Lives of the Hudson*: not to create a closed case, a scholarly summary of historical terrain, but to lead readers and visitors into a speculative journey through a rich historical topography, aided by an enticing, useful, and provocative set of literary and visual way markers. We invite our visitors and readers to map out their own itinerary through the many Hudsons, and to use this book as an imaginative printed guidebook, one proposing a varied set of ways to listen, look, write, and read about the Hudson River and its many lives.

In creating *Lives of the Hudson*, Ian Berry and Tom Lewis have selected a set of historical artifacts, art works, images, and documents relating to the Hudson's long history and enlisted a truly distinguished group of artists and writers. Yet their endeavor represents but one selection; there can and should be many others. The point is not to have the last word, but to offer a set of first words in order to inspire new conversations and dialogue.

On behalf of the Tang Museum, my sincere thanks to Ian Berry and Tom Lewis for their work as curators and editors, to the staff of the Tang for implementing their vision and ideas with creative expertise, and to Skidmore College for its support of the museum and its distinctive mission. As with any such effort, we can accomplish our work as college and museum only with the help of benefactors equally committed to our goals, and I am pleased to recognize major exhibition support from the Andrew W. Mellon Foundation, the Getty Foundation, the Tadahisa Kuroda Exhibition Fund, the Virginia Gooch Puzak '44 Faculty Curatorial Endowment, and Friends of the Tang, with additional support from the Henry R. Luce Foundation and the Creative Thought Fund at Skidmore. Special thanks to the City of Saratoga Springs, Lew Benton, and Johnnie Roberts, for including *Lives of the Hudson* in a grant funded by the New York State Department of Environmental Conservation, Environmental Protection Fund.

My thanks as well to the many artists and writers involved in *Lives of the Hudson*, who have contributed to the exhibition, book, website, and many public events at the Tang. Particular thanks to the numerous Skidmore faculty who worked with Ian and Tom on the exhibition, and all those who incorporated the exhibition into their classes during its run. Finally, it is with great pleasure that we have collaborated with Mary DelMonico of DelMonico Books • Prestel and designer Barbara Glauber of Heavy Meta to create this unique and beautiful volume. We offer this publication as testimony to new ways of thinking about objects, histories, exhibitions, and books, and we invite audiences of all sorts to share our fascination and enthusiasm.

John S. Weber
DAYTON DIRECTOR

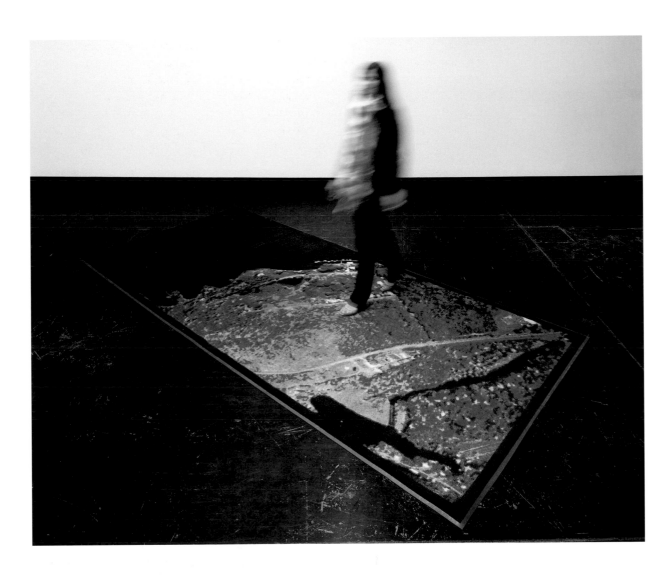

Bob Braine and Leslie C. Reed, **Tectonic Plate Entrance**
Mat #1 Brick Row the Hudson River and Murderers Creek,
Non georectified cartographic view, 2009
Digital print on nylon and rubber, 67½ x 145 inches

Installation view, *Lives of the Hudson*
Tang Museum, Skidmore College, Saratoga Springs, New York

ACKNOWLEDGMENTS

The Hudson River is a daunting subject to take on in any form whether it is painting or film, an exhibition or a book. The river's long and winding history encompasses important moments of political and cultural history, science, environmental policy, art history, social and industrial development, tourism, and geology. Part of our job as curators was to recognize the ways in which these various strains of thought influenced one another and blurred the boundaries between what many had considered carefully constructed and discreet disciplines. That interdisciplinary blurring led to many new discoveries and opened us up to new ways of understanding the river.

Our discoveries most often started with objects. We have many individuals and institutions to thank for their assistance with research, photography, and loans. Thanks to: Kevin Avery, Associate Curator, Elaine Bradson, Emily Foss, and Saskia Verlaan, The Metropolitan Museum of Art; Maud Ayson, Executive Director, and Lori Butters, Fruitlands Museum; Louis Benton, Saratoga Springs Visitors Center; Robert E. Bullock, President, New York State Archives Partnership Trust; Bartholomew Bland, Curator of Exhibitions, Hudson River Museum; Peter Blume, Director, and Denise Neil-Binion, Registrar, Ball State University Museum of Art; Doreen Bolger, Director, Jay M. Fisher, Deputy Director for Curatorial Affairs and Senior Curator of Prints, Drawings and Photographs, The Baltimore Museum of Art; Robert Boyle;

Elizabeth Broun, Director, Smithsonian American Art Museum; Suzanne Christoff, Associate Director for Special Collections and Archives, USMA Library; Debora Ryan, Senior Curator, Karen Convertino, Registrar, and Justin Rabideau, Everson Museum of Art; Matthew Conway, Registrar, and Liz Emrich, Herbert F. Johnson Museum of Art, Cornell University; Sharon Corwin, Director, and Patricia King, Assistant Director, Colby College Museum of Art; John Cronin; Ronald Crusan, Director, and Susan Ballek, Lyman Allyn Art Museum; Paul D'Ambrosio, Vice President and Chief Curator, Christine Olsen, Registrar, John Hart, and Glenn Linsenbardt, Fenimore Art Museum, New York State Historical Association; Todd DeGarmo, Director, Center for Folklife and Cultural Programs, Crandall Public Library, Glens Falls; John and Janice DeMarco, Lyrical Ballad Bookstore; Linda Ferber, Executive Vice President and Museum Director, Marilyn Kushner, Curator, Marybeth De Filippis, Assistant Curator of American Art, Kimberly Orcutt, Jean Ashton, Jill Slaight, and Scott Wixon, the New York Historical Society; Virginia Foster, Associate Registrar for Loans and Exhibitions, The Colonial Williamsburg Foundation; Joel B.Garzoli, Garzoli Gallery; Rich Goring, Director, Senate House State Historic Site; Anne Goslin, Collections Manager, Historic Hudson Valley; Paul Greenhalgh, Director and President, Sarah Cash, Curator of American Art, Ila Furman, and Andrea Romeo, Corcoran Gallery of Art; Tammis Groft, Chief Curator, Douglas McComb, Curator of History, Ruth Greene-McNally,

Barbara Bertucio, and Allison Munsell, Albany Institute of History & Art; Janice Guy, Murray Guy Gallery; Leanne Hayden, Collections Manager, Berkshire Museum; Hosfelt Gallery; Franklin Kelly, Senior Curator, Amy Johnston, Carlotta Owens, Emma Acker, Barbara Goldstein Wood, and Alicia B. Thomas, National Gallery of Art; Sean Kelly, Lauren Kelly and Denis Gardarin at Sean Kelly Gallery; Elizabeth Kornhauser, Deputy Director, and Aileen Bastos, Wadsworth Atheneum Museum of Art; Arnold Lehman, Director, Charles Desmarais, Deputy Director for Art, and Teresa Carbone, Curator of American Art, The Brooklyn Museum; Amy Lipton; John Lovell, Acting Director, New York State Bureau of Historic Sites; Anthony McCall; Erin McCutchen, Museum of Fine Arts, Boston; Jennifer McGregor, Senior Curator, Wave Hill; Jillian Mulder, Curator, Chapman Museum; James Mundy, Director, and Karen Casey Hines, The Frances Lehman Loeb Art Center, Vassar College; Vivian Patterson, Associate Curator, Collections Management, Williams College Museum of Art; Tatiana von Prittwitz und Gaffron, Curatorial Researcher, Center for Curatorial Studies, Bard College; David M. Reel, Director, and Gary Hood, Curator of Art, West Point Museum; Jock Reynolds, The Henry J. Heinz II Director, Yale University Art Gallery; Paul Schweizer, Director, Mary Murray, Maggie Mazzullo, and Lori Eurto, Munson-Williams-Proctor Arts Institute; Angela Snye, Assistant Curator, Adirondack Museum; Gail Stavitsky, Chief Curator, Montclair Art

Museum; Paul Warwick Thompson, Director, and Flora Mae, Cooper-Hewitt Museum, Smithsonian Institution; Gillian Thorpe, Director, Julia L. Butterfield Memorial Library; Lucy Tower; Meredith Ward, Meredith Ward Fine Art Gallery; Susan Wides; Kathleen Young and Melody Moore, Staatsburgh State Historic Site.

Special thanks to the Senate House for their loan of the pilot wheel from the great steamboat The Mary Powell. The Senate House State Historic Site is one of 35 historic properties administered and operated by the New York State Office of Parks, Recreation and Historic Preservation; David A. Paterson, Governor.

Great thanks to the artists who worked alongside us during the entire process, often making new work for the exhibition, taking part in lectures and teaching classes at Skidmore, all the while guiding us to new ways of seeing. Thanks to: Bob Braine and Leslie Reed, Matthew Buckingham, Bradley Castellanos, Margaret Cogswell, Maxine Henryson, Peter Hutton, Yvonne Jacquette, Kysa Johnson, Annea Lockwood, An-My Lê, Michael Light, Alan Michelson, Jason Middlebrook, Shaun O'Boyle, and John Stoney. Matthew Buckingham's film installation was originally commissioned by Minetta Brook as part of *Watershed: The Hudson Valley Art Project*. His project was made possible through the generous assistance of: Montana Cherney, Jimmy Durham, Andrea Geyer, Sharon Hayes, Peter Hutton, Ned Kihn, Lan Thao Lam, Lana Lin, Cara O'Connor, and

Diane Shamash. Alan Michelson would like to thank Andre Costantini, director of photography; Vanessa Reiser Shaw, editor; Laura Ortman, composer and performer; and Greg Porteus and the crew of Launch 5 for their assistance making *Shattemuc*.

The entire staff of the Tang Museum helped build this project—thanks to Ginger Ertz, Torrance Fish, Megan Hyde, Elizabeth Karp, Susi Kerr, Gayle King, Chris Kobuskie, Ryan Lynch, Patrick O'Rourke, Vickie Riley, Lori Robinson, Barbara Schrade, Kelly Ward, and Tang Director John Weber for their support. Thanks also to our great installation crew: Sam Coe, Rob Goodale, Jack Schaefer, Shawn Snow, and Jay Tiernan, and to Alexander Chaucer, GIS Instructional Technologist, IT Academic Technologies at Skidmore for his work to produce two new computer maps of the river.

We can list all the essayists in this book as our cherished colleagues and good friends, thanks to: Peg Boyers, Kristen Boyle, Akiko Busch, Kathryn Davis, Terry Diggory, Carolyn Forché, Judy Halstead, Mimi Hellman, Larry Hott, Bob Jones, Karen Kellogg, Fred LeBrun, Phillip Lopate, Rick Moody, Greg Pfitzer, Rik Scarce, Tom Sleigh, John Stilgoe, and Paul Tucker for their insightful responses.

Thanks to Barbara Glauber and Erika Nishizato at Heavy Meta, whose catalogue design is as layered as the many ways we approach the river. Their inventive design leads readers to many of the revealing juxtapositions that

we hoped would be possible in a book. Very special thanks to DelMonico Books • Prestel and Mary DelMonico for their important production support and work to get the book to new audiences across the globe. Thanks to Arthur Evans for his brilliant new photography and to the many other photographers whose work is included here. Thanks to Jay Rogoff for his text editing and to Ginny Kollak and AnnaZofia Valenzuela for their critical assistance during the formation of the exhibition.

We had the very good fortune of insightful questions and assistance from a group of students that added to our project in many ways, thanks to: Riley Albair, Naomi Brown, Alicea Cock-Esteb, Sophie Cohen, Emily Devoe, Rachel Downes, Sarah Faude, Fran Gubler, Jessica Hass, Rachel Haas, Michelle Julian, Kengo Ikeda-Iyeki, Kacey Light, Nida Pellizzer, and Blair Stelle.

We share all of our thanks and offer a special appreciation to Kristen Boyle, Curatorial Assistant for Special Projects at the Tang, who helped in every way on this long-term, complex project.

Lastly, we would like to thank our families, especially Monica Berry and Jill Lewis for their ever-present support and encouragement. We have spent many days and nights reading, writing, and talking about the Hudson when it would have been far more pleasurable floating on its waters with them.

Ian Berry
SUSAN RABINOWITZ MALLOY '45 CURATOR

Tom Lewis
PROFESSOR OF ENGLISH

Image credits

All images courtesy of the Frances Young Tang Teaching Museum and Art Gallery, Skidmore College, Saratoga Springs, New York by Arthur Evans unless otherwise noted.

Page 10: Acquired through the Membership Purchase Fund, photograph courtesy of the Herbert F. Johnson Museum of Art, Cornell University

Page 11, 15, 28, 40, 46, 177, 182, 194, 196, 197, 198: Courtesy of the Chapman Historical Museum, Glens Falls, New York

Page 12-13, 204-205: Courtesy of The Frances Lehman Loeb Art Center, Vassar College, Poughkeepsie, New York

Page 14, 174: Courtesy of the artist and Hostfelt Gallery, New York/San Francisco

Page 16: Courtesy of Munson-Williams-Proctor Arts Institute, Utica, New York

Page 30, 68, 69, 207: Courtesy of the artist and Pierogi, Brooklyn, New York

Page 33, 34: Courtesy of the artist

Page 39: Courtesy of the artist

Page 48: Lent by the Metropolitan Museum of Art, New York, Rogers Fund, 1942 (42.95.9)

Page 62: Courtesy of the artist

Page 70, 71, 72, 74, 75, 76, 77, 160, 180–181: Courtesy of Munson-Williams-Proctor Arts Institute, Utica, New York

Page 81: Courtesy of the Corcoran Gallery of Art, Washington D.C., Gift of William Wilson Corcoran

Page 84: Collection of The Berkshire Museum, Pittsfield, Massachusetts

Page 86: Courtesy of Ball State University Museum of Art, Muncie, Indiana

Page 88–89, 90–91: Courtesy Sean Kelly Gallery, © Anthony McCall

Page 92–93: Courtesy of the Everson Museum of Art, Syracuse, New York, Museum purchase, 72.26

Page 98, 99, 100, 101, 102, 105: Courtesy of the Board of Trustees, National Gallery of Art, Washington D.C.

Page 122: Courtesy of the artist

Page 113, 123, 124, 178–179: Courtesy of the New-York Historical Society, New York

Pages 128, 130: Courtesy of the artist

Page 154: Courtesy of Abby Aldrich Rockefeller Folk Art Museum, The Colonial Williamsburg Foundation, Williamsburg, Virginia

Page 158: Courtesy of the Fenimore Art Museum, Cooperstown, New York. Gift of Stephen C. Clark.

Page 159: Courtesy of the artist and Caren Golden Fine Art, New York

Page 165, 166: Courtesy of the artist

Page 173: Courtesy of the Historic Hudson Valley, Tarrytown, New York

Page 189, 190, 193: Courtesy of the artist and Murray Guy Gallery, New York